Anatomy
of a Waterfowl

*Also by Charles W. Frank, Jr.*
**Louisiana Duck Decoys**

# Anatomy
## of a Waterfowl

*for Carvers and Painters*

CHARLES W. FRANK, JR.

Pelican Publishing Company
Gretna 1982

**Library of Congress Cataloging in Publication Data**

Frank, Charles W., 1922–
  Anatomy of a waterfowl, for carvers and painters.

  Bibliography: p.
  1. Waterfowl in art.   2. Decoys (Hunting)   3. Art—
Technique.   I. Title.
N7665.F68        704.9'432        81-10657
ISBN 0-88289-290-8                AACR2

Photo credits: John Culbertson, photographs 66, 73, 81, 106, 116, 129, 208, 215;
Bobby Castlebury, photographs 149, 150, 156, 157; Elizabeth T. Adler, photographs
74, 253, 261, 262, 263.

Paintings by Charles Hutchison

Manufactured in the United States of America

Published by Pelican Publishing Company
1101 Monroe Street, Gretna, Louisiana 70053

# Contents

# Introduction

When I began to consider writing another book, I toyed with the idea of creating an artist's reference of color and anatomy of waterfowl, as much for my own enlightenment as for any other reason.

I carve and paint waterfowl. The ideal environment for the waterfowl artist would, of necessity, have to include a habitat for dabbling and diving ducks. But how many of us are fortunate enough to have the opportunity to observe these ducks in their native element? Of course, you can begin to collect taxidermy mounts and study skins. The study skins are slightly less expensive, but do not furnish poses and are without glass eyes. I had some sixty mounts collected when the May 1978 flood hit New Orleans. Some forty specimens plus thousands of photographs, taken throughout the years, were lost in this inundation. So my enthusiasm for a permanent file of photographs in book form, directed to the artist and his needs, became much more clearly defined.

Almost all craftsmen are quick to acknowledge their artistic shortcomings in portraying the nuance of colors that wildfowl art demands. I must admit to sharing that view. It is impossible to duplicate nature, and the subtlety of color found on these birds cannot be reproduced with complete accuracy. One of the problems that can never be completely overcome by a literary attempt to portray the painting process, with assistance from photographs, is that many colors are reflective rather than chemical in nature. These appear on the photographic plate in shades dependent upon the angle at which the light strikes the section of the bird being observed. Also, in time light causes a deterioration in this reflective process, so that frequently the speculum loses its luminosity, and painting from specimens gives a false color value.

With the help of Freddie Bowen, a talented and patient artist and teacher, and John Culbertson, a gifted artist and carver, I have attempted to describe in some detail the problems and solutions that confront those who would create waterfowl in wood. Dick LeMaster has inspired me to extend the analysis of carving and painting so splendidly described in his book *Wildfowl in Wood*.

Charles Hutchison, winner of the *Best in Show* award for 1977 and 1978 in the Louisiana Wildfowl Carvers and Collectors Guild competition has made magnificent color renditions of birds in flight, from above and below, standing and swimming. Reproductions of these paintings are included in this book, as is a diagram of the waterfowl's anatomy which you will want to refer to throughout your work. Thus the anatomy of a wildfowl can be observed and portrayed as accurately as possible and the nomenclature can be studied at leisure, since each photograph in this book taken with a macro lens illustrates a particular part of the anatomy.

I would also like to mention the patience with which my secretary, Norma Roycroft, has transcribed, retranscribed, and then transcribed again—until we finally came up with a mutually satisfactory expression of a very imprecise art form.

Although I have concentrated on the painting and carving of decorative, fully textured, and burned waterfowl, the painting techniques are equally applicable, in most cases, to what are referred to as "slicks." These are works in which a smooth sanded surface creates the base or ground on which oils or acrylics may be used. Of course, a greater viscosity and more opaque colors can be applied to slicks than to textured birds. No doubt the artist or student of the craft would supplement the material I have compiled with slides or photographs of his own creation. My own library consists of thousands of photographs of waterfowl, taken on game farms and in situs.

Since waterfowl are as kinetic a subject as one could select, there is a never-ending number of poses and postures to be captured. I have found

a small, opaque screen projector, called a Kinderman projector, which is most useful in holding a slide on a small glass screen during carving or painting. Enlarging to approximately six by eight inches, this device permits a degree of concentration on one small area of a waterfowl or a study of the entire bird in a frozen moment that appeals to the artist. I have found that filing photographs of birds by species and sex gives me a ready reference to the work I have done in the past. I like to review these slides before starting on a particular species.

Although there are a number of fine books in which artists have published their renditions of species, you may well copy their mistakes if they are your primary reference. Live birds are still the best models, as they were in Audubon's time. Your second reference would be your own photographs taken of live birds, being careful to observe color variances caused by the angle of reflection of the sun's light on the feather pattern. As a third reference, I would list study skins and taxidermy in general. Unfortunately, most taxidermists are not adequately trained in the anatomy of waterfowl, and although their mounts give fair color renditions, as a reference point, they are not always accurately laid out with respect to the natural pattern of the primaries, secondaries, and tertials. The musculature is frequently eliminated by the use of body fillers that do not reflect the little indentures·caused by a twisting of the neck or a raising of the side pocket or leg.

As imperfect as it may be, I hope that this work will serve to fill a niche in the wildfowl artist's library. I have tried to design it for both amateur and professional, to the best of my ability.

One brief comment might be in order as to the variety of techniques and effects used in waterfowl carving and painting. Although I have concentrated on the use of oil colors, lacquer thinner, and Grumbacher Medium I, II, and III, do not be afraid to experiment. I have constantly tried to expand the diversity of media and visual effects by the use of both transparent and opaque colors, the use of speckles of paint, and a variety of textures and techniques. The use of india inks and a host of other materials should not be overlooked. I have used watercolors, lacquers, enamel, varnishes, and tempera. I have used dental drills, diamond touch wheels, saw blades, a variety of Carborundum-type materials, wire brushes, steel wools, sandpaper, engraving tools, and a host of twentieth-century wood fillers, water putty, and epoxies. Experi-mentation with techniques and media can add an entirely new dimension to your work. As you progress you will find that many of the media are not mixable, but an equally large number are. Study the manuals and books available to you free in most art stores; you will find materials advertised that are worth trying. Haunt the hobby shops. Frequently they have small tools that lend themselves beautifully to an effect that has eluded you for a long period of time. Join an arts or crafts club, if one is available in your area. Here, men and women with kindred interests can exchange ideas, and this will hasten your growth as an artist. I do not believe in secrecy insofar as technique is concerned. For every assistance I have rendered a fellow craftsman, I have been rewarded tenfold with information and techniques given to me in return. Your growth as a waterfowl artist will have reached its zenith when you have learned all there is to know on the subject—but it seems to me that there is always more to learn and higher aspirations to adopt.

I would be remiss if I did not thank Mrs. A. L. Blouin of Raceland and Mr. Charles Lynch of Lafayette for their assistance in permitting me to photograph birds in their game farms. These have been privately maintained throughout the years. Here, I have been able to see many of the birds photographed in this work at closer range than would normally be available to the photographer in the field. I would also like to thank Dr. John P. O'Neill and Mr. John Maroney of Louisiana State University for their constructive criticism and constant assistance, as well as for the use of innumerable specimens from their vast collection. While working with their collection I was able to take photographs of some of the waterfowl more difficult to obtain and eliminate errors in this tome.

Since time immemorial, man has recognized that the purest and most brilliant colors in waterfowl are not the pigment colors with which we are conversant and with which we attempt to paint our waterfowl carvings, but the interference colors. The iridescence in waterfowl creates a miracle. To date, the artist has been unable to completely capture this phantom of light. The colors that appear almost black from one angle, with a slight shift of the angle of light burst into magnificent brilliance, varying from the deepest purples and blues to the brightest and most iridescent of greens. These "fragments of rainbows" can be

created by the bird's movement changing the angle at which the light strikes the feather pattern, or by the observer shifting a few degrees to the left or the right. The most intense color will always be seen when the light strikes the area of feathers from a more or less vertical angle. As the angle becomes more oblique, the color becomes weaker. Hilda Simon, in her book on iridescence, has explained: "thus, a color whose basic tone is bright green is less brilliant when it gets a bluish cast in light slanted at an oblique angle." There is no way to aptly describe the magnificence that nature creates in iridescent hues. Artists can only rudely attempt to emulate with fidelity the unbelievable virtuosity that has been formed in the genes of an avian life form, created in an unlaid egg, where a pattern of visual beauty was established in generations long past. When you realize that these light values are created by structures that are seven-millionths of a centimeter in thickness, you will marvel at nature's ingenuity.

The precision and minuteness of nature gives the artist a challenge which this work can only hope to accentuate, not to solve. The tens of millions of submicroscopic structures which make up these light values are a lasting tribute to nature's creative forces, and we, as artists, can only reach for higher ideals. I hope that this work will enable the struggling artist to come one step nearer the goal.

Anatomy
of a Waterfowl

# 1

## Black Mallard (Black Duck)

**DRAKE**

1) Three black mallards offer a muted combination of color that is often excessively drab if one does not understand the highlighting procedure. The basic color is comprised of burnt umber and black in the darker shades, with the lighter shades, in the head particularly, being a little burnt umber mixed with yellow ochre and white. The greenish color of the bill can best be made by mixing black with a cadmium yellow (light). The leg color can be obtained by mixing cadmium yellow (light) with a little touch of burnt sienna and a touch of cadmium red (light).

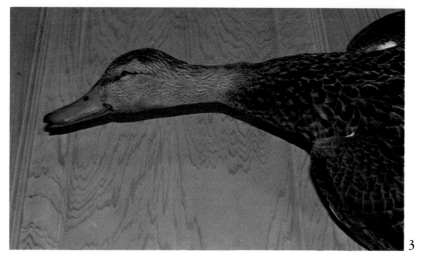

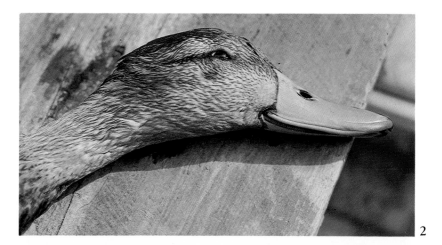

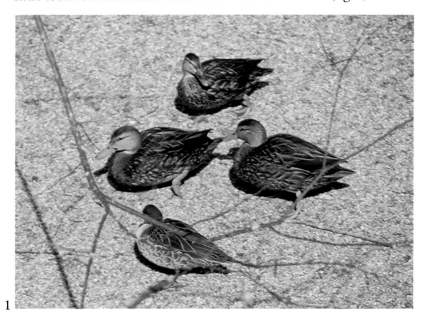

(2,3) The black mallard drake head shown here poses some interesting problems in the development of half tones. The darker portions of the head should be painted first, with burnt umber and black interspersed and blended. Then come back with white and just a touch of yellow

ochre so that the interfaces can be blended. Note that there is very little regularity to the pattern. The top of the head is considerably darker with much more black and burnt umber than the cheeks. The bill is that yellowish green that can be made by mixing cadmium yellow (light) and black. Then blend in the little dark touches for the nostrils and the lamellae. The nail is black. Note the irregularity of the line separating the lighter head from the neck, chest, and breast. Note also the irregularity of the back feathers, showing no pattern to speak of. The scapulars and the lesser coverts on the wings are outlined with a touch of sienna and burnt umber, with a little touch of white or yellow ochre to give the variance that this highlighting requires.

(4) This is an excellent shot of the speculum. Notice the bronzing effect and again the irregularity of the interfaces between the brighter colors of the speculum and the blacks. Notice the delicacy of the blending of the interfaces; also note the irregularity of the pattern highlights on the back feathers as they approach the speculum. The blue shown in this particular illustration is completely reflective and is much brighter than would

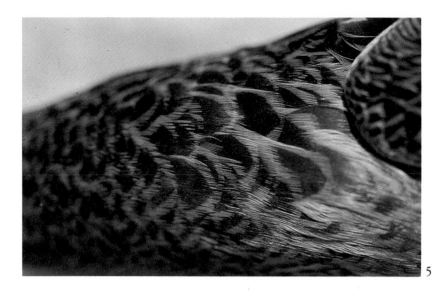

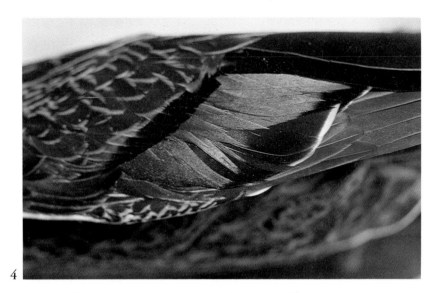

normally be seen. The interesting thing about this is that the variance between the angle of light can cause a tremendous difference in these bronzing, reflective colors. That speculum could be everything from a purple black to a greenish purple. As the bird turns and twists in the sunlight, it is very difficult to imagine duplicating the variance in color that one sees—but it can be done. While the base blue and black are still tacky, highlight with a touch of white pulled through.

(5) This is an excellent shot of the feathers on the neck and shows the highlighting in great detail. Notice that the burnt umber shows through the edges. This part of these feathers should be done with a very fine brush, mixing the medium to give you a thin wash of burnt sienna, burnt umber, and a little yellow ochre with a touch of white. Another technique for letting the burnt umber show through the highlighted edges is to use a bristle brush with the same color mixture and paint against the burn marks, so that the burnt umber from the original undercoat will show through.

(6) The breast shot here gives a good example of the irregularity of feather pattern in nature. This is not a fish-scale effect, but a flow of different shapes and sizes. As the breast blends into the neck area, you will notice that the colors get brighter and more luminescent, but the lack of pattern is still noticeable. I believe that one of the biggest mistakes painters make is to pattern feathers more than nature does. One of the problems that has to be recognized is that to paint realistically you

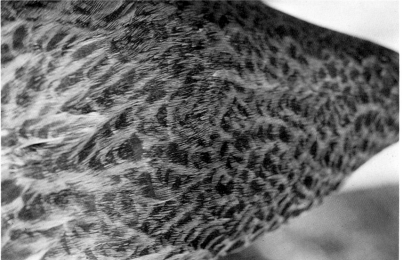

have to carve realistically. You cannot put an irregular paint pattern on a uniform set of feathers. The carving itself must show each feather in its natural irregularity, in order to let your paints duplicate nature.

(7) These are the under tail coverts of the black duck and show the light-bordered feathers with the brighter under tail coverts blending into the tail feathers. The tail feathers themselves, on the bottom or underside, are white with just a touch of burnt umber and raw umber. The under tail coverts have a base coat of burnt umber and black. The edges should be put on with a bristle brush, mixing burnt sienna, yellow ochre, and white for the edging. If the feather pattern is burned in, you can use the bristle brush. If the burning is straight line burning with no feather pattern carved in, you will do better to use a sable brush, dabbing in each little stroke as delicately as possible. Strokes should preferably come from the front of the bird, lifting the weight off the brush as you proceed to the rear. Try to paint with washes (thin coats). Do not allow your paints to layer and build up. This conceals your detail.

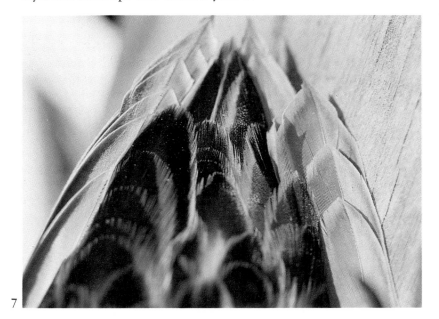
7

# 2
## Bufflehead

### DRAKE

(8) Here we see the strong contrast between blacks and whites that makes the drake a difficult bird to do an outstanding job on. The back feathers and the primaries are an almost jet black with a slight iridescence. This is purplish, with a touch of bronze and a touch of green. The bill of the drake is a much lighter gray than the bill of the hen; it is more of a blue gray. You could use a Payne's gray and black—unlike what you would use for the brownish cast of the male's bill. Note again that there is no scaling of feathers, but a hairlike effect on both side pocket and crest. The tail coverts are bordered with an off-white, but the basic color is raw umber and black, lightened with white. If the white is added while the dark paint is wet, you will get a much softer effect. Remember, do not paste your colors on; use wash after wash. The biggest mistake we all seem to make is an overabundant application of paints in order to obtain opacity. This gives you a buildup that destroys the detail you have taken such pains to burn in. This is an easy mistake to make; I plead guilty of it myself.

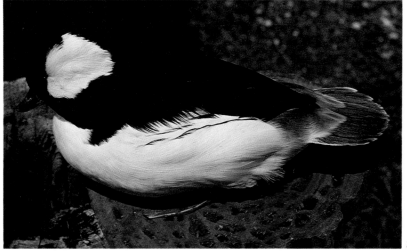
8

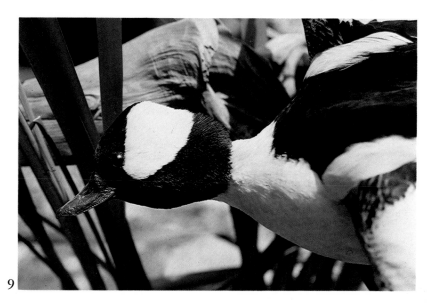

9

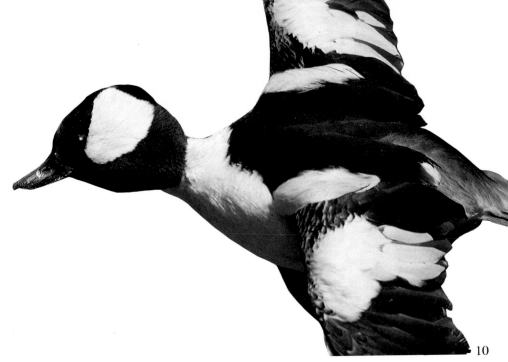

10

(9) This bufflehead shows a slightly darker bill than is normal, but offers an excellent opportunity to look closely at the irregularity of the interfaces between the white of the breast and of the crest and the darker color of the rest of the head and the back. An interesting thing to note on this particular illustration is that on the leading edge of the crest patch the black should be pulled into the white. On the trailing edge of the white patch of the head, the white should be pulled into the black. Similarly, in blending the interfaces of the breast and the back, you will note that the black must be pulled into the white. The lesson is that you must thoughtfully determine from which direction to pull in order to effect the flow of color.

(10) You can see the purple iridescence in the head very clearly here and also the unusual shape and leathery surface of the short, rather stubby bill of the drake. You can also see the hairlike pattern of the feathers on the breast and the roundness of every surface. Many of these little birds are carved in a rather slab-sided fashion because the curvature almost seems pneumatic. The pallet required for doing the scapulars, the cape, the back, and even the area of the upper tail coverts is composed of a very limited number of colors. Black and burnt umber, with a small amount of white added, give you that blackish purple required for the cape—more black as you reach toward the scapulars, and all white for the scapulars themselves. Note the broken pattern of the lesser coverts. The lesser

coverts should be painted first with a dark color of black and burnt umber. There are no sharp edges as the lesser coverts work their way towards the break in the wing created by the alula. After this has been permitted to dry for a few hours, but before it is completely fixed, come in with a fine #1 sable brush to delicately apply the broken pattern of the white in the lesser coverts. Note that the splines of the feathers are very prominent in the secondaries and the primaries. The color for the splines involves a touch of yellow ochre, with possibly the slightest amount of burnt sienna added. Note the effect created by the darker outer edge, working into a lighter area in which sienna predominates as you reach the spline.

(11) The side of the drake again shows the pneumatic curves of the breast, the back, and the under tail covert, as well as the flatness of the tail feathers themselves. This is rather typical of the diving ducks. Note how irregular the white patch is on the crest of this little bird. Again, remember that the pattern of all birds is completely irregular. Note that the breast itself is a rather mottled umber and white in contrast to most birds whose breasts are lighter. Since many birds are being carved in the round today, it becomes increasingly important to notice details of this sort.

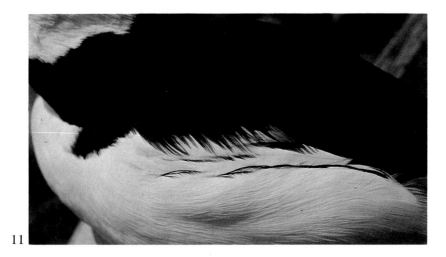

11

(12) This top view of the drake shows the softness with which the upper tail coverts blend into the tail feathers themselves. The top view also shows quite clearly the pneumatic roundness of this little bird. Having seen generations of Louisiana's long, thin decoy shapes, many of our carvers fail to recognize that a bird at rest has this bulbous, plump breast

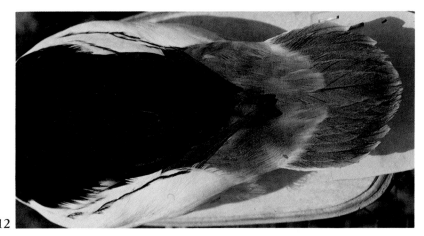

12

effect. It has only been in recent years that this teardrop effect has begun to appear in Louisiana's decorative decoys. Note also that on the tail feathers of the drake, the light edges of the feathers are pulled into the darker surface of the main area, and that the shaft is almost black. The double line of black that gives this little bird a unique appearance where the side pocket works its way into the back is lamp black with a touch of prussian

blue. The primaries are short and cross much further into the back of the bird than towards the tail feathers, as is typical of puddle ducks. This is strictly a diver and you will note that the tail feathers are almost at the water level, or on the water level, while the breast rides high and proud.

(13) Here we see the back feathers overlaying the side pocket. Since the side pocket itself is articulated, it is equally possible that the side pocket could overlay the back feathers instead of the reverse. But I think the effect here is much more dramatic, and it is certainly physically possible to arrange the feathers this way. The black line at the top of the side pocket is very striking in this photograph. The white patch of the crest is completely irregular and again illustrates that on the leading edge, the dark color of the front of the bird's head must be pulled into the white, while on the rear edge and the bottom of the feather patch, the white must be pulled into the darker area. The same thing is true where the breast feathers meet the throat and neck. If you are going to do this bird in stages, be very careful when you put in your patches of color to avoid leaving any hard lines that have to be covered at a later setting. It is much better to blend these interfaces roughly, even though they don't follow the exact pattern you desire, than to leave a harsh line that has to be painted over at a later moment. It is almost impossible to remove these lines once they have set up and dried. Keep those washes thin and translucent. They will become opaque as additional washes are added and you will get a depth of color that will be much more delicate.

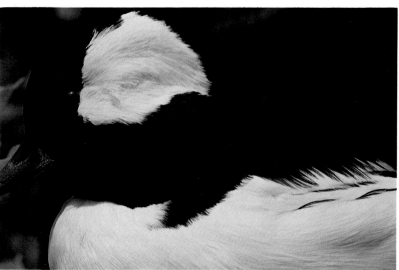

13

(14) This photograph merely gives an extension of your perspective of the color pattern of the drake bufflehead. No further description of the painting process is necessary here.

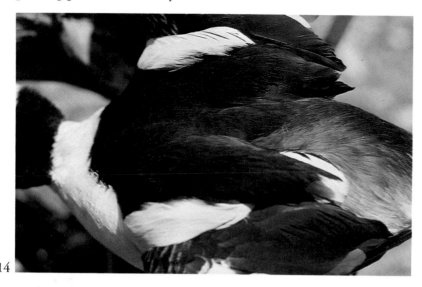

14

(15) A beautiful example of the sweep and grace of the feather patterns! There are no straight lines, very little scaling effect, but a beautiful flowing pattern that sweeps from the throat up and around into the breast and blends with the flow of the hairlike pattern into the belly. Note the delicate interplay of pulled, hairlike feathers created as the throat joins the neck—no straight line here. After the colors of the breast have been blocked in, burnt umber, black, and a touch of bronzing powder (a pur-

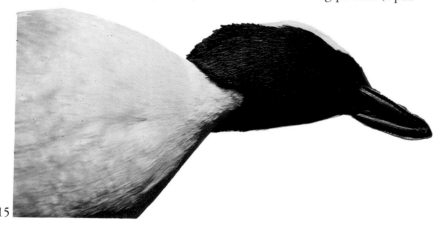

15

ple and a deep green) can be pulled with a fine sable brush into the neck area. The white of the neck should be completely dry before attempting to do this, since from a distance the line itself will appear to be a straight one. Notice that the breast itself does not appear white, as it is a white that has a little raw umber here and a little burnt umber there, pulled with a fan blender while still tacky.

(16) A hen bufflehead, because of its relatively monochromatic coloring, can be a very frustrating bird to paint. It is a combination of muted blacks, purples, greens, and whites. Since this little bird has darker tips on its feathers, the paint should be applied in a reverse fashion from that used for birds in which the tips are the brightest edge; that is, the

16

undercoat should be an off-white and then the overlaying color should be added, brushing raw umber from the back of the feather to the front. In some areas, a touch of burnt umber should be added to give you the color variance that shows in the back. Notice the pattern and sweep of the feathers in the side pocket. There is no feather pattern or scale effect. It is more hairlike, coming from the breast and sweeping down and then up on the side pocket. Many carvers make the mistake of scaling birds, which may win contests, but is far from realistic. There is a touch of purple iridescence on the crest, but basically the head is black with burnt umber—mostly black. The bill effect should be handled by painting with black and burnt umber and then highlighting the nostril area and blending, while still wet, to get that blue black tint rather than a uniform color. The white should be blended into the burnt umber and black to give you the grayish color. The lamellae could be touched just a bit lighter. This is one of the few birds where the speculum is a pure white, but add a little silver or gray to effect the shadows that feathers cast on one another.

(17) The color in the head is warmer than that of the back. This is quite obvious in this shot of the hen bufflehead. Also notice the slight purplish iridescence on the crest. Notice that the breast is not pure white, but that there are thin and irregular overlayers of white pulled through burnt umber and black.

(18) This shot, showing the crossed primaries, the speculum, and the tail feathers, as well as the upper tail coverts, again illustrates that the edges of the feathers are, in most instances, darker than the leading edges. This means that one must add the raw umber and black by stroking from the rear of the feather to the front, rather than the reverse.

(19) Note that on the tail feathers and the upper tail coverts, as well as the side pockets of the hen bufflehead, there are no warm browns. The colors used are raw umber, black, and white. On the back feathers, the secondaries, primaries, and tertials, there is a little burnt umber, which must be added to give the warmer brown cast to what is otherwise a rather grayish black bird. Again, notice that only the speculum is pure white. This is a bird that should be painted with a rather slow-drying medium (Grumbacher III), as all of the colors have to be blended and pulled. If you can paint this bird at one sitting, it will be a great deal easier than trying to paint it piecemeal as would normally be required. If you are going to try to paint the bird in more than one sitting, finish one area at a time rather than using an undercoat over the whole bird, as almost every area of the bird must be painted wet on wet (alla prima) in order to pull the colors. Be sure to get both sides of each area from the same blends. You will have an easier time than trying to match colors once they have dried, which can be most frustrating.

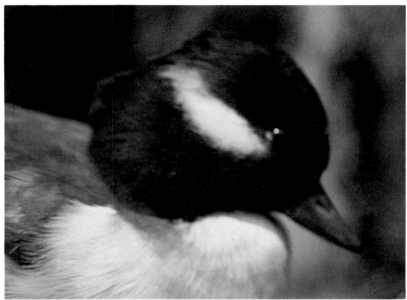

17

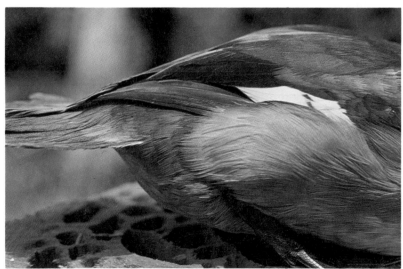

19

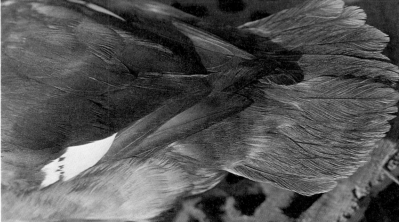

18

# 3

## Canvasback

### DRAKE

(20)  The canvasback drake, colloquially called *canard cheval* or horse duck, is one of the most regal of birds. It is larger even than the mallard and faster than the teal. It feeds on wild celery and is the most delectable of table fare. It isn't very difficult to recognize why market hunters came close to eliminating the species. At one time our winter marshes were host to vast flocks of this species. Today, small bands visit us with increasing frequency in the vicinity of Lake Salvadore and at the head of the Passes, near the mouth of the Mississippi River. The feet in this standing specimen are correctly placed almost two-thirds of the way back from the breast. The canvas-colored silhouette of the bulk of the body, the black breast and tail feathers, the burnt sienna of the head, and the black and burnt umber of the bill, touched on the edges with a little yellow ochre, make a distinct pattern in flight which is easily recognized.

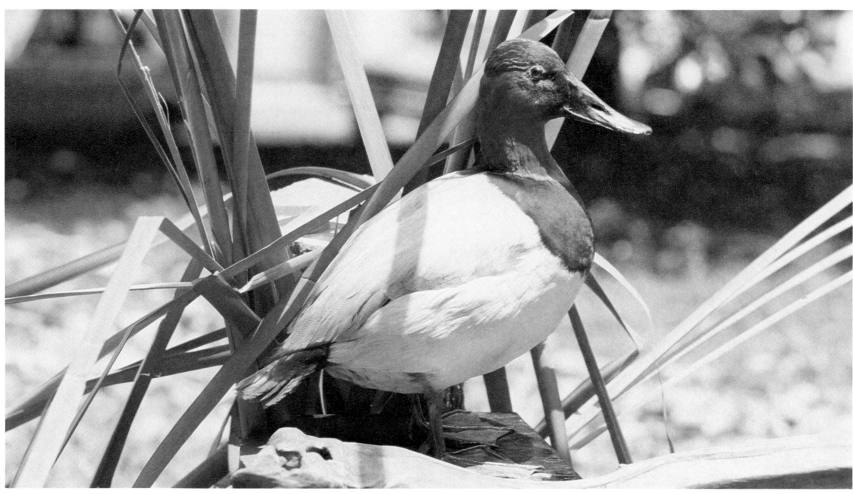

20

(21) The rich burnt sienna of the head is set off by the black of the bill and the cape and breast. The forehead is darkened with burnt umber. The cheeks and jowls are highlighted with yellow ochre and a dab of white brushed in to brighten the red cast of the sienna. Both the white and the yellow ochre must be applied very sparingly.

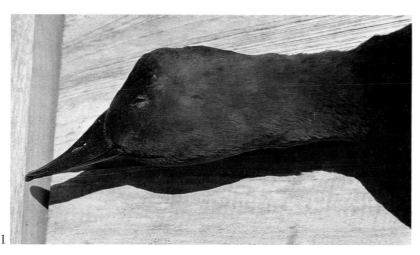

21

(22) The blue black of the mantle and the breast contrasts sharply with the gentle vermiculation of the scapulars and the upper wing coverts, shown quite clearly in this photograph. Note how the vermiculation of the upper tail coverts and the underlying feathers of the back beneath the scapulars is a much darker vermiculation than the faint pattern shown on both cape and scapulars. The pattern changes again as it works its way

22

into the upper wing covert area. The trick in achieving these effects is again accomplished by squinting the eye when looking at the photograph, which enables you to visualize the underlying color to be washed in. The vermiculation itself is only a tonal value different from this undercoat. It isn't the hard, sharp vermiculation of the wood duck drake or other more dramatically marked waterfowl.

(23) The pattern of the outstretched wing, showing the shortness of the primaries and the multiplicity of tonal values required of a small number of pigments is beautifully illustrated in this photograph. The feet and legs are gray with a slight bluish cast that can be obtained by mixing black with a touch of Payne's gray with the white. The knuckles are darker and require a slightly greater amount of the darker shades. Note the difference in the pattern and the color of the greater and lesser wing coverts. A fine burning iron should be used to achieve as much detail as possible before the painting is commenced. The vermiculation is irregular and very soft. One-half of the primaries contains a stippling on the outer edge which should be achieved in three steps. First, apply the off-white prime coat comprised of white tinged with a small amount of raw umber. Second, permit this to dry thoroughly and paint in the darker base of the feathers by pulling gently with raw umber. The tips of the feather then require pure raw umber, pulled into the lighter sections of the base of the feather. The stippled areas are the last stage. These areas should have been left uncovered by the two preceding coats and can now be stippled with raw umber to approach as closely as possible the detail shown in this photograph.

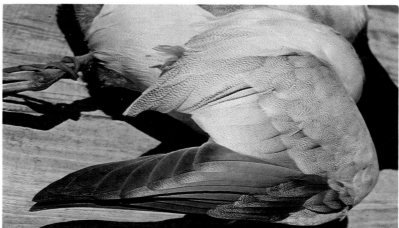

23

(24) This is a close-up view of the same general area, giving a little more detail for you to observe.

24

(25) This is a macro photograph, showing the overlay of the scapular and the darker vermiculation of the upper tail coverts and back. Again, squint your eyes to determine the tonal value required of the base color, a white tinged with raw umber.

25

(26) A rear view of the canvasback drake shows the rust effect that is achieved with yellow ochre, burnt umber, black, and white. The pallet requires burnt umber for the tail feathers and a blue black to be applied to the under tail coverts. The successive washes applied to the belly area and the rump should be brushed on with a liberal use of Grumbacher I medium to avoid the establishment of any color interfaces. This is not a bird that should be painted with sharply delineated color areas. The beige of the breast blends into the side pocket; the dark color of the under tail coverts pulls into the abdominal area; the rich, warmer brown of the tail feathers blends into the blue black of the under tail coverts. After this is thoroughly dried, take a fine sable brush and do your vermiculation with a slightly darker tonal value.

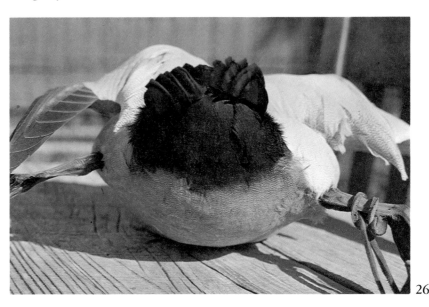

26

## CANVASBACK HEN

(27) The hen canvasback complements the drake with her soft raw umber and burnt umber tones. This is an old specimen that was mounted by Edward Morgan, one of Louisiana's premier naturalists and taxidermists. The color of the bill is faded and should be ignored, but the shape of the head and the position of the feet and legs made me want to retain this photograph for nostalgia if for no other reason.

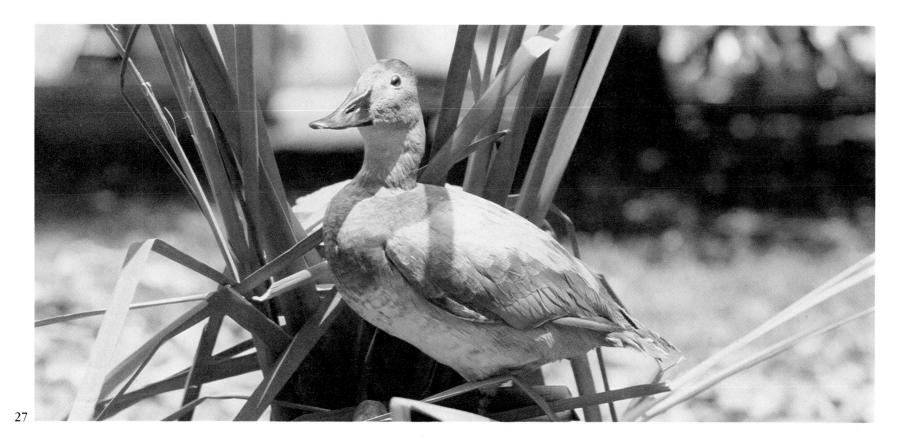

27

(28) The shape of the head contains a depression, which creates an almost crestlike effect on the topknot. The canvasback shares this characteristic with the ringneck and the scaup. The neck is thick and the feathers are hairlike on the neck and very small on the cheek and jowls. The appearance of the feathers on the head is more akin to fur than to feathers. As the neck breaks into the cape and breast, the pattern of larger feathers becomes apparent. The pallet requires burnt umber and black for the top of the head, burnt umber and raw umber blended with white for the eye patch, cheeks, and jowls, and highlighting with yellow ochre as the neck works its way into the mane, the cape, and the breast. The back requires the delicate use of the burning iron to prepare the surface. The feathers, irregularly overlaying one another in a shingle pattern with irregular trailing edges, expand as they approach the scapulars.

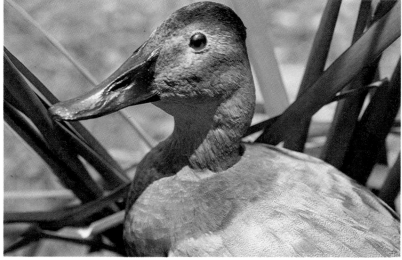

28

(29) This close-up of the lesser wing coverts and the cape should be carefully studied to discern the proper colors required for the undercoat. Liberal use of medium should be used in establishing the ground so that there will be no sharp interface to plague you when commencing the detailing. The areas of raw umber that darken sections of the cape are not completely covered with vermiculation. Similarly, the flight feathers shown in the lower center of the picture are tipped with a stippled white effect. This is done by using a stiff bristle brush and tapping it on the edges of the feathers after the ground has been established. A touch of yellow ochre here and there, and a touch of burnt umber lightened with white to create the warmer colors of the breast and shoulder, will be helpful.

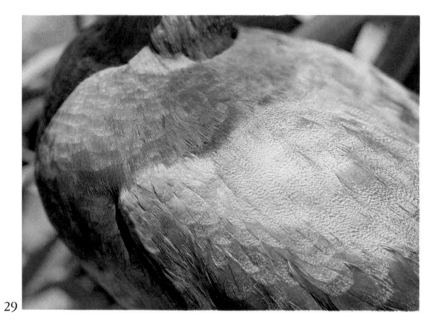

29

(30) There is a great deal of variance in the color of the breast of canvasback hens. This depends to a great extent upon the herbs on which she has fed and the length of time she has been subjected to a particular environment. This specimen has achieved the maximum in rustlike coloration that many of these birds obtain. Your undercoat should be white with just a hint of raw umber. Permit this to thoroughly dry. Then create the rustlike effect by interspersing yellow ochre, burnt sienna, and raw umber applied by the drybrush technique. An occasional touch of raw

sienna could also be used. Notice the hairlike effect that can be achieved with a burning iron. A texturing tool can also be used.

30

(31) The back of the canvasback hen gives you the anatomy of the mostly concealed primaries, to the right of the photograph, with a brightly

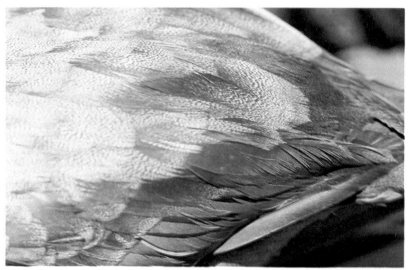

31

colored spline showing in the first primary. The speculum is raw umber and white with a touch of black added, and the edge of the feathers is highlighted, alla prima, in white. The scapular should receive darkening with raw umber and a touch of burnt umber, over the off-white base wash. Wash the interfaces with adequate amounts of Grumbacher I medium, the whole permitted to dry thoroughly. Now apply the vermiculation with raw umber, burnt umber, and a touch of yellow ochre here and there.

(32) We have already described this area in intimate enough detail. Additional description would be superfluous, but this view pulls the whole area together, showing you the feather groupings and their position and the supple tonal values and intense vermiculation that interplays over the entire back area. Although the vermiculation itself is intense, it has a soft effect. The splines of random feathers should be shown by using a liner brush with burnt umber and black.

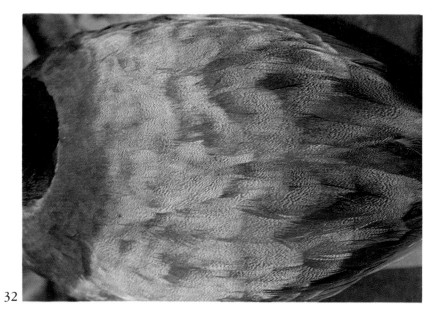

32

(33) This is an excellent opportunity for you to observe how far to the rear of the bird the speculum on a diving duck is located. The pearl gray of the speculum contrasts with the vermiculation of the side pocket and the scapular. The downward thrust of the tail feathers is very apparent and shows you why, when the bird is floating, the tail feathers frequently touch or almost touch the water level. Many carvers are guilty of placing the speculum further forward and, in the case of puddle ducks, this is not an error. The diver is different!

Note the swirl of the side pocket as it overrides the flight feathers. Note the warmth of the upper tail coverts and the rough edges of the trailing edge of the scapulars. These are fairing agents that streamline the wings to the body.

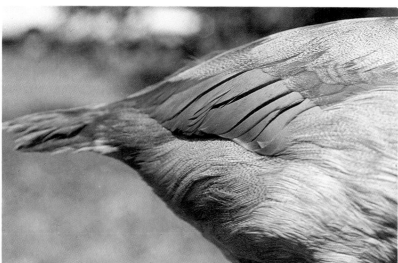

33

# 4

## Gadwall

### DRAKE

(34) The drake gadwall is one of the most colorful ducks, or, perhaps more accurately, one of the most handsome. It is quite plentiful in the Louisiana marsh, but frequently overlooked by carvers because of the difficulty involved in getting the warm browns, blacks, and siennas to properly match the specimen. This shot gives a good head shape, showing the roundness of the breast and the delicacy with which the breast pattern works its way into the side pocket and the back. Notice the burnt sienna needed to give you the little patch, with a little burnt umber blended in. This forms the middle coverts of the wing. The primary coverts are black; the speculum is black and white. An interesting but a very difficult bird to paint.

(35) Now you can use fish scales on the breast pattern. This is one of the birds where you definitely have a more distinct pattern to the feathers than is the norm. Still, there is a great deal of irregularity. The breast itself shows the contrast of black, burnt umber, and white in larger dimension than the back feathers that blend into the neck, where the same colors are used, but the feathers diminish in size. Then as we work down the back, they again begin to expand. Although the head is basically a light, warm color in contrast to the breast and back, the base color should be burnt umber and black. Then come over this with white and raw sienna. The third stage would be to bring in the pattern of black, burnt umber, and raw sienna that creates a crestlike effect in color. Unlike the

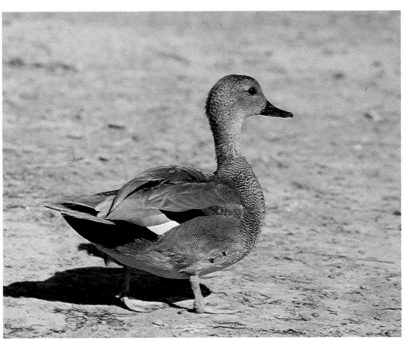

34

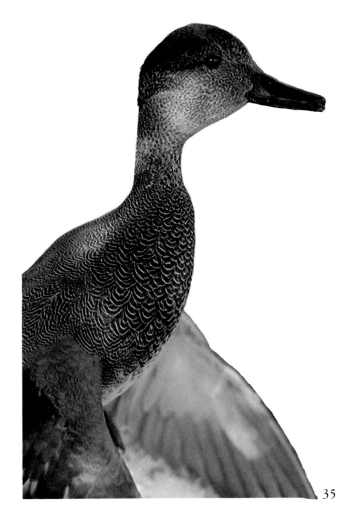

35

mallard hen, for example, which has straight, dark streaks in the head, this bird has an irregular pattern to the dark lines that is almost a vermiculation. Notice the yellowish cast to the lower mandible (where the lower mandible and the lamellae touch the darker upper mandible). The upper mandible is rather dark, raw umber with some highlighting of yellow ochre possible on the edge. A touch of raw sienna would also give a good effect.

(36) The drake gray duck in flight gives a good example of how the speculum shows black and white, the middle coverts are black and burnt sienna, and the lesser coverts, raw umber and white. Note the magnificent scalelike effect of the black and white crescents that make this bird such a handsome avian specimen. Also note how much finer these crescents appear on the back. The white in this breast patch is an off-white which requires just a touch of raw sienna. The wing lining is mostly white with a little raw umber. The base coat, once applied, has to be highlighted by coming in from the trailing edge of the wing with raw umber, and the wing lining, which is a base coat of white and raw umber, must be highlighted by bringing additional white in a second wash from the leading edge of the wing to the rear.

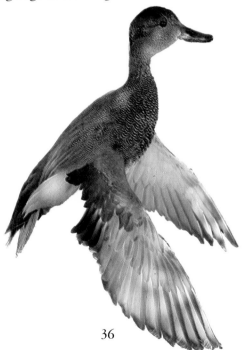

36

(37) The back, upper tail coverts, and tail feathers give you a splendid example of the diversity of colors required to render this bird. Let us discuss the scapulars for a moment. The central part of the feather is a blend of burnt umber, black, and white. The edge of the feather is burnt sienna, burnt umber, and white. Again, if these feathers are burned into a pattern, you would use a sable brush to highlight the edges. If, on the other hand, you have merely burned in the hairlike effect of these feathers without patterning them, you would highlight the edge of the feather with a #3 liner brush and then come back with a bristle brush to blend, slightly, the interfaces. Remember, this must be done on the edge of the feather, leaving the dark centers. The upper tail coverts are black with just a little touch of ultramarine blue. This gives a slight luminosity of reflective character to these feathers which is quite effective. You can then highlight with a little cadmium yellow (light) to give you the greenish tint that effects iridescence. The top of the feathers are burnt umber, black, and white. The under tail feathers are raw umber and white.

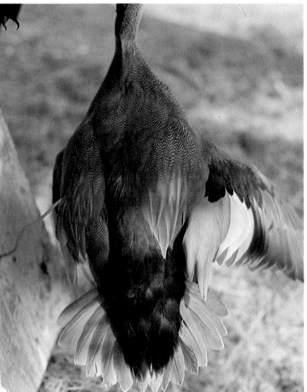

37

(38) The pattern of the dots on this side shot of the head of the drake gadwall are larger and more noticeable on the crown, while finer and more streaked on the neck. You cannot see too much of the crown in this illustration, but the crown is very dark, with streaks of black, burnt umber, and raw umber—not a solid color. Note the detail of the nostril and the upper mandible. This bird is frightened and the eye reflects this fear.

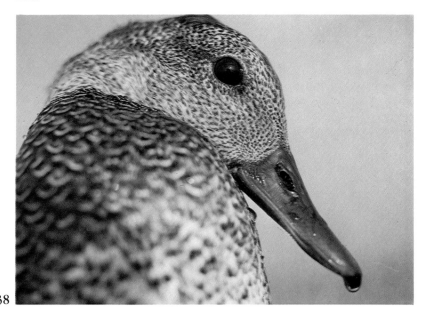

38

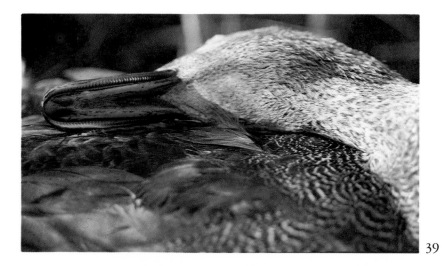

39

(39) An excellent shot of the underside of the bill may show a few colors that you do not want to see. This has been caused by the base of the throat, where it joins the mandible, being wet. The right-hand edge of the photograph shows a truer color, an off-white: a touch of yellow ochre and a touch of raw sienna. The dark dots are burnt umber, pulled into this mixture. It is a little easier if you let your base coat dry here before coming back to detail your pattern.

40

(40) For the vermiculation, a macro shot of the area where the shoulder joins the wing is most useful. The base coat should be burnt umber, yellow ochre, and white. Let the undercoat dry, then come back with white, raw sienna, burnt umber, and burnt sienna. Varying these colors will create the broken pattern that this section of the bird requires. Good luck—this is really a tough one.

(41) Here again you can see the contrast of the breast feathers and their specifically fishlike scale effect, and the irregularity that is created as they change shape, moving into the back. The base coat of the breast should be burnt umber and black, mostly black. Allow to dry before you try to highlight the edges. The feathers should be highlighted on the breast with white. Add a touch of yellow ochre in some places and raw sienna in

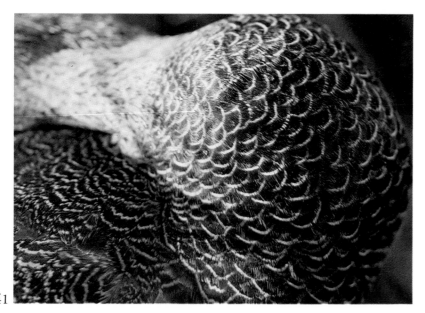

41

others. Break this pattern up as much as you can. Do not let it get too scalelike.

**GADWALL HEN**

(42) The color of the hen gadwall is very similar to the hen mallard, but the bill is narrower and more yellow, and the tail feathers do not have the whitish outer edging. The undercoat should be a wash of burnt umber and black and the feather highlighting should proceed from tail to bill. Note the irregularity of the highlights and the feather pattern itself. The edging of the upper tail coverts and the back feathers should be raw sienna and white. This should be pulled from the back edge of the feather to the front. The tertials are raw umber and white, with black added gradually to the back feathers to get the darker color. The center of the bill should be raw umber on the darker part, and the yellow would be cadmium yellow (medium) blended with burnt umber. Be careful not to add too much burnt umber, as the bill is quite yellowish and you do not want to kill this effect. The head itself is washed with raw umber and white. Then proceed with the detailing. Notice that the cap or crown of the head is almost completely streaked with burnt umber and black. Note the effect on the cheek. It is darker on the female, with an almost continuous group of dots that are black or burnt umber with a little touch of yellow ochre.

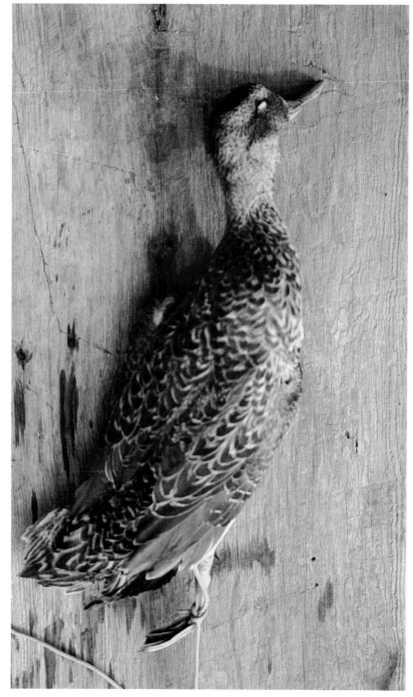

42

(43) The over tail coverts and the tail feathers themselves are shown very clearly to have a great variety of shades and tonalities, but the same basic colors obtain as described in the previous two illustrations. The edging has a great deal more white in some sections than in others. The feathers are not uniformly edged with the same colors. Some have a tendency toward the sienna, others toward the umbers.

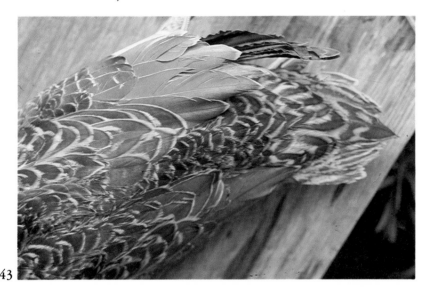

43

(44) Photograph 44, which shows the tail feathers, is an excellent contrast between the warm brown and the cool brown. The warm browns are

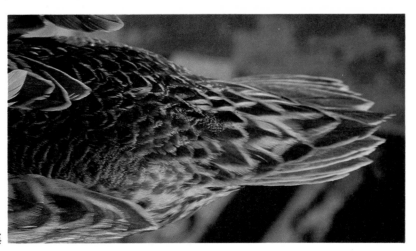

44

the scapulars, which have a certain amount of sienna, mixed with umber. The cool browns of the tertials are merely raw umber and white. The warm colors also contain burnt umber and black. The burnt umber has more brown, the warmer color. The tertials are more inclined to the raw umber, which is a gray brown rather than a warm brown. This shot shows the wings lifted free and gives you a better perspective of the back feathers and the upper tail coverts, with a much richer, warmer color in the specimen. Note again that you would pull the lighter edging from the back of the feather to the front. Notice a very fine vermiculation covering a few odd sections of the back. This is the kind of detail that can make a real contest winner, as opposed to other birds in which the small details were overlooked.

(45) This is a bird which has been hung to demonstrate some of the poses that can be used in creating the trompe d'oeil effect. You will notice that the foot has been arranged to come out between the primaries and the under tail coverts on the right. The under tail coverts are very plainly shown to be mostly an off-white with a touch of raw umber. The darker parts of the under tail coverts are burnt umber and black. Remember that the raw umber is cooler than burnt umber. Burnt umber gives you a richer, golden brown.

(46) When you notice the side of the neck blending into the back, you can easily detect the difference in carving a realistic bird as contrasted to a decorative one. Look at the irregularity that the feathers of the real bird enjoys. Many carvers constantly try to decide just how far to go in the pursuit of realism before they must exaggerate the uniformity of the pattern in order to put a decorative piece in the winner's circle in competition. Dick LeMaster brings out the point in his definitive *Wildlife in Wood* that one must decide whether to carve a decorative or a realistic piece. By depicting the irregularities of the real bird, one almost preempts winning a place in the top category of decorative carvings.

The colors on your pallet for this particular part of the bird are burnt umber, raw umber, burnt sienna, and white, with black, of course, to give the darker tone to some odd feathers. Remember, again, do not paint your feathers in a uniform hue for any particular section of the bird. There is a wide variety of tonality from this section of the neck, chest, and back.

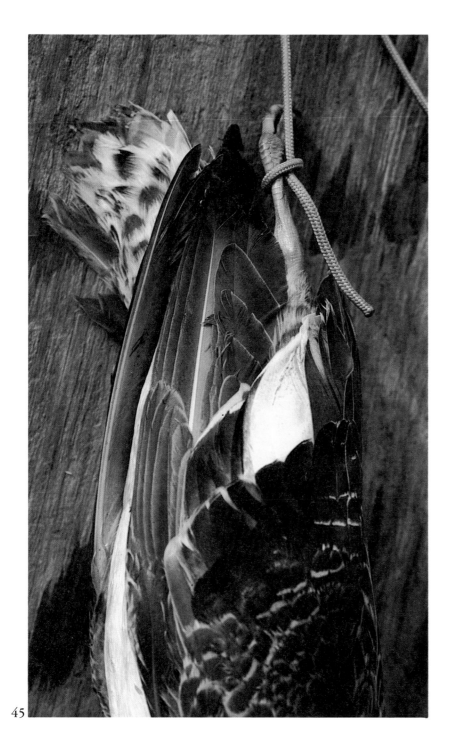

45

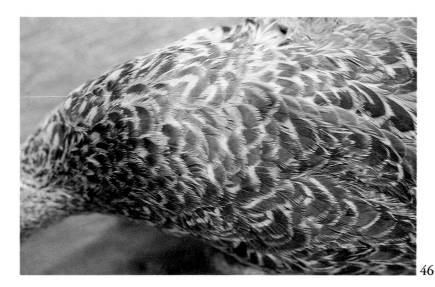

46

(47) A drake gadwall shows you how much warmer and richer the colors are in the drake in contrast to the muted colors of the hen. Note the contrast between the white of the speculum and the black and burnt umber of the outer wing coverts; also note the rust color of the middle coverts. When you see the variance of tonality that this bird enjoys, you can see that it is one of the most difficult to portray accurately in wood.

47

(48) The back is undercoated with burnt umber and black, with the edging slightly highlighted. The black and burnt umber are lightened by the white from the edging being pulled into them, and some of the feathers are considerably lighter than others. The breast color is a mix of raw sienna and burnt sienna and the edges are contrasting black and burnt umber.

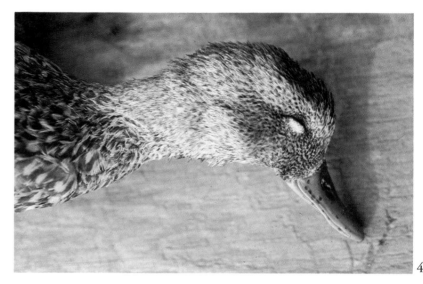

49

48

(49) The head and bill of this gray duck hen (gadwall) give an excellent pattern for the carver or the painter, showing a typical head shape as well as the light yellowish cast of the mandible shading into the darker burnt umber and black of the top of the bill. Notice the little dark spots (very irregularly placed on the upper mandible), which are also typical of the gray duck hen. Note that when the eye is closed, only the lower lid is raised and that this is white with a touch of raw umber. The cheek itself is slightly darker than the rest of the head and neck; merely using a slightly increased amount of raw umber for the undercoat will suffice. Do not forget about blending these colors on the undercoat. Do not leave a sharp line of demarcation between one color and another. If you do, you will have a heck of a time trying to cover it up with later washes.

# 5

## Common Goldeneye

**DRAKE**

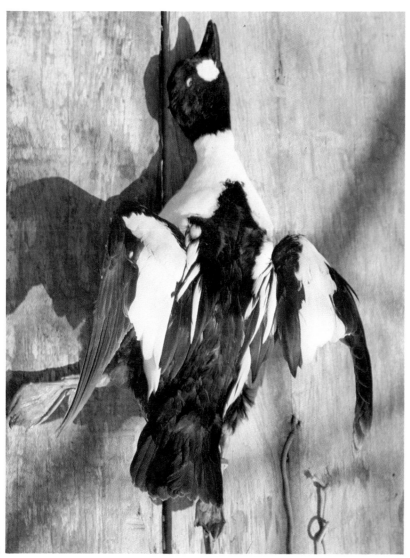

(50) This photograph shows a drake goldeneye held in a trompe l'oeil position. Like the bufflehead, the goldeneye is one of those basic black and white birds that appears to be simpler to do than it really is. The pallet requires relatively few colors, but a great deal of sophistication in handling them. The back and the tail coverts, blending into the tail feathers, consist of black, gradually working in burnt umber tinged with just enough white to give you a purplish cast. The primaries start off in the leading edge with burnt umber and black. The trailing edge is raw umber and white, blending in with the edging, lighter on the back edge of each feather than on the leading edge. You can see very clearly in the primaries on the left wing how far the edging of raw umber and white progresses.

(51) The basic pattern of the back feathers, the scapular, and the tertial are clearly illustrated here. Notice how freely and loosely these feathers fall together and how important it is to think before you apply the colors. Are you going to pull the black into the white or the white into the black? This will depend upon the part of the feather area that you are dealing with. It can save you an awful lot of grief if you think before you apply your colors. That slight purplish color is white, burnt umber, and black. There is a little bit of white in certain feathers, pulled into the wet mixture of burnt umber and black. Yellow ochre in minute quantities is also useful to create the tonal effect and slight color deviations required.

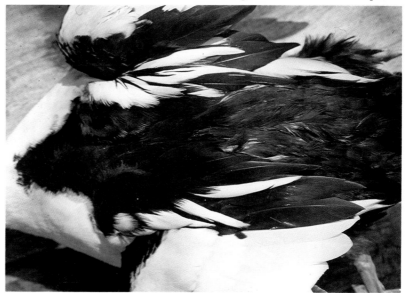

(52) This shot of the head of the goldeneye drake gives you a good opportunity to observe the iridescence of blues, purples, and greens that can be obtained either by the use of bronzing powder or by the delicate application of purples, greens, and whites to create the illusion of iridescence without the use of bronzing powders. Many people feel that bronzing powders are not nearly as permanent as the creation of the illusion of iridescence. However, I have found no diminution in color using bronzing powder, as far as its time frame is concerned. I find that if they are carefully applied and blended into the colors, they retain their iridescence without any loss of value. Of course, my experience only covers some few years. How will these procedures hold up twenty or fifty years hence? We know that oils have stood the test of time.

Note how irregularly shaped that white cheek patch is. Do not make the mistake of laying out this patch in too regular a shape. Similarly, the interface of the white throat with the head is an irregular line, softened by pulling the darker colors into the light.

53

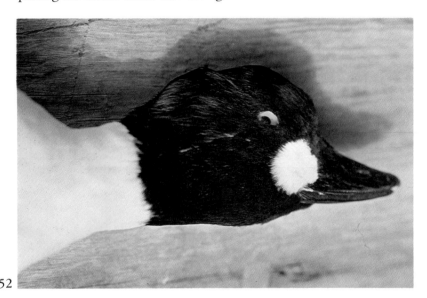

52

(53) Here you can see the difference between the breast and the under tail coverts of the hen goldeneye in contrast to the next photograph, which shows the same area on a drake. The colors are much cooler in the hen than in the drake. This requires the use of raw umber in the hen and burnt umber in the drake.

(54) The drake has much warmer colors than the female in the mottled breast area. The feet are cadmium yellow (light), cadmium red (light), and burnt sienna, pulled together while they are wet. You have to be careful to use cadmium yellow (light) as the bulk of your mix, or you will end up with too red a color.

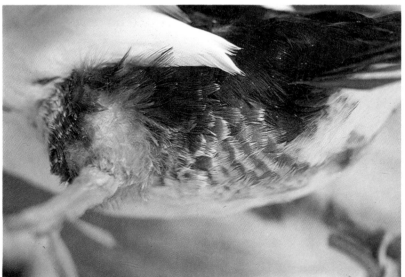

54

(55) In the area where the wing is joining the back, the pure white of the scapular overrides the tertials. Again, when carving this bird, one must decide just how much detail is going to be carved in. The painting style is then determined by the amount of feather detail burned into the pattern. If you are not burning in each feather separately but are using a textured or straight line burn, your colors can be applied in a more random manner. A little more carving on this area would pay big dividends when you finally begin to paint the finished product. I prefer to burn each feather as a separate entity.

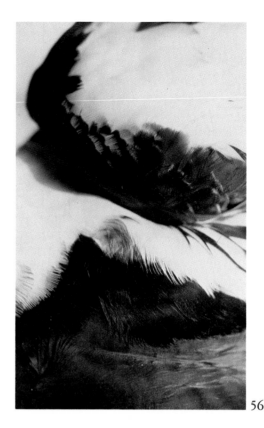

56

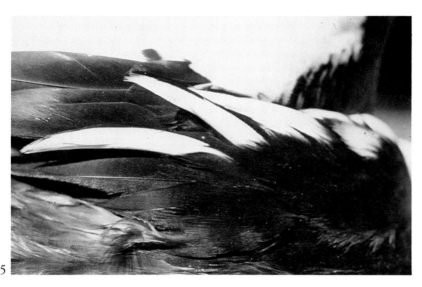

55

(56, 57) In the area where the shoulder joins the lesser coverts and the scapulars, the edging of white and the flow of the feather pattern should be noted. You have here a more hairlike effect to create and emulate than the scale effect on other species—so these are excellent photographs to keep in mind when putting the finishing touches and highlights to your work. The tone values from the top of the photographs to the bottom will help you recognize how delicate nature is in fashioning these contrasts.

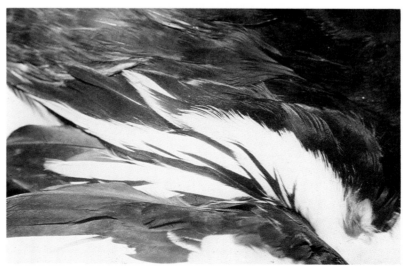

57

## GOLDENEYE HEN

(58) Look how nature shows the variance of tonal values in what appears from a distance to be a black and white bird. The use required of burnt umber, black, and white creates the separation of feathers by establishing tonal highlights. I have had a great deal of difficulty in getting a specimen for a hen goldeneye, as she is not too frequent a visitor in our area; this at least gives you some concept of the edging required on the back feathers, the brownish rust color of the head, and the short, knobby appearance of the bill. The pallet for painting the head calls for burnt umber, burnt sienna, black, and white. The pallet for the back, the tail feathers, the primaries, and the speculum would require burnt umber, black, and white. This pallet is deceptively simple. Its colors are few, but you can see the variety of tonal values you have to create with different mixtures of the three basic colors.

(59, 60) These are good shots of the side pocket going up into the back of the hen. A very simple pallet required—black, white, and burnt umber. But consider this: which way are you going to pull the darker colors into the lighter parts of this area? In recognizing this detail you come a long way in realistically separating the individual feathers and feather

groupings. Notice how narrow the primaries are and how short and stubby the wings are. This is true of most of the diving ducks. On the back of the neck the pattern is quite irregular and the edging of the feathers on the back requires pulling the lighter colors from the rear of the bird to the front. It would also be a good idea, on the primaries and in certain areas of the back, to take a little burnt sienna and tone it down with burnt umber to give that little color value that breaks up the pattern and warms the color of this group of feathers.

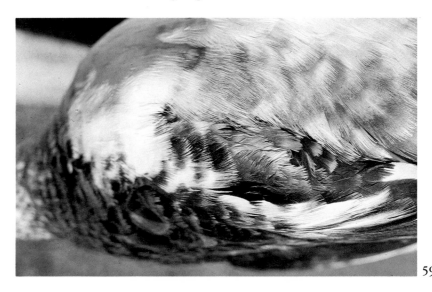

59

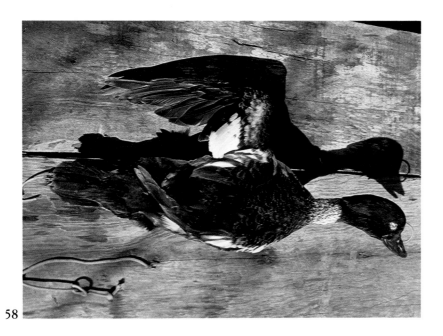

58

60

(61, 62, 63) This area is shown for those who wish to carve in the round, and shows the thigh coming out of the breast. Note the delicate hairlike aspect of these feathers as opposed to the scaly effect that many puddle ducks enjoy. Here the back gives you something of the muscular configuration, but will be mainly useful in illustrating the irregularity of pattern, as the back of the neck works its way into the back itself.

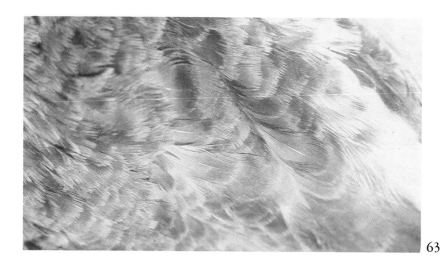

63

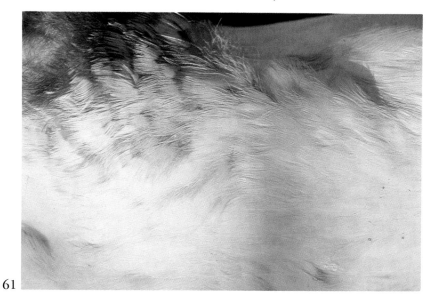

61

(64) A profile of the tail feathers shows the curvature required and the closeness of the overlay of the upper tail coverts and the back feathers. The color of the feet should be carefully blended—not at all a monochromatic mix. Your pallet here would require burnt umber and black for the darker phase. The yellowish phase requires burnt sienna, yellow ochre, and white. Start with yellow ochre and, while still wet, add a little burnt sienna until you get the right depth of color, pulling these colors together before they dry.

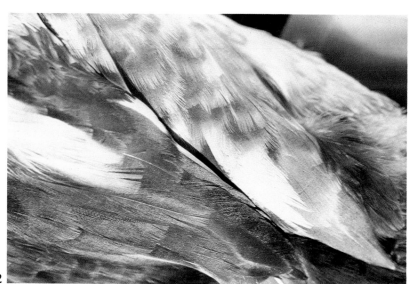

62

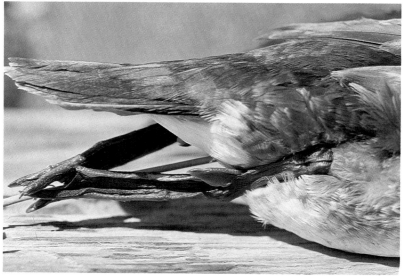

64

(65) The under tail coverts again require a very limited pallet of raw umber, black, and white. A little touch of Payne's gray mixed with white will help to give you a cooler tone with a slight blue cast. This will soften the effect of the rather monochromatic values in the rest of the bird. Note again that the white of the under tail coverts must be pulled into the darker tail feathers, while the reverse is true on the breast area, in which the darker color must be pulled into the lighter. This is a very vivid detail that can only be seen by an enlargement with a magnifying glass. You should particularly observe that many of our birds contain fine areas of vermiculation which are normally overlooked by painters or considered to be just another detail that one can afford to ignore. Again, it is attention to these details that wins a *Best of Show* award. The most common mistake made in vermiculation is the presumption that only two colors are involved. Properly developed, at least three and sometimes four light washes are required to develop the correct effect, and each wash is a different color or shade.

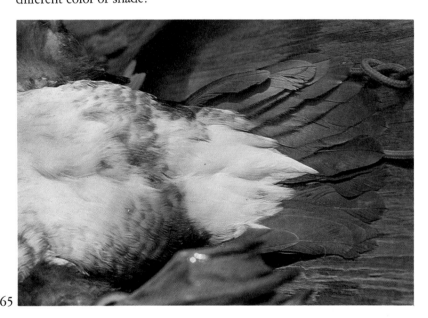

65

# 6
## Mallard

### DRAKE

(66) Probably everybody's favorite is the mallard drake—colorful, plentiful, and providing a never-ending variety of poses. Your pallet must be expanded considerably, adding prussian blue and cadmium yellow. A good alternative mixture for the head of green is prussian blue and cadmium yellow (light) with black or thalo blue to highlight. The breast—burnt umber and burnt sienna. The shoulder—burnt umber, yellow ochre, and white. The upper tail coverts—black tinged with a metallic green iridescence. The iridescence of the head—a green and purple. Do not be afraid to use touches of several different bronzing powders. Since the iridescence is mechanical, every few degrees the bird is turned creates a host of reflected colors.

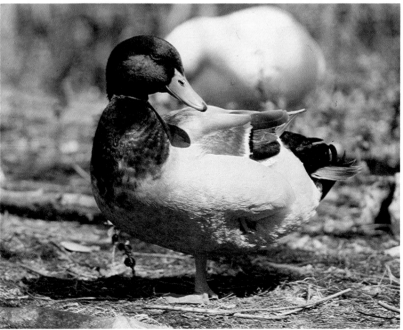

66

(67) This shot of the speculum of the mallard drake shows you why you needed so many colors in your pallet. Notice the amount of vermiculation in four different, distinct hues, as well as the combination of colors in the iridescence of the speculum. Almost your complete pallet is required in this one section of the mallard drake that encompasses no more than a four-by-four-inch section of the bird.

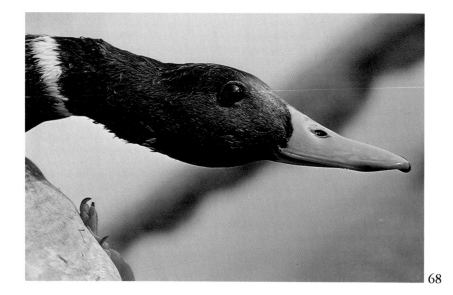

68

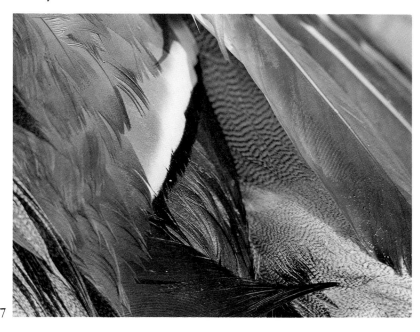

67

(68) The head of a mallard drake shows how bright the yellow of the bill can be. Again, there is a great deal of variation among specimens, but this particular bill would require cadmium yellow (light), cadmium yellow (medium), and black. The highlights on the nostril and those near the tip of the bill are white. The nail is black. To achieve the iridescence on the head without the use of bronzing powder, the undercoat could be made of black and thalo blue, stippled with cadmium yellow (light) and then pulling softly, as required. Do not forget about that white ring around the neck. Put it on the raw wood, covering slightly more area than is necessary; then when you paint the rest of the head and neck, pull the black and its components into the leading edge of the white. When you do the breast and throat, pull the white into this. Do not apply your color in an opaque layer. Use successive washes.

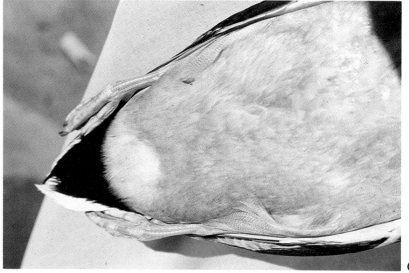

69

(70, 71) The area where the breast feathers are blending into the chest requires a soft amalgam of color, no straight lines. Note the vermiculation and its irregular interspersal with the breast feathers. Again, do not scale it—use soft brushwork and multiple washes of hues rather than colors. The irregularity of vermiculation required of the artist is very apparent in this specimen. Note that the vermiculation on the mallard drake is soft and does not require a great deal of contrast. Do not make the mistake of using black and white, as a lot of carvers and painters are doing, but rather soft shades of gray and white with touches of ochre in the first wash or undercoat. Looking carefully, you will realize that the underlying colors are not monochromatic. Note the irregularity of the wing linings and the vermiculation that joins the chest and breast. The amount of edging required as the russet of the chest blends into the breast, involving a lot of feather detailing, is most important. You will be much better off carving in a very irregular pattern and then edging. This is more effective than straight line burning in this sector or the texturing with fine Carborundum wheels that some carvers are using. If you are carving in the round or for a trompe l'oeil pose, note also that the rust color of the belly is actually a loose vermiculation.

(72) Here is a tough one for you! Again, notice the variance of color and the flow of feathers from the shoulder and the tertials into the primaries. A lot of colors from your pallet will have to be blended if you are going to get this effect properly. Notice the amount of vermiculation and the delicacy with which nature has handled it. You have to have the right mixture of medium and paints to effect this soft, minimal-contrast vermiculation. The texture of your wash should be just a shade darker with each successive application. You might be thinking it would be nice to go back to working on a few simple hunting decoys. But I find this a most stimulating relief from fully decorative work.

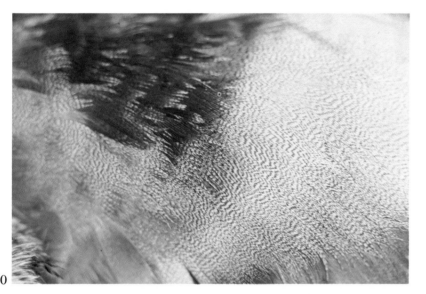

70

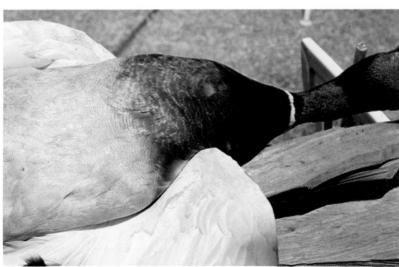

71

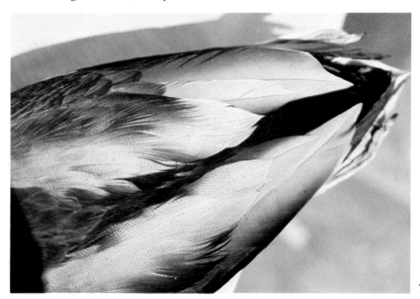

72

(73) The effect of light and shadow on iridescence is a magnificent aspect of nature's beauty. The iridescence in the back is more blue than green. The vermiculation on the head shows a half dozen different gradients of green. Although it is very faint, remember that the side pocket is itself a lightly and finely vermiculated area. It is articulated so that it may either override or underlay the secondaries. This gives the taxidermist, the artist, and the carver a great deal of latitude.

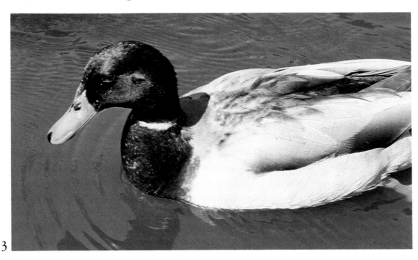

73

(74) This hen mallard is stretching herself with one wing lifted and one foot outstretched. The graceful curvature of breast, neck, and crest can be

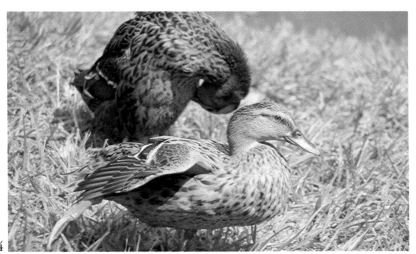

74

seen. The color difference between these two birds is typical, mostly because of the difference in angle of the light. You must, however, realize that waterfowl have several molts and even in the same molt can have great difference in color. This can be caused by the ecological environment (salt water, brackish water, or sweet water), as well as feed and temperature. Remember, most of the color in these birds is reflected, not pigmented. These birds would never win a competition as decorative carvings. They are just not regular enough in their patterns. That decision is before you again—are you going to paint for realism or competition?

The edging of the primaries on that outstretched wing is soft yet shows a definite, firm contrast.

(75) This shot of a mallard hen nesting gives you the overstuffed look that most pen-raised birds seem to end up with. Their feather pattern requires a pallet of burnt umber, yellow ochre, black, and white. In painting the speculum, decide whether you wish to use bronzing powder or pigments and then apply your base color of ultramarine blue and black. Highlight the blue by touching it gently with a fine brush tipped with white. A little raw sienna will help you to achieve that rust color on the breast.

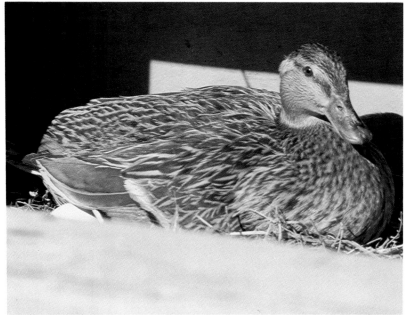

75

(76) Here I have tried to find an example to illustrate the difference between the use of raw umber and white on the lesser wing coverts in the lower right hand corner, as contrasted with the use of burnt umber and black for the basic dark color of the neck and back. All of the edging of the neck and back is done with white touched with raw sienna; the edging of the lesser wing coverts is almost, but not quite, pure white. If you are painting it wet on wet, the pure white will pick up enough of the raw umber to give you the off-white softness required. If not, you will have to add a touch of raw umber to the white to edge it.

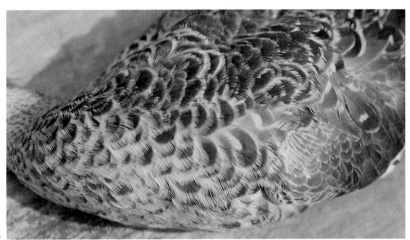

76

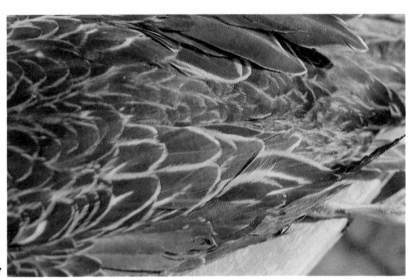

77

(77) The basic color difference between the back of the hen mallard and the hen gadwall is subtle, but not too difficult to define. Notice how much richer and warmer the colors are in the mallard and how sharp the edging, in contrast to the burnt umber and black of the center of the feathers. Also notice how the feathers are patterned, having an almost secondary pattern of burnt umber and white. You have to use a little raw sienna to get the golden glow of this bird.

(78) Try to see the difference in the profile of the bill of the hen mallard when compared with other species. Note the shape of her head and the curvature of the breast, as reflected in the pattern of the feathers as they flow from the lightness of the cheek into the chest and into the breast. Notice the dark spots that irregularly mark the upper mandible. This is another one of the details that judges frequently argue about. There is such a great diversity of pattern in the coloring of bills and such a wide variety of tonal values, depending on the time frame in which the specimen is photographed with respect to its molts, that one is constantly at odds with a judge who comes from an area where birds are only taken in one particular season with one particular molt. I am also impressed with the fact that Central Flyway birds, nesting in fresh water marshes, have much brighter tonal values than birds shot on the Eastern Seaboard or the Pacific Flyway, where they are apt to be feeding and nesting in brackish or salt water marshes. Note the almond shape of the eye. In particular, the

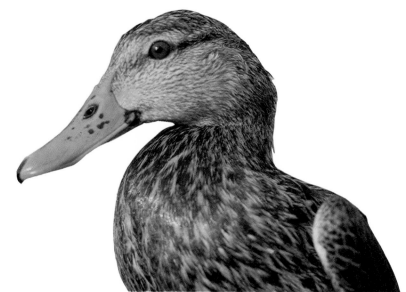

78

soft sweep of the upper edge of this mallard hen's mandible and also the detail where the upper mandible joins the jaw must be reproduced with great care. See that little upward curl of the mandible? Notice how deeply inset that notch is. You should not overlook such details.

(79) A mallard hen at rest is to me one of the most beautiful examples of broken-pattern camouflaging. The feathers of the back, the breast, the speculum, the primaries, and the tertials are clearly delineated. The color of the bill and of the feather outline is soft, but quite distinct. Note that this particular bill has a great deal more orange than some, but again, there is a lot of latitude, depending on the specimen you have used as a model. The pallet for this bird would require burnt umber and black for the base coat. The edging would require varying amounts of raw sienna and white, with variations created by utilizing small dabs of yellow ochre and burnt sienna. The pallet for the bill would require cadmium yellow (medium) with a touch of cadmium yellow (light). Pull the burnt umber and black of the upper part of the bill gently into this mixture while wet. Since the bill has a rather glossy, leatherlike texture, it helps sometimes to mask the rest of the head and spray a product like Deft onto the bill to give you the depth of finish it normally obtains. Be sure that the bill is thoroughly dry before using this spray. Another way of obtaining this leatherlike effect is by the use of copal medium, painted on clear and allowed to dry for approximately forty-eight hours. This is applied on top of the final coats. Note the black on both sides of the speculum and the white tips on the edge of the middle wing coverts.

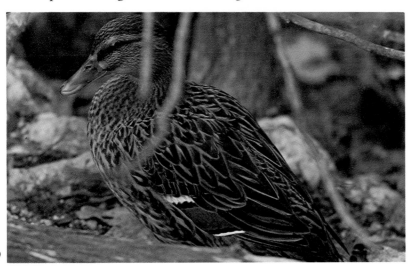

79

(80) The irregularity of the back pattern can again be observed. Notice that the width of the edging on these patterns is also irregular. The side of the edging of the feather is much broader than at the tip. The dark center of the feather is burnt umber and black and almost comes to a point on each feather. Note how much larger some feathers are than others. There is no gradation; it is a broken pattern.

80

(81) A splendid view of the hen, swimming, shows the back pattern, the crossed primaries, and the side pocket, also the white edging of the tail feathers. This can be of great value in carving and burning and will help quite a bit in establishing the paints in a lifelike manner.

81

# 7

## Red-Breasted Merganser

**DRAKE**

(82) This photograph illustrates a red-breasted merganser in prime plumage. Note the shape of this magnificent diving duck and the forward cast of its head and neck. Many diving ducks, at rest, assume a similar

pose: downcast tail, head, and neck at about a twenty degree forward angle. Many carvings are well painted, but the anatomy and position incorrectly illustrated.

Note the sharp contrast in the color of the tertials overlying the black primaries, and the large fanlike shape of the secondaries. Note the strength of the vermiculation and the irregularity with which the shoulder (green black with a slight iridescence) works its way into the reddish mottled breast. Note the crest, which consists of a long series of hairlike feathers in two groupings. In carving this, it is necessary to shut the eyes in a squint when looking at the illustration. Visualize what must be produced in wood to represent this erectile crest. The sawlike bill is another characteristic of the species. The bill is actually much more tubu-

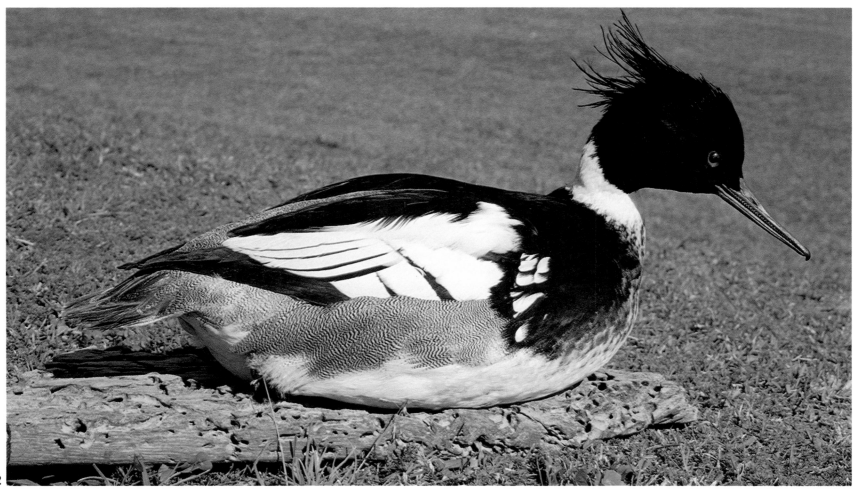

82

lar than it would appear from the mating edges of both upper and lower mandible. The French name for this bird is *bec-scie* (colloquialized by the Cajuns as *bec a la sec*), also referred to in some areas as the becse, phonetically pronounced *bec-see*, meaning "bill like a saw." Note how long the undercut must be on the tail coverts when compared with most other ducks. The whole configuration is one of a long, slender, streamlined bird designed to function efficiently underwater, which is its feeding environment. I would recommend priming the entire bird with white before proceeding to the detail painting.

(83) I find the red-breasted merganser a most fascinating waterfowl. Most hunters and bird watchers who come in contact with him see him as a black and white silhouette in rapid flight at about a hundred yards distance. In our area in particular, his autumnal molt does not reflect the beauty others find in his coloration in the spring. The hairlike crest has been copied in a thousand different ways, by carvers of a dozen generations. A texturing tool in combination with a burning iron are both required to create the plumes that make his head so distinctive. The head itself is a combination of burnt umber, white, and black. Some areas should be given a touch of blue black and just the slightest brushing of a deep green bronzing powder to create the iridescence, which is only marginally visible. The white neck band is not a pure white but is broken

into a feather pattern with a little raw umber. The breast shows a mottled effect, with the white being pulled into and intermixed with burnt umber, yellow ochre, and a little burnt sienna. I like to have four brushes, all used interchangeably, to create an effect of this type. If you notice that the colors are muddying up, wipe the brush on a dry rag and start with the pure color again, to create the interplay of the mottling that is visible here. Note how the effect of the neck begins to break up as it approaches the shoulder and works its way into the almost pure white of the breast.

(84) Here we see the same colors, but in different amounts. The cape should be studied carefully here, from the standpoint of both color and burning technique. Again, you have to create a mottled effect rather than individual feathers. Note that as the cape works its way back from the breast area and the neck, wet-on-wet techniques are almost mandatory. Paint the lighter colors first and then, when tacky, apply burnt umber and black as you work your way to the rear.

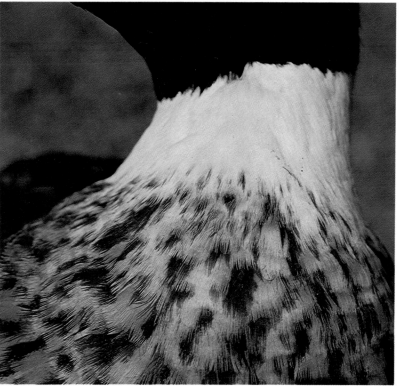

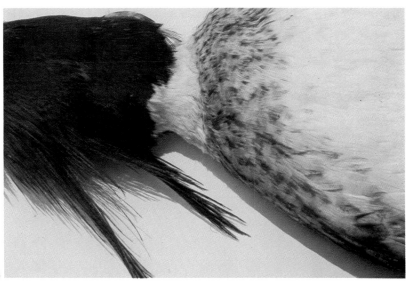

83

84

**(85)** Note those bright orange feet with a touch of burnt umber at the joint. To create that brilliance in the feet, use burnt sienna, yellow ochre, and cadmium red (light)—then a touch of burnt umber at the joints, with a little more burnt umber as you work your way from the feet up into the tarsi. On the breast, paint the dark colors in on the raw wood in splotched areas with burnt umber and yellow ochre, leaving holidays for the areas that you want to be predominantly white. While still tacky, pull titanium white across and through the darker area.

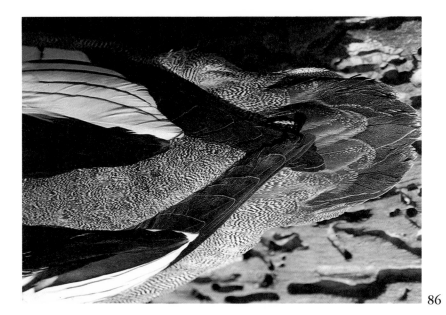

86

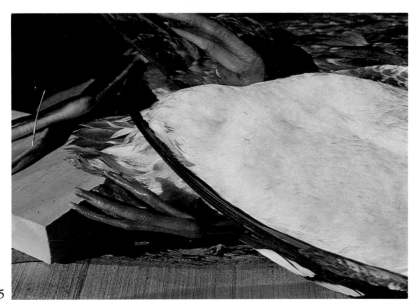

85

**(86)** Try to ignore the fact that this specimen has had a rather rough treatment before being photographed. Notice the color and the broken pattern of the vermiculation in the upper tail coverts and in the tail feathers themselves. Notice the color reversal with the dark centers and the light edges. This must be highlighted and then gently stippled to prevent having a harsh line between the bright color of the edge and the deeper color of the center of each feather. Note that the vermiculation works its way far back into the tail feathers. The splines are almost a pure white. You need a very limited pallet, but a great variety of tonal value. You will be using titanium white, raw umber, burnt umber, and a touch, here and there, of burnt sienna. These subtle colors can be hard to work with. Frequently it is more difficult to create the tonal values in a muted fashion than it is to paint the more brightly colored avian specimens.

**(87)** Isn't this a magnificent area to try to reproduce? Your pallet will contain burnt sienna, black, white, burnt umber, and yellow ochre. Following the detail you have created with your burning iron, I would suggest trying to block in with black and white. Then, while still tacky, pull in the darker colors of the vermiculation at the top of the side pocket. The underlying tonal values should have been established before you attempt the burnt umber and black in your final detailing.

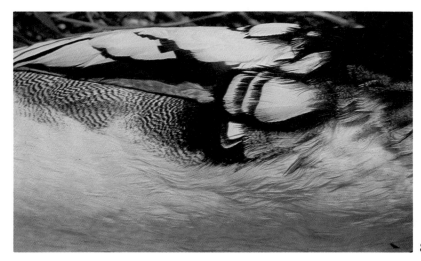

87

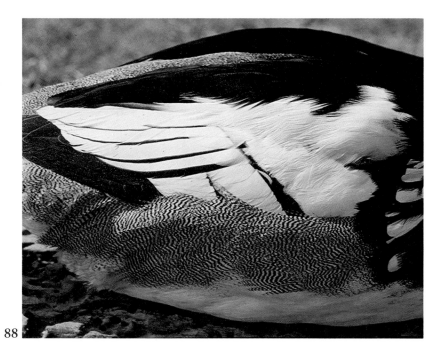

88

(88) Photograph 88 is merely an expanded view of the preceding photograph, giving a more general layout, but following the procedure previously outlined.

(89) Another view of the shoulder. The procedure for establishing these values may appear repetitious at this point, but I would like to call your attention to the fact that the angle at which the light is striking the subject is well illustrated by the last three photographs. I have tried to keep it at right angles to the subject in order to establish the maximum refractive index. The brightest and richest tonal values are always obtained if the light strikes at right angles to the area. All in all, the red-breasted merganser is a handsome bird. It presents a number of challenges but the rewards are commensurate with the difficulties. The detailing requires study if you are to produce an accurate copy of one of nature's masterpieces.

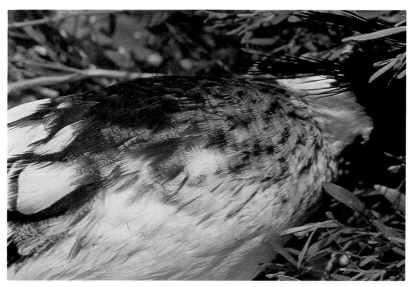

89

# 8

## Hooded Merganser

### DRAKE

(90) A drake hooded merganser illustrates another of the most popular birds in decorative carving. You will need a full pallet for this little fellow. Starting at the tail, the pallet requires burnt umber, black, and white. As you progress to the front of the bird, more black would be required, plus the white that appears in the tertials. We will get to the side pockets later. There is a purplish iridescence in the back that can be created in a number of ways. One method would be to mix black with ultramarine red, pulling out a little of the brighter shades with a touch of white. Another method would involve the use of several shades of bronzing powder, pulled into the still wet base coats.

(91) Looking at the bird from another angle, notice the vermiculation on the side pocket. This time the pallet must be expanded to include burnt sienna and yellow ochre. The white in the speculum and the tertials, as well as the white throat patches and crest patch are a pure white. But you must highlight with sparing use of burnt umber or very pale, washed highlights of any earth color. Do not forget the directions in which you are going to pull the leading and trailing edges of these patches.

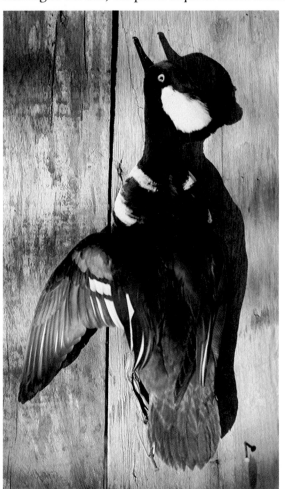

90

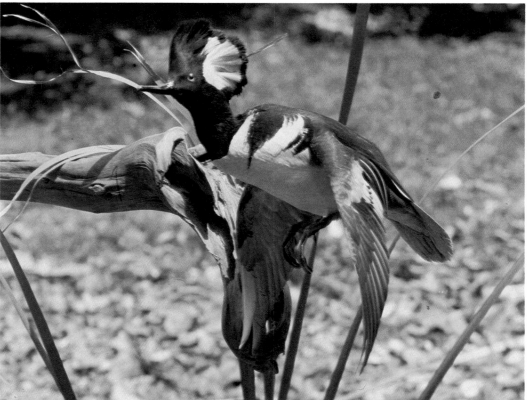

91

(92) Ah, here we have it! Here is a vermiculation that is completely different from anything we have looked at so far. Note how straight the darker lines are. They are mostly burnt umber, with a touch of black. Note the burnt sienna, lightened a little with white and a touch of yellow ochre, that underlies the pattern. Notice the variance of the undercoat from the yellow ochre of the leading edge to the burnt sienna that increases in intensity towards the rear. It is very important to remember that in applying this undercoat you do not leave any sharp lines. They are impossible to cover up. This is a delicate process, but one which creates a beautiful effect. Again, you won't see a scaling effect on this side pocket; instead, what you see is a flowing pattern of hairlike lines that the burning pen can duplicate almost perfectly.

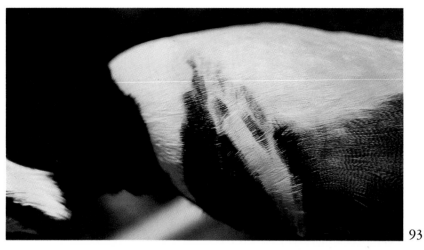

93

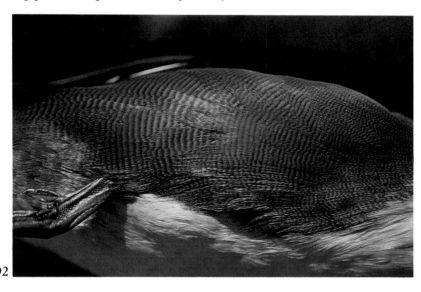

92

(93) In this photograph you will see the shoulder patch of the drake, rendered by pulling burnt umber and black into the white, then burnt umber and black into the vermiculation. The undercoat would be burnt umber, burnt sienna, black, and white, blended and softly pulled into the richer tones to the rear of the side pocket. The vermiculation is a darker black and burnt umber. Note the subtle half tones required in the breast. The front part and the crest patch are almost pure white, but as you progress to the chest and breast, a host of half tones are required. These are mostly mixed from a very faint touch of raw umber and white. Note the almost smudgelike effect in the shoulder patch. This is done

with a line of pure black pulled lightly through the white, followed by a line of very delicately applied burnt umber, white, and black with a touch of sienna. Multiple washes again, applied while still tacky or wet.

(94) This is principally illustrative of the iridescence on the leading edge of the brow and the irregularity of the white patch in back of the eye.

Note the pointed little bill, which led the Cajuns to refer to this as the *bec a la sec* (bill like a saw), a term applied to all of the mergansers. This bill is more birdlike than ducklike.

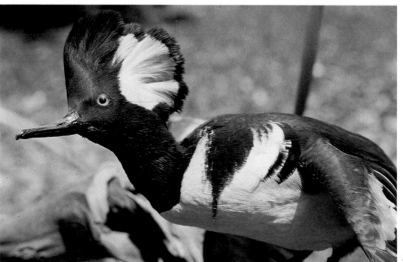

94

(95) For those of you who want to do a hooded merganser drake in the most intimate detail, here is a photograph that will allow you to count the primaries, the secondaries, the inner coverts, and the outer coverts. If you will also pay close attention to the half tones involved in this photograph, you will come up with a spectacular wing detail. Observe how pure the white is, how black the black is, and how delicately shaded the primary coverts and the middle coverts are. Your pallet would require black, white, raw umber, burnt umber, and just a touch of burnt sienna.

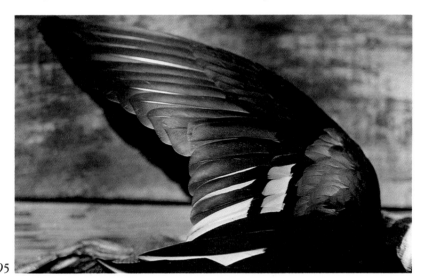

95

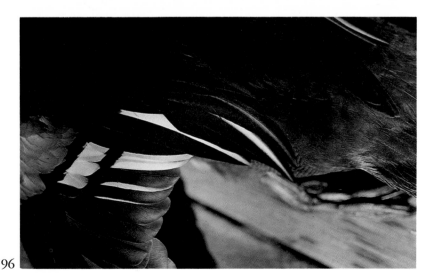

96

(96) The scapular, the secondaries, and the side pocket are contrasted with the back feathers and the primaries here. The delicate vermiculation in the scapular is soft and almost translucent. A touch of thalo blue on the black of the tertials might help you to achieve this effect. That second line of white feathers in front of the speculum or secondaries is actually the ends of the greater coverts.

(97) The under tail coverts and the tail feathers give you an idea of the complexity of the feather arrangement of the hooded merganser. To get the softness of the interfaces of the under tail coverts, use burnt umber, black, and white with a heavier amount of burnt umber than black on the under tail coverts and a greater degree of black in the tail feathers themselves. You will note that there are nine tail feathers on each side of the central shaft. This can vary slightly, due to the loss of one or more feathers in preening and molt.

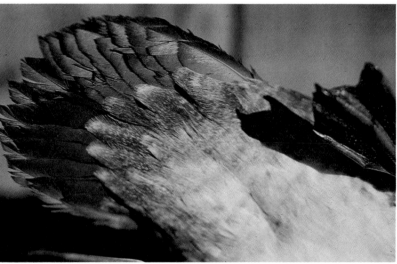

97

## HOODED MERGANSER HEN

(98) The hooded merganser hen is another softly muted little witch of the marsh. Her colors call for a very limited pallet—white, black, burnt umber, a touch of burnt sienna, and a touch of yellow ochre. These colors must be very delicately applied. The bill requires an additional dab of cadmium yellow (medium), applied to give a tonal effect to the grayish

black of the bill. This is pulled through from the rear of the lower mandible to the front, while the base coat of black and white is still wet.

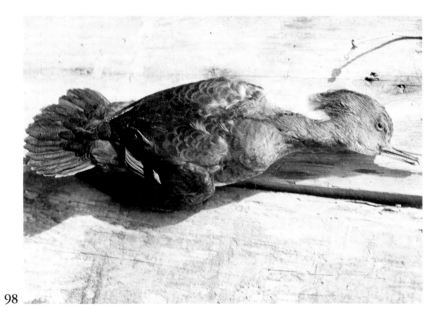

98

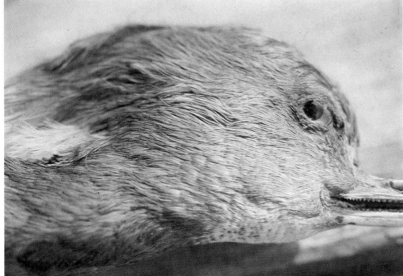

99

**(99)** Here you can see the hairlike effect of the head feathers and that dab of cadmium yellow that must be worked into the gray black of the bill. The corner of the sawlike bill curves up as it reaches the throat. The russet color of the crest is a blend of burnt sienna, yellow ochre, black, and white. Notice the gradient of half tones required, and the combination of hairlike patterns and tiny feather groupings on the back of the cheek. It is frequently this attention to detail that distinguishes great craftsmanship. The half tones and the changes in the burning techniques required to develop the feather patterns should be carefully observed in all photographs and in all mounted specimens. Establish your texture and feather groupings carefully and you will simplify your painting.

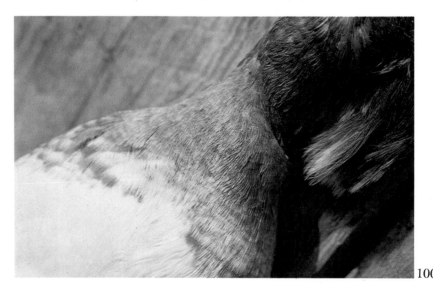

100

**(100)** I like this shot of the throat and neck blending into the head. It displays the lack of straight lines as one color works its way into another. Notice the manner in which the darker feathers are pulled over the lighter colors. The undercoat should be an off-white, with just a touch here and there of burnt umber, black, and white—but the amount of black and burnt umber needed to create the off-white is extremely minute.

As the throat blends into the head, pull the overlying burnt umber and black with a fan blender while the undercoat is still tacky. As you proceed to the bill of the bird and encompass the neck and head, the black predominates. The russet color on the end of the crest is obtained by mixing burnt sienna, yellow ochre, and white. As you get into the crest, begin to work in this russet color towards the end.

(101) Photograph 101 shows the juncture of the wing into the back and a portion of the breast below. The irregularity of the feathers is nowhere more apparent. The highlighting is obtained by that muted combination of burnt umber and black, pulled through the undercoat and touched on the edges with an increased quantity of white and yellow ochre. Note that even the application of burnt umber and black is in itself a half-tonal proposition, requiring a variance in the amount of white that is mixed with each successive feather. No two feathers have precisely the same combination of colors. It is the variance of the percentile of each of these

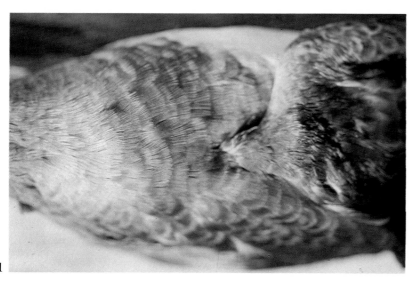

101

colors which creates the multiplicity of facets that a live bird obtains in nature. The thinness of the washes will prevent you from building up layers of paint that cannot be concealed once they have set up and dried. It is important to realize that if you are painting as we recommend (directly onto the wood rather than on an established ground), frequently you will obtain a natural effect by having an overlay of one wash over another, sometimes using as many as eight or nine. Do not be afraid to use another wash. It is a lot better than putting your color on opaque and concealing the detail you have been so careful to apply in the burning process or the texturing.

(102) The hooded merganser hen, in this illustration, gives a painter the opportunity to observe at close range the delicate gradient of color in the crest, the neck, the breast, and the belly. Although the pallet is limited,

102

the shade of gradients requires a delicacy of brushwork and should be painted from the darker colors on the neck towards the rear, pulling each successive layer with an increased amount of white, mixed with the raw umber. Note also the small touches of yellow ochre that should be added to change the gradient on an irregular basis; this can be seen in the detail of these feathers.

(103) The crest of the hooded merganser hen consists of a large number of hairlike feathers which can best be achieved with a texturing tool, followed with a burning iron. This procedure will create the required softness and intimacy of detail. Note the interplay of small amounts of raw sienna, burnt umber, and yellow ochre mixed in with the raw umber and white that should form the base color. The raw umber and burnt umber in the neck should be pulled from the front to the rear. The breast should have an increasing amount of white mixed with the raw umber as one approaches the belly.

(104) Although it is possible for the bird to achieve this position of the flight feathers overlaying the side pocket, in most instances I prefer to see the side pocket overlaying a portion of the wing and flight feathers. This is a position more typical of the bird at rest on the water. The faint vermiculation in the side pocket feathers is beautifully illustrated, as are the half tones involved in pulling the darker colors into the light colors of this area. The diverse pattern of the wing coverts, the tertials, and then the

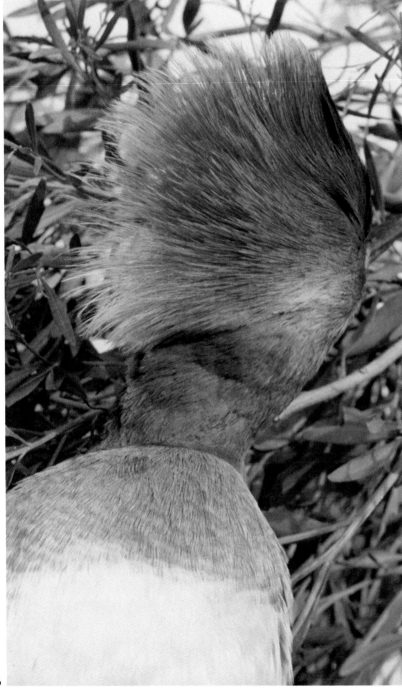

secondaries as they work their way into the primaries is well worth noting. I would suggest using a texturing tool on the side pocket and the burning iron for the flight feathers. After completing the tonal washes, highlight with pure white to accentuate the streaks that occur on the edges of the flight feathers as well as in the body of the feather itself. Remember, none of these feathers are monochromatic. Raw sienna, burnt sienna, a touch of burnt umber, and black all play a part in achieving this effect.

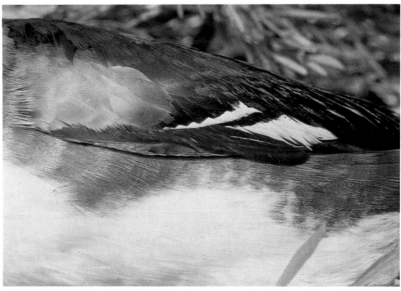

104

103

# 9

## Pintail

### DRAKE

(105) One of the most magnificent and most difficult birds to paint realistically is the pintail drake. Although we try to illustrate with photographs, the colors of nature can always best be found by watching live birds in prime plumage. I am going to try to describe a painting technique and a color use that may not always completely match the color balance of the photographs available. The criticism of this photograph that I must make is that the head is not quite as warm a color as it would usually appear in the field. It is much darker than it would appear in the field. It is much darker than it would appear had the light struck it from a slightly different angle. Since this is a reflective color, which we have discussed in previous illustrations, it is an excellent example of exactly why it is imperative that a living specimen be observed as a primary reference and a taxidermy mount be available as a color reference, using

photographs as a third choice. It is seldom that one can photographically record the colors as accurately as they are obtained from a skin, and even a skin frequently will not be as fine a source of color as the actual living bird. The shape of the tertials and scapulars and the manner in which they are overlaid make this bird one of the most resplendent members of the aviary.

(106) This photograph affords the opportunity to examine four or five different areas of the pintail drake. Starting at the right side of the photograph, we have the scapulars, which are the dark spikelike feathers bordered with gray and edged in a much lighter buffy gray. I would like to call your attention to the difference between those and the tertials with which they are often confused. An example of the tertials would be the feather in the uppermost right-hand corner of the photograph, and you can see that the central area of the feather is not as wide as that of the scapulars, and that the bordering is considerably wider. These are two distinct, different groupings, the tertials being the initial feathers in the wing, where the scapulars are a group of contour feathers that overlay the back and streamline the bird. The next grouping would be the oil gland coverts, which are the very soft gray-looking feathers that are edged in a lighter gray and extend from the scapulars down towards the rear of the bird, approaching a more pointed shape as they go towards the tail.

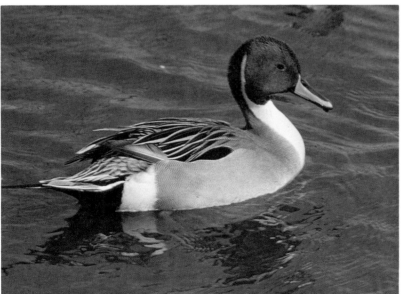

105

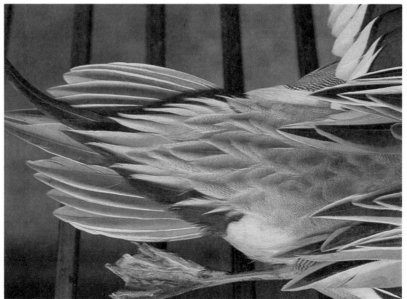

106

Right below the oil gland coverts and continuing to the rear would be the upper tail coverts, which are elongated, pointed feathers, unique in that they appear to be black on the outer edges with a very subtle white coloration on the inner half of the crest. This is very difficult to achieve, but it is characteristic of the pintail drake and should not be omitted.

Also shown are the tail feathers of the pintail drake. No other bird has a tail assembly that has just this shape. The two central feathers are substantially longer than the other feathers in the tail and are layed out above them. The two black spikes of the pintail, which are really an extension of the tail coverts, are being held out of the way to better expose the pattern. These two feathers extend three to four inches past the tip of the tail feathers and are characteristic of this bird. The carver/artist should pay particular attention to the very soft vermiculations noted on the oil gland coverts and the lighter portions of the upper tail coverts. These are very soft and should be applied wet on wet, and the color tones should not provide very significant contrast. At this point it might be interesting to mention that the vermiculations on the side pockets and the back are done by letting each succeeding coat dry before the next coat is applied. But in the tail covert area it might be best to apply the vermiculations wet on wet or alla prima, to achieve the soft blending required.

(107) The back pattern of this dabbling pintail could not be better illustrated than in this photograph, as far as the layout of the scapulars and the tertials are concerned. The pins, almost blue black, are equally well illustrated. The primaries are burnt umber and black edged with white; the white is applied by drybrush on the edges while still wet. Note how sharp the interfaces appear on the pointed quill-like scapulars and tertials, but how delicately the vermiculation of the cape encompasses the butt end of many of these feathers. If one examines a single scapular feather, it is astounding to consider the range of techniques required to copy this single feature in wood.

(108) Notice here the side pocket vermiculation with its high area of contrast compared to the muted tones in the upper tail coverts. The reflective, dark bronze green of the speculum is effected by the front edge being white with a touch of burnt sienna and yellow ochre. The gray of the greater coverts is obtained from the use of raw umber and white. The green of the speculum is obtained from a mixture of thalo blue and black, highlighted with a touch of cadmium yellow (light) and a touch of bronzing powder. One must be very careful to use the cadmium yellow (light) sparingly, as this is merely to highlight a small section of the speculum, not to make it the bright green that appears on other species. Note that the top part of the speculum is almost a blue black, of great intensity and great contrast, with no blending of the interface.

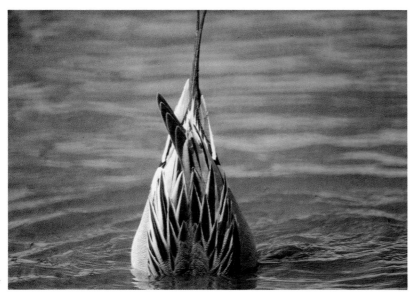

107

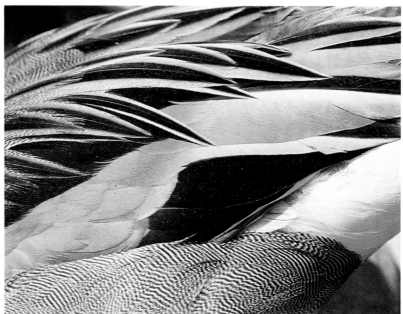

108

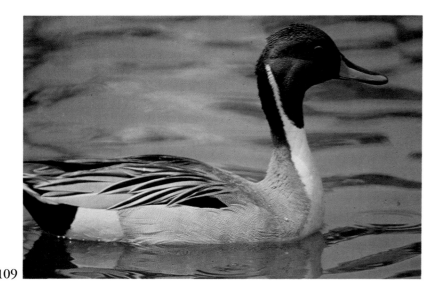

(109) The white of the breast extends up the neck and all the way to the rear of the nape. The contrast of the color of the bill with the black edging is quite dramatic. The blue of the bill on the upper mandible can be obtained by a mixture of white, thalo blue, and black. The shadows of the head must not be confused with the chemical color that must be created. The back of the nape of the neck is black. The crown of the head is burnt umber with a touch of burnt sienna. If you stipple a little raw sienna into the cap, this will also highlight the area very attractively. As a general rule, always try to bring in three colors to any area. No part of the feathers in a bird is monochromatic. The back and lower portion of the neck blends quite gently into the cape and its vermiculation. The edge of the gray side pocket and rear portion of the breast must be created with the undercoat, noting that the edges of this area are not sharply delineated but carefully blended into the adjacent color. The rear edge of the side pocket should be highlighted, particularly in the lower corner, with a touch of yellow ochre. This feature is apparent in this photograph. Note the blue black under tail coverts—again, not a pure black, but black with a touch of thalo blue. This photograph also illustrates an area that requires extreme attention to detail: the irregular interspersal of cape feathers with tertials and scapulars. Notice how the rounded vermiculated cape feathers overlay the long pointed splines of the scapulars and how the vermiculation itself works into an occasional edge of the scapular. The joining of the cape and these extremely decorative feathers constitutes a most important transition zone. Attention should also be paid to the variance of the undercoat. Note that while some areas have a dark, raw umber cast, others show a burnt umber and black undercoat, but the majority show an almost pure white with a touch of raw umber. Again the splayed, variegated, softly applied undercoat should prevent the vermiculation from having a uniform, monochromatic appearance.

(110) Look closely at the under tail coverts and the abdomen in the area of the vent. Notice the rust-colored area—blending is required here. Again the creation of a ground for the detailing is necessary. This can be accomplished by blending, while still wet, small dabs of burnt umber and raw umber into the white. As before, create this ground by blending in tiny amounts of the contrasting earth colors. Even the smallest excess will create a muddy field that would have to be rewashed with white. Don't go too far with the heavier, darker wash. Notice the slight iridescence of the blue black of the under tail coverts and the warmer tones of the primaries and the secondaries. This iridescence can be created with a touch of thalo blue or with a minute quantity of bronzing powder in a suitable color.

(111) The creation of the ground for the vermiculation must be accomplished before the detailing is begun. Create an area that is very light gray, comprised of 95 percent white with a touch of burnt umber and

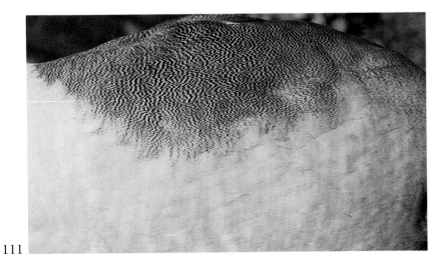

111

black. The breast itself and its rust-colored, stippled appearance would be established by stippling in a tiny amount of raw sienna on a stiff bristle brush. After the undercoat has dried, you can come back with a tiny amount of white applied by drybrush to the breast. This should produce a very soft appearance. Note that the preparation of the ground or undercoat involves the use of small amounts of raw sienna in the vermiculation.

(112) The cape blends into the scapulars and the tertials. Each feather group is fanlike. Splay the feathers as you would spread the fingers of your hand. Do not permit them to establish a straight line or even a crescent.

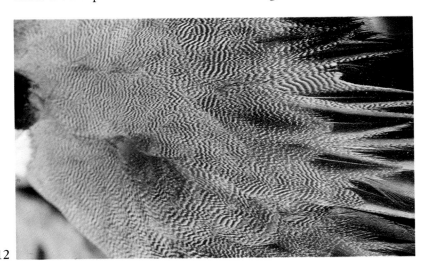

112

They must be worked into vermiculation with care to establish their contrast without overpowering the rest of the cape. You will again note that the ground (in the area of the mane and cape) is not a pure white, but a combination of white with irregular patches of burnt umber and raw umber, overlaid with the vermiculating lines. Quite a magnificent effect, isn't it?

## PINTAIL HEN

(113) The pintail hen, the mallard hen, and the gadwall hen require a similar pallet. The irregularity of the side pocket, and the manner in which the lesser coverts, middle coverts, and greater coverts work their way into the tertials, secondaries, and primaries can be noted here. The pallet requires burnt umber and black for the darker portions of the centers of the feathers and for the back of the head. The edging is a combination of white mixed with raw sienna, and an occasional feather has just a touch or fleck of burnt sienna. Notice how the feather pattern begins to almost disappear as the side pocket blends into the under tail covert.

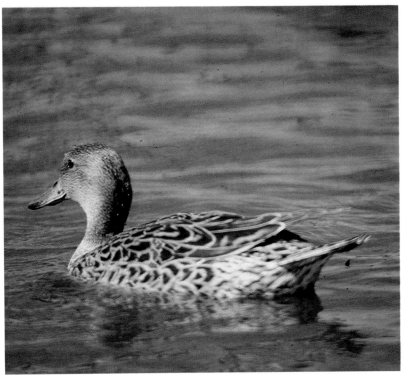

113

(114) The half tones are very apparent here, as is the change in color density as the cape works its way into the scapulars and the secondaries. The center of the feathers in the cape is more black than burnt umber, but as the feathers proceed into the scapulars, the secondaries, and finally into the tertials, the darkness of the center becomes warmer with a little more white, burnt umber, and yellow ochre. The edges of the feathers on the scapulars are white with a touch of raw umber. Again, you will notice a scattering of feathers that requires a touch of yellow ochre and a touch, in some instances, of burnt sienna. These little color differences do not appear on every feather, but if you look closely enough, you will see the need for the additional colors in your pallet.

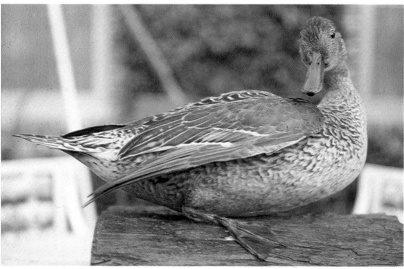

115

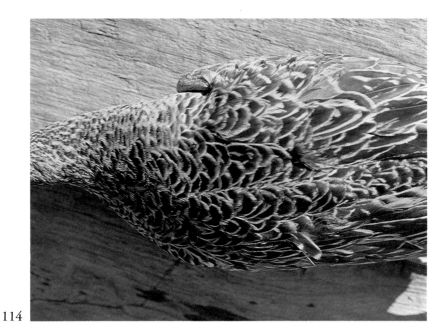

114

(116) The back of the hen pintail requires a pallet of black, burnt umber, burnt sienna, and white. Just a touch of yellow ochre is required to highlight the edging of a few odd feathers. The golden look of some of these feathers is obtained by lightening the burnt umber with yellow ochre and white. The contrast in the rich, warm tones of this specimen are used to illustrate just how much effect the molt and the environment can have on color. Birds that have frequented salt water marsh tend to be subdued in color. Birds that have fed and lived in sweet water and are in a nuptial molt are almost too beautifully plumed to seem real. I feel fortunate to

(115) Photograph 115 can be used to illustrate a number of features, but color is not one of them. The specimen here is not in prime plumage and the speculum itself has lost its florescence as the bird is in an intermediary molt. The line of the primaries in a semi-preening position, the manner in which the secondaries and the tertials overlay one another, and the shape of the body, if one is carving in the round, could be quite useful. Note how straight the sides of the bill are. Many carvers allow the pintail bill to be spatulate, as in the mallard and other species. It is a bit narrower and a great deal straighter along the side than other bills.

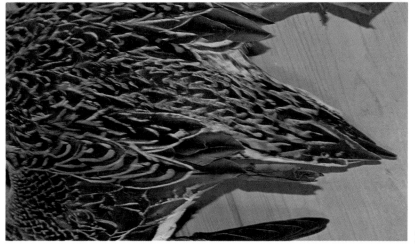

116

live in an area where birds arrive in good plumage. I have seen judges argue that our Louisiana painters use too much color—only because they are more acquainted with birds of the coastal marsh or open bays of the Atlantic Seaboard. Even more brilliant color is visible if one visits the north country in breeding season (i.e., the prairie provinces of Canada, or the Alaskan breeding grounds).

(117) The belly of this bird requires washes applied liberally, thinned with whatever medium you prefer. Grumbacher I would work ideally here. Mostly white must be used, which you've got to work in while still very wet, with a touch of burnt umber and a touch of yellow ochre. Remember, if you thin your white with burnt umber, you get a purplish cast. The yellow ochre is required to give you a warmer or golden brown that is typical of many waterfowl species. The reason for the liberal use of a medium in the application of the undercoats is to prevent the formation of lines or a buildup of paint that would be impossible to cover when you came back to do the detailing of the little smudges of color that this particular bird requires. A small amount of lacquer thinner added to your primer wash causes rapid drying and excellent penetration of the bare wood—both desirable attributes in this stage. Or, you could use Grumbacher III medium, which is a more rapid drying agent. Allow the undercoat to dry thoroughly before you go to work on the detailing. This is a case where you have to be careful not to destroy the undercoat but to overlay it with a third or fourth wash in order to obtain the irregular pattern required. The detailing is usually done by drybrush and stippling.

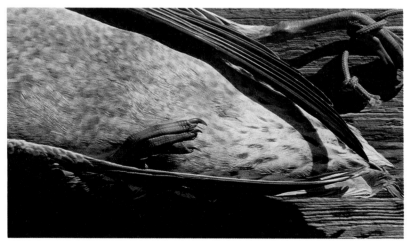

117

(118) The side pocket shown in this illustration can best be effected by painting vertical strips of burnt umber separated by raw wood, then a strip of raw umber separated by a piece of raw wood, then another strip colored with a light wash of burnt umber. Each of these areas must be lightened with at least 50 percent white. Do not forget the touch of yellow ochre when you are lightening the burnt umber. Now, with a stiff brush, starting from the front, pull through this interspersed mixture of color so that you blend out all lines and, in effect, have a softly mottled side pattern showing a variance of umbers, brown, golds, and even occasionally a touch of burnt sienna. You have no detailing at all now, but soft, muted pastel shades for your undercoat—no strong lines, no precise detail. Allow this to dry thoroughly. Now you are ready for the detailing. Look closely at how irregularly and interspersed the feathers themselves appear to be. Pull these colors, by drybrush, from front to rear. Notice the double curvature of the side pocket. Notice how the feathers flow in a gentle sweep up toward the center part, then down and up again towards the rear of the bird. The application of the darker colors requires that they be pulled from front to rear, overlaying the lighter colors. The edge of the lighter colors can be stippled in to blend the interfaces where dark and light meet. Note how much darker the cape of the bird appears in comparison to the side pocket and the under tail coverts. If you have done this bird properly, you have created a masterpiece that only nature can top.

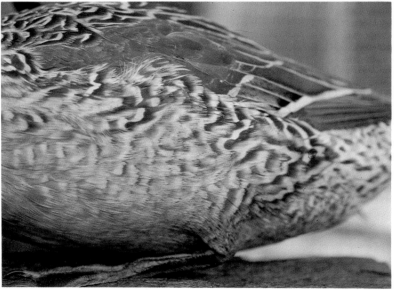

118

(119) An illustration of the secondaries, the scapulars, and the primaries, showing the manner in which they overlay the tail feathers, should be of great help to the carver. The delicacy and richness of these feathers is produced with mostly raw umber and a touch of black. The edges are detailed in a white that is gently toned with yellow ochre and burnt umber. The warm tones of the centers are created with a mixture of raw sienna and white, with just a touch of burnt sienna to increase the warmth of the color. Notice how delicately the interface on the edge of the speculum is blended into the darker colors.

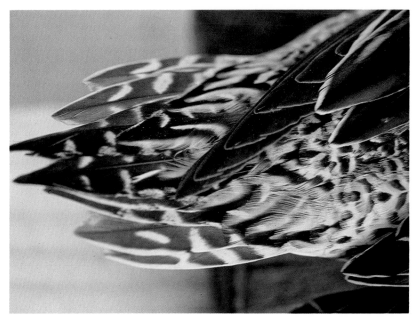

120

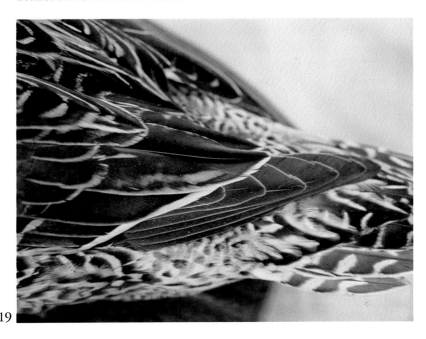

119

(120) The tail feathers of the pintail hen, showing the overlay of the primaries, is frequently given too rich or warm a base. The pallet here requires only raw umber and white with a touch of black to darken the ends of the tail feathers and the centers of the secondaries. Here and there an almost infinitesimal fleck of raw sienna can be blended into the white for lighter areas.

# 10
## Redhead

**DRAKE**

(121) Becoming increasingly scarce in our area, the dainty little redhead is one of my favorite birds. Notice how low he sits in the front. The back line follows this low angle, a feature atypical of the puddle ducks in which there is a definite rise from the breast to the tail. You have to have a rather extensive pallet to get all of the colors required to do this bird justice. The pallet should contain black, white, burnt umber, raw umber, yellow ochre, burnt sienna, and a dab of Payne's gray to bring out the bluish gray tint of the upper mandible.

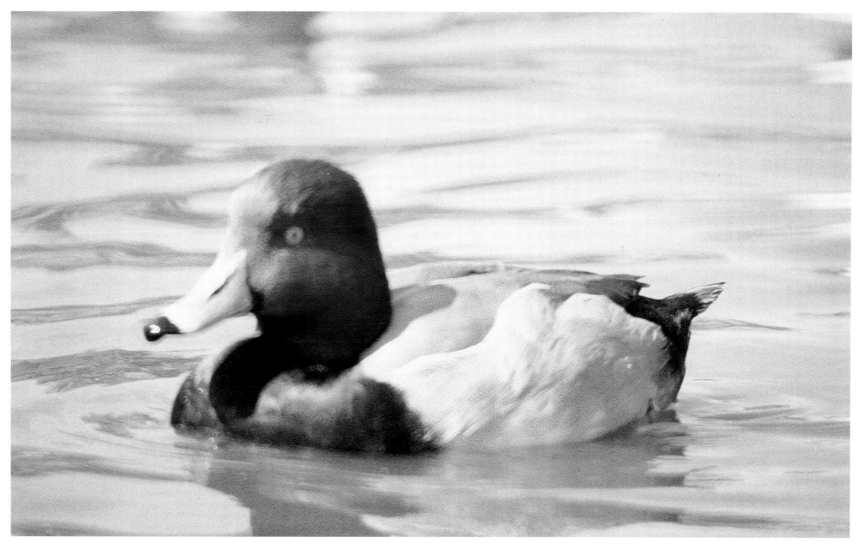

121

(122) The drake's crown has a warmth and richness that few other birds can match. I would start by painting this area with pure burnt sienna, being careful to blend the area that the neck completes so that it will not show a buildup of paint when you apply the black of the breast. Now you have the undercoat of burnt sienna, blended into the wood. Catch those darker areas by working in, while still wet, flecks of black and burnt umber. Highlight the areas in which the color is richer by pulling in, while still wet, a touch of yellow ochre. As the neck approaches the breast, carefully take only the most minute quantity of violet and pull it into the area at the base of the neck where it joins the black breast. Be careful not to overdo this purple. It is at just the faintest variance with the burnt sienna. The bill is a gray blue. This is created with white and just a touch of black and Payne's gray. There is also a definite whiteness that separates the black of the nail and the tip of the bill from the gray blue of the remainder of the bill. It is not quite as distinct as that in the ring-necked duck, but it is there nonetheless. Do not overlook it.

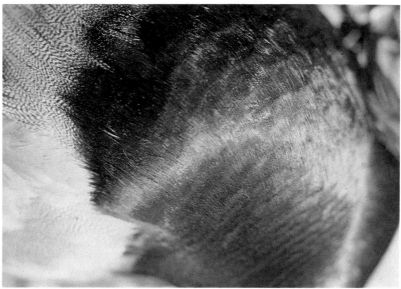

123

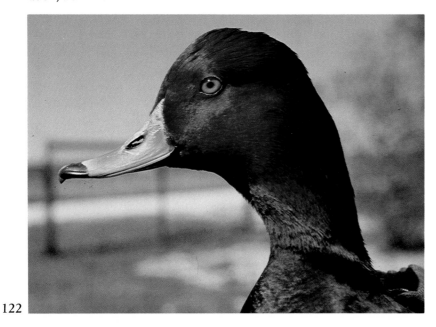

122

(123) The black of the breast here shows just the faintest purple cast. Burnt umber and white will give you this shade. The first wash should be a pure black. Use Grumbacher I medium sparingly, so that the wash is almost opaque from the beginning. This is not too difficult with black, as it is a very intense color. Now, while still wet or tacky, work in the high-lights on the edges of the feathers by very carefully using minute quantities of burnt umber and white. In other areas, use the most minute quantities of white, stippling to give the soft effect that the breast requires. Note the importance of having your undercoat already applied to the area that will receive the vermiculation. It is necessary to pull this black over the area of the side pocket and then apply the burnt umber and black required to complete the vermiculation. Let the base coat dry thoroughly before detailing.

(124) The back of the drake redhead is quite a time-consuming chore and must be approached with an expanded pallet to get the variety of colors it involves. The pallet would contain black, white, burnt umber, raw umber, and yellow ochre. Now to work on the back area. Get an adequate amount of medium and set your pallet up so that you can quickly, while still wet, intersperse the variance required in the undercoat. Start by applying, liberally, pure white on two-thirds of the back. Now come in with a dab of burnt umber and a dab of raw umber, pulling this into the white to create what, in effect, would be the color you would see if you looked at this photograph with your eyes squinted and saw a uniform color. Now, be sure to recognize that the undercoat itself consists of blotches of different colors. One area has a little more burnt umber,

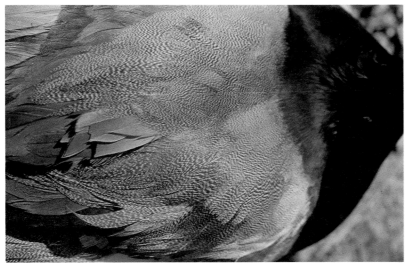

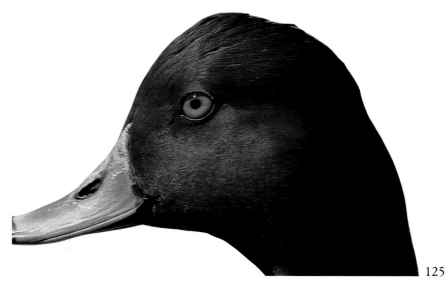

124

125

another a little more raw umber, another a little more white. Create this effect while the paints are still wet and you can blend all of the interfaces so that they disappear completely. Pull in a little more raw umber and white from the upper tail coverts into this central area and pull in a pure black from the cape, again always being careful to blend these interfaces so that there is no straight or hard line separating one portion of the bird from another. Put the bird aside and let these colors dry thoroughly. You have established the ground, and can now observe the intimacy with which the vermiculation must be applied to create the irregular pattern of fine lines in one area and heavier lines in another. You will use darker blacks and burnt umbers in one section and a touch of raw umber in another, or occasionally just a touch of burnt umber, yellow ochre, and white. This creates warmth and keeps this area from being strictly black and white.

(125) Another detail of the redhead, this photograph shows the black line of the lower lid of the eye, and the intensity and richness of the burnt sienna as it blends from the bill to the darker sections of the nape of the neck and the mane. Highlight the jowl with a little yellow ochre. Highlight the ear area with a little burnt umber and black. Darken the mane with a little burnt umber and black. The gray blue of the bill can be accentuated by touching the nostril with black. The gray blue itself is comprised of white with a touch of black and can be brightened with the faintest amount of Payne's gray.

(126) This illustration gives you an opportunity to observe, at close range, the blending of the cape into the lesser coverts of the wing. The lesser coverts are raw umber and white. While still wet, apply the faintest amount of black stippled with white to try to effect the very, very fine vermiculation that occurs in this area. The effect is so delicate as to be almost invisible unless one looks at it with a magnifying glass. The quills can be brushed in with a #3 liner brush while the undercoat is still tacky, using raw umber. Come back for a second coat, starting at the base of the quill, with just a touch of white pulled in to give the highlight effect.

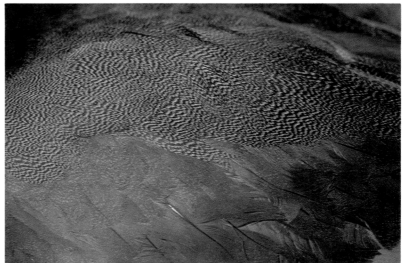

126

(127) Here again we notice the half tones required to get the softness of the breast feathers. Many painters apply this as pure black. While still wet, the breast should be washed with black, burnt umber, and raw umber, blended together to give a slightly irregular gradient to various areas. While still tacky, the edges of the feathers can be applied by drybrush with a minute quantity of white, using a fan blender for the upper part of the breast and graduating to a #8 or #10 sable brush as the feathers get smaller in size toward the lower breast.

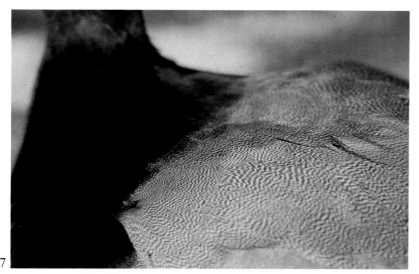

127

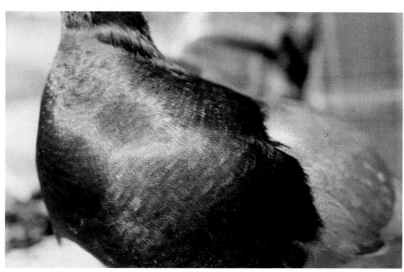

128

(128) If you have applied your undercoat properly, the application of the vermiculation to the interface between the cape, the breast, and the scapulars can be daintily and softly obtained. If your undercoat was not applied properly, you are going to have a great deal of difficulty with this area. Once again, let us repeat the lesson. You are pulling from the front of the bird to the rear. Pull the darker color over the light, almost in a shingle effect, as you apply the washes. The line where the neck comes into the cape is not a straight line and can best be applied by pulling the head colors into the area of the mane, while still wet.

## REDHEAD HEN

(129) This pair of redheads is illustrative of the common difference between drakes and hens. In almost every species the vibrance of color in the male is more dramatic than in the hen. But this does not simplify the painting of the hen. The soft earth colors of the hen require more finesse to emulate than the dramatic colors of the drake. Even the detail of the bill shows a greater contrast in the drake, and the white ring behind the black band at the tip of the bill is less noticeable on the hen. Note the brilliance of the burnt sienna, with yellow ochre and white added, on the side pocket. The spots are pure burnt umber pulled through the undercoat while still tacky.

(130) The pallet for the hen requires white, burnt umber, burnt sienna, yellow ochre, black, and a dab of Payne's gray to bring out the blue cast to the upper mandible. A great portion of this bird can be completed in

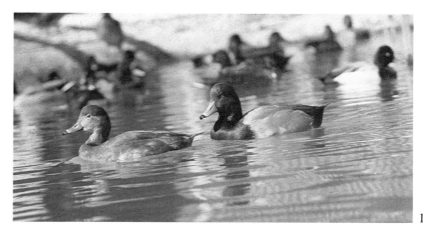

129

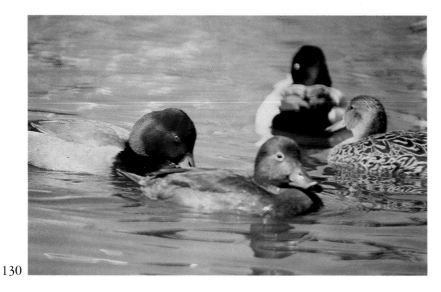

130

the washes of the undercoat. The cap or crown of the head is done in the second wash. The first wash is mostly white with irregular swatches of burnt umber, burnt sienna, and yellow ochre. These colors will create a soft, irregular, broken effect before you begin to do the detailing.

(131) The arrangement of the feathers in this museum specimen leaves a great deal to be desired from the standpoint of anatomy, but the broken pattern of the side pocket feathers, the change in the under tail coverts to

131

a coarser appearance, and the light breaking of vermiculation in the middle wing coverts are well worth observing in detail. Note that the back and the wing are slightly darker than the side pocket, but both are comprised of burnt umber, yellow ochre, and white. A small amount of black added to the blend used on the side pocket would give you the effect you require on the back. While still tacky, the ends of these feathers should be pulled across the darker areas, wet on wet. Work from the back of the bird to the front so that the feathers will have the effect of being shingled on rather than blocked in.

(132) The redhead, like all diving ducks, sits low in the water. The curvature of the back is almost completely hemispheric. There are no slab-sided areas. Everything is curved and blended into the teardrop that can be observed when viewing the bird from above. Note the buff white circle around the eyes, which is atypical. This circle is white with just a touch of raw sienna. The back feathers are burnt umber, yellow ochre, and a touch of burnt sienna, edged in white and painted wet on wet. It would be a good idea to let the undercoat get tacky before applying the edging, so that these white edges can be pulled in but not completely blended. If too wet, you will just create a muddy color.

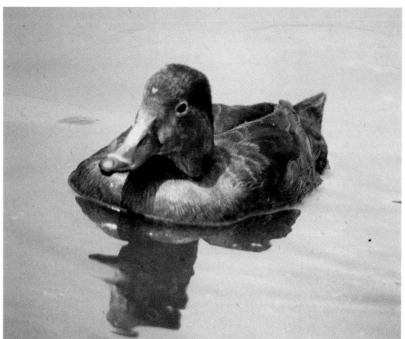

132

(133) Photograph 133 is a pen-raised bird but is illustrative of the typical head shape. The bill, however, is not typical, showing a little too much black in the rear portion of the upper mandible, but the white band in back of the bill tip is well illustrated. Note the sweep of the hairlines of the cheek. The feathers do not have a scalelike effect, but gentle curving lines that create the modeling of the cheek and the mane. Paints can be used to establish contours as effectively as carving. Establish your curved interfaces as much with color as with your knife or texturing tool.

two-tonal value, by varying the percentile of one of the primary pigments. After you have created this effect, you can wipe the brush off thoroughly, let the colors tack up even further, and just before you shut down for the evening, pull a fan blender once more very gently across the whole area.

134

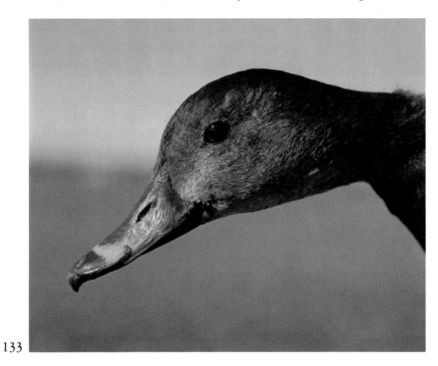

133

(134) How's this for a tough area to try to copy? At first glance, one might presume there was some semblance of a pattern, as the feathers appear to be laid on in rows—but look a little closer. None of the feathers are the same size and many go in odd directions from one another. The whole effect has to be created wet on wet. I would suggest using a Grumbacher III medium, which is a slower-drying medium. It will permit you, after you have applied the white and after the base coat is washed directly to the wood (white with a touch of raw umber and the slightest amount of black), to come back over this with a fan blender. Use a titanium white and break your pattern according to the direction. Create a

# 11

## Ring-Necked Duck

### DRAKE

(135) Burnt umber, black, white, ultramarine red, and a touch of white—not a very expanded pallet, but one that must be handled with the utmost of care to create this saucy little waterfowl. I would use this photograph to establish both the flow of texturing preliminary to painting and the blocked-in patterns of color, which together will make a suitable ground for the final detailing. The angle at which the light strikes the ring around the neck can cause the ground to change from burnt sienna and alizarin crimson, highlighted with white and yellow ochre, to a color that reflects purple. The nail is a leathery black with a white band which offsets the nail and breaks the edge of the bill as it reaches the cheek. There is a slight hump in the skull structure, which gives this bird a topknot rather than a crest. The white of the side pocket works its way almost halfway up the cape. The black of the breast is a deep, rich, pure black. The cape itself has an extremely light vermiculation when viewed at close range. As the side pocket works its way into the rear, raw umber must be pulled through to create the tonal variance required as one approaches the under tail coverts, which are again a pure black. The purplish cast of the lesser wing coverts and the middle coverts is created with burnt umber and white with a touch of black on the trailing edge of the feathers. Note that the central portion of the feathers has a lighter, more purple cast. This is created by lightening burnt umber with white without the addition of yellow ochre. Be sure to pull the interfaces of the black breast feathers into the belly area, so that you create an overlaying effect that will follow the pattern of your hairlike burned or textured marks.

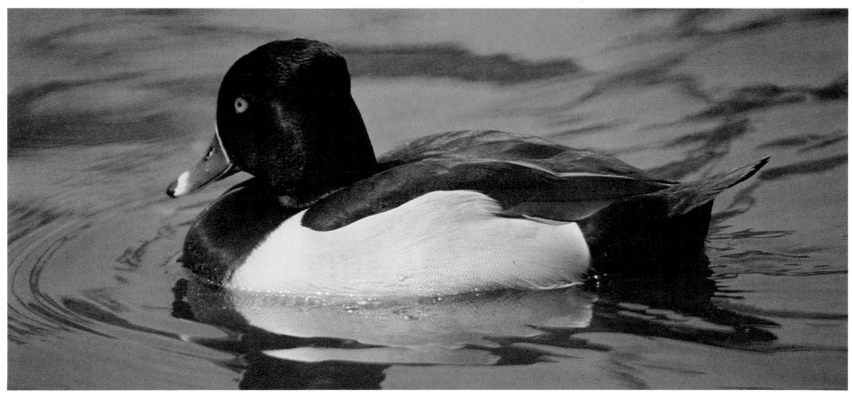

135

(136, 137) The delicacy with which the vermiculation of the side pocket must be applied and the stippling that appears in the scapular as it overlies the secondaries must be carefully created. This should be stippled on while still wet. Usually these specks are created with a stiff bristle brush, touched and wiped dry with burnt sienna and white. Note how the speculum is softly blended with the leading edge of the feathers—burnt umber, black, and white blending the interfaces. You should be careful to continually wipe the brush clean, or rather than blending the interface, you will create a muddy ground.

(138, 139) The speculum is an excellent example of interference colors created by the angle at which the light strikes this area. In reality, the speculum is white, as seen in the preceding photograph. Here it appears to be gray blue because the angle at which the light is striking the interface has changed by almost forty-five degrees. The chemical colors are evident on the tail coverts, the primary, and the tail feathers themselves, as the light is striking them at a right angle. Note the slight earth green cast to the scapulars and the tertials. The tail feathers themselves are burnt umber, black, and white, pulled while wet to establish light inner edges and darker outer edges. The upper tail coverts have a greater percentage of black, but fine hairlike brush strokes of white, while still wet, will create a softer effect. There is very little highlighting on the edges of the primaries or the scapular, in contrast to other specimens in which such highlighting is a common phenomenon. The rear edge of the side pocket is the same color as the tail feathers themselves, with the added feature that the trailing edges of the side pocket feathers must be touched with yellow ochre to give them a golden cast. Remember that a very fine vermiculation appears on this area of the side pocket.

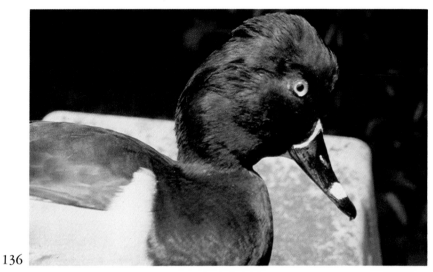

136

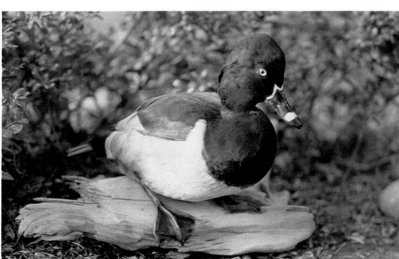

137

138

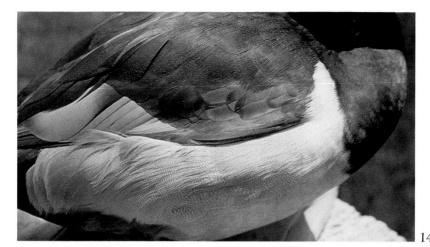

140

139

lighting small areas with white and breaking up the interface as the breast feathers join the abdomen.

(141) We have explained the colors in sufficient detail in preceding slides, but once again I would like to call your attention to how small a color value difference there is between the dark area of the vermiculation and the light. I have found that the most frequent error in applying vermiculation is excessive contrast. A great deal of white is required to lighten the contrasting colors to create a soft pattern rather than a sharp, hard interface.

141

(140) We can still maintain a rather blue cast to the speculum, but remember that the light is striking these feathers at a forty-five degree angle due to the curvature of that area. The delicacy of the vermiculation on the side pocket is excellently illustrated. The undercoat is burnt umber, yellow ochre, and white, white being the predominant color. After you have completed the undercoat, come back with white using a Grumbacher III medium to slow the drying process. Pull your white vermiculation into a pattern, working from the back of the bird to the front. While still tacky, take a fan blender and gently smudge certain areas of the side pocket to create the irregular definition it requires. Although the breast is almost pure black, note the beautiful effect that can be obtained by high-

## RING-NECKED HEN

(142) The form of the ring-necked hen is clearly brought out in this photograph, but the colors appear as they would be seen if the bird were in shadow rather than in direct sunlight. The positioning of the feet, head, neck, and wing are all excellent, but we will use other illustrations to discuss color more fully.

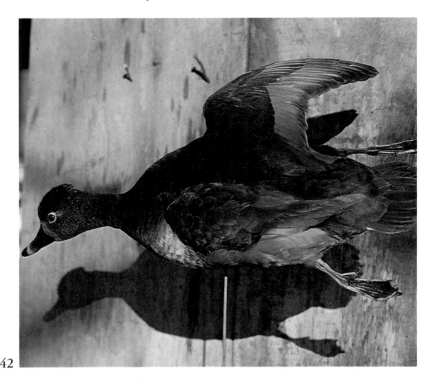

142

(143) Here we note the color of the head area of the ring-necked hen. The white band on the bill, the white eye patch circling the eye, the faint rust color that frequently dapples the area on the front of the cheek—all can be clearly seen. The pallet is raw umber and white, highlighting with raw sienna. As the nape of the neck and the throat go into the breast, the raw umber changes to burnt umber, giving you a slightly warmer brown interspersed with streaks of white, pulled in while the colors are still wet or tacky. The head has a definite crest, very similar to the canvasback. This head shape is actually more due to the skeletal structure than it is to the feathers, which it helps to mold into a slight crown.

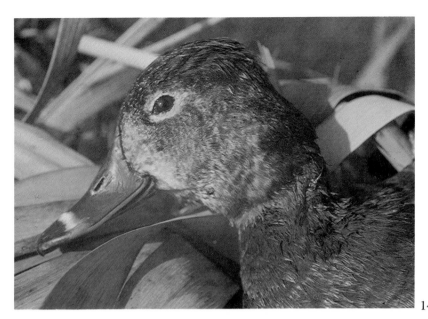

143

(144) In creating the breast pattern, the burning should be in rows of hairlike feathers created either with a texturing tool or by burning. I have always preferred to create this effect by burning from the rear of the feather to the front, but you can get in a number of arguments with other carvers as to how to create this rowlike effect.

144

The first wash, starting from the front of the breast, would be white with a heavier percentage of burnt umber and raw sienna, gradually increasing the amount of white as you pull the washes to the rear of the bird. Then allow the undercoat to dry thoroughly, and build your darker areas with burnt umber and raw umber, interspersed with touches of black. Highlight while still tacky on the second and third washes with a little yellow ochre and an occasional fleck of raw sienna.

(145) Another view shows the interplay of light and shadow that creates the mottling effect through polychromatic use of shade variance. This effect can be produced either by texturing before painting or by a careful application of polychrome washes on the hairlike burn marks used instead of texturing. Note that every area is a combination of white, yellow ochre, burnt sienna, and black. Some of the richer tones of brown in the upper part of the breast can be created with raw sienna and just a touch of burnt sienna. This can be lightened with another touch of white applied while the paints are still tacky.

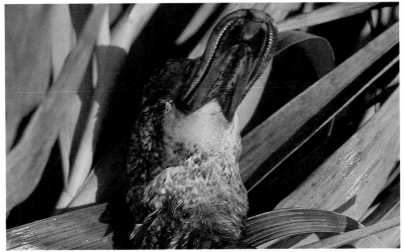

146

(147) If the carver can create this effect, his painting will be a great deal easier. The area of splayed feathers is the junction of the shoulder coverts and the side pocket. This effect can only be achieved with a burning tool. The pallet requires black, white, burnt sienna, raw sienna, and burnt umber. In creating this layer effect, paint from the back of the bird to the front, but pull the colors from the front of the bird to the back using brush strokes with a darker color, starting at the leading edge of the feathers and lightening as you go to the rear.

145

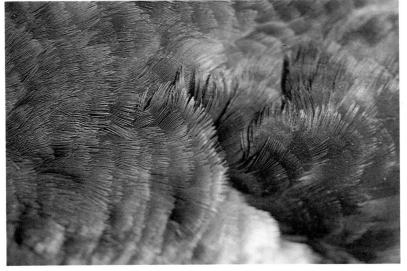

147

(146) The lower mandible, throat, and upper neck area require a pallet of white, black, burnt sienna, and raw umber. The throat itself is mostly created with white, touched with spots of raw umber and a little raw sienna on the edges. The lamellae are highlighted while still wet with a touch of white, the undercoat being burnt umber, black, and white. This combination will give a slightly purplish cast.

(148) For those who wish to carve a flying or hanging bird, an illustration of the wing showing the primaries, the secondaries, and the greater and lesser coverts should be particularly useful. Notice the large dimensions of the scapulars, which act as a fairing agent to streamline the juncture of the wing with the back and the cape. The speculum of this bird is extremely visible in flight, giving it a black and white silhouette that is most noticeable. The short, blunt appearance of this wing is typical of the diving ducks in contrast to the more elongated and extended shape of the wing of the puddle duck. The painter who has a group of specimens available should endeavor to mount birds in as varied a mode as his imagination and his taxidermist's ability will permit. The colors can be referenced from one specimen, the feather patterns and structure of the carving from another. Thus, it would be best to have one bird mounted flying, one sitting, one standing, one rising with wings thrust down, one hanging trompe l'oeil on an old piece of weathered wood. You will be able to learn a great deal by examining these specimens with your friends and discussing the attitude of feather groups and the means of obtaining colors.

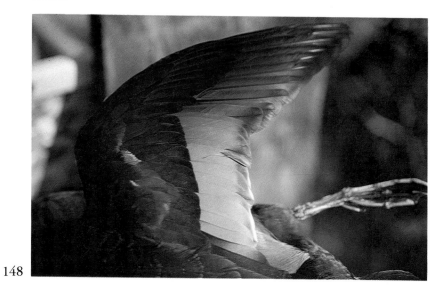

148

# 12

## Ruddy Duck

### DRAKE

(149) One of the sassiest little birds in the Louisiana marsh is the drake ruddy. At rest the bird sinks low into the water, and its tail coverts, especially during the breeding season, are usually erectile. This led Cajun hunters to nickname it the "marionetta," since the position of these feathers reminded the early settlers of the French constabulary, the Marionettes. The pallet requires Payne's gray, white, black, raw umber, burnt umber, burnt sienna and yellow ochre. The head appears to be oversize with respect to the rest of the body, and when thoroughly at rest, the bill is tucked in so that the tip barely extends past the leading edge of the breast. As in all diving ducks at rest on the water, the breast is higher than the upper tail coverts. The bill itself is very spatulate.

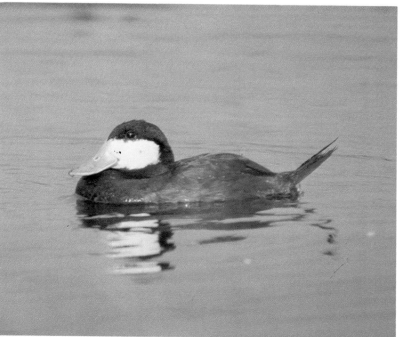

149

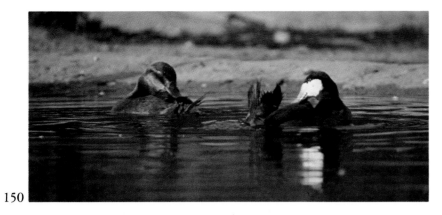

150

(150) Note the erectile fan, shown by the drake, in display before a female preening. The deep russet of the flight feathers, the neck, and the breast are burnt sienna with touches of burnt umber to darken. The top of the head and the back of the neck are almost black. The bill is a combination of Payne's gray and white. The cheek is pure white, with the faintest touch of yellow ochre.

(151) The throat and breast consist of groupings of feathers that commence under the throat with small, tight feathers, gradually enlarging as they approach the breast into rows of larger feathers. Ignore the color of the bill shown here. This is a taxidermy specimen of a mounted bird and the bill has not been painted. Note the breakup and overlay of the jowl feathers, and the irregular edge of the white, touched with yellow ochre, that overlays the throat. You will use burnt sienna, highlighted here and there with touches of burnt umber, yellow ochre, and white. Gradually working toward the rear, burnt umber, black, and yellow ochre begin to predominate. The breast itself should be painted with a fan blender, pulling layers of burnt umber, raw umber, and yellow ochre into a tacky wash of white. After the bird has been primed and the prime coat has dried, the second wash of white should be allowed to tack before attempting to create this mottled effect. I would suggest using Grumbacher III medium on the second wash, so that the drying time will not cause an undue delay. The drying is much more rapid with Grumbacher III than with Grumbacher I medium. I would suggest using the fan blender from the back pulling into the front to create these layers of crescent-shaped patterns overlaying the throat.

Since the feathers of the throat and breast on this bird are so fine, I would recommend using the burning tool with overlapping layers of

151

straight burned lines, without trying to show any particular feather pattern. This pattern would be created with the use of the brush and the fan blender.

(152) The top view of the ruddy drake, starting with the "toupee," can be achieved with the use of a texturing tool and a burning iron. Although the feather pattern is very irregular, it can be shown. The crest of the bird should be painted with black, burnt sienna, and touches of yellow ochre. The neck is done with burnt sienna highlighted with yellow ochre, raw umber, and white. Note that as the feathers work their way into the cape area, there is a dappled, weak, speckled pattern. The color here is stippled in with raw umber and white over the underlying feathers' color, which is burnt sienna and yellow ochre.

152

(153) The back feathers are large; the edges are irregular and present a very soft appearance, with lack of extreme contrast in color. The stippling of white over the areas of burnt umber mixed with white, interspersed with burnt sienna also lightened with white, gradually works its way into the side pockets, where the predominant colors are raw umber and white. The spiked tail feathers protrude from the upper tail coverts and are quite unique to this particular species of waterfowl. Note the area where the ends of the scapulars overlay the base of the body feathers, which are burnt umber and white. The upper tail coverts are a mottled mixture of raw umber, burnt umber, burnt sienna, white, and yellow ochre. I would again suggest using Grumbacher III medium with a white and raw umber wash before attempting to achieve this soft mottled effect. This is a bird that requires a great deal of alla prima technique. The colors are softly applied and pulled from the front of the bird to the rear. You achieve as much of the feather pattern with the brush as with the burning iron.

154

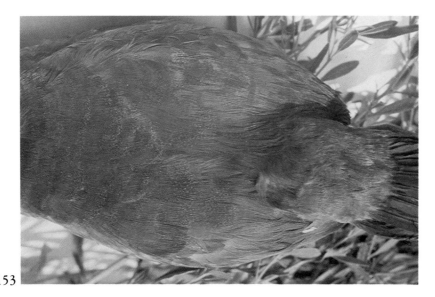

153

(154) The pattern of the side pocket is dramatically illustrated in a position contrived by forcing the side pocket to override the flight feathers. Ignore the shape and position of the flight feathers on the upper edge of this photograph and concentrate on the pattern and sweep of the feathers on the side pocket. Again we must resort to light washes of color, in which the first wash or prime coat is pure white applied with Grum-

bacher I medium and allowed to dry thoroughly. The second wash is mostly white with a touch of raw umber and yellow ochre irregularly brushed in and permitted to tack with Grumbacher III medium. Once the tack is achieved, paint from the rear of the bird to the front, gradually using darker and darker drybrush pulls with a fan blender or stiff bristle brush. If you look very closely at these layers of color, you will see that the upper portion of the feather is a burnt umber thinned with white and a touch of sienna, but the leading edge of the feather is white, which must be pulled over this underlying color. I would suggest that you ignore the lower edge and the upper edge of this photograph and concentrate on the pattern in the center. The cleft of the breast is exaggerated in this mount, but does exist. The downward sweep of the feathers in the leading edge of the side pocket gradually swirls in an irregular fashion to the rear and upward. The mottled half tones only show a pattern in portions of the side pocket. Again the brush, rather than the texturing, must achieve most of the detailing. I would recommend doing this whole area with a fine, sharp-edged stone, achieving the hairlike effect with the delicate use of the fan blender and wet-on-wet painting. The color of the throat consists of successive layers of raw umber thinned with white or pulled into the tacked wash that precedes it. A #1 sable brush then details the burnt umber and pure black that is carefully pulled from the throat toward the belly.

## RUDDY DUCK HEN

(155) The pallet required for the hen ruddy is rather limited. Again the earth colors predominate particularly in the hen. White, raw umber, burnt umber, black, and yellow ochre should suffice. The initial wash for the undercoat is burnt umber with a touch of yellow ochre lightened with white, increasing the amount of white as you approach the breast, the throat, and the side pocket. Once again, the texturing and the burning techniques are going to make or break this carving. There are no intense, bright colors to attract the eye. The real attention to detail will be required in the mottling and the muscular treatment of the initial carving.

This specimen's bill does not reflect a proper color. The bill on the hen is actually a blue black, more on the black side than the blue. I would suggest using a pure black and then, while still wet or tacky, pulling a small amount of white through the initial coat. This will give you the metallic blue black or gray black that is required. Let the undercoat dry thoroughly, being sure to use adequate amounts of medium to wash out any interfaces between the darker umber of the back and the side pocket. A fan blender will be most useful in detailing this bird. The interspersal of burnt umber, yellow ochre, and a touch of black here and there gives you the mottling effect rather than a distinct feather pattern. The tail feathers themselves are burnt umber with just the slightest amount of yellow ochre added.

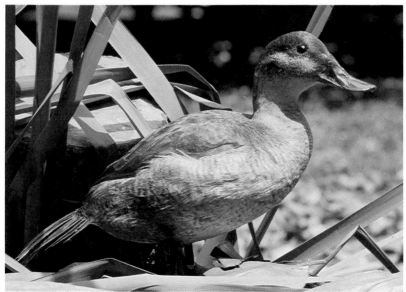

155

(156) The hen ruddy also has the capability of raising the spikelike feathers in a stiff, fanlike arrangement. The bill is almost raw umber, with a touch of white to give you that slightly purplish, dark cast. It may be necessary to add a small amount of black to tone down the effect a little. The nail of the bill and the leading edge can also be touched with yellow ochre, pulled into this darker mass. The top of the head is burnt umber with touch of burnt sienna and small dabs of white to lighten and highlight portions. The cheek, better illustrated in succeeding slides, is a burnt umber lightly pulled over a wash of white. Note how low the bird sits in the water, and the configuration of the large head, the tucked neck, and the rounded breast.

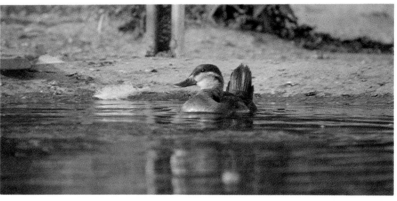

156

(157) The tail coverts are a blue black, the under tail coverts, white touched with raw umber. The thickness of the neck and the slope of the breast into the back, the spatulate shape of the bill—all of these characteristics should be worked into the carving before attempting to prime.

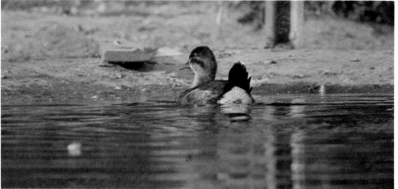

157

73

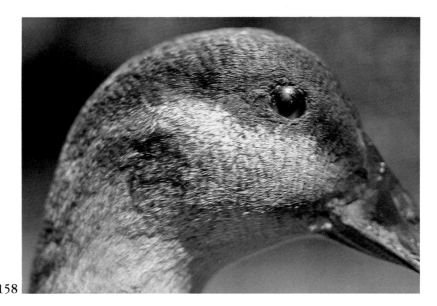

158

(158) The closer the macro lense brings you to the specimen, the more the delicacy of the detail and the number of applications of color become apparent. You can see that the fan blender is a perfect brush with which to achieve this effect. The burning is in rows rather than in a fish-scale pattern. I would start with the darker shades, pulling burnt umber from the front of the bill to the rear of the crown. Then brush over this with a little yellow ochre, pulling through the burnt umber. Follow with just a touch of burnt sienna, and finally, just the faintest amount of white.

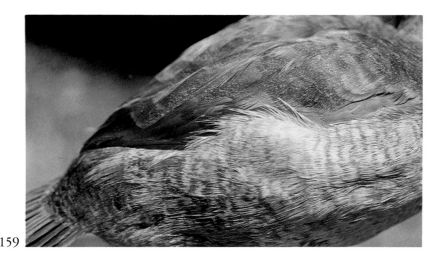

159

(159) We have already covered the color and the application on both the side pocket and the back, but again the macro lense zooms in on the detail you are trying to reproduce. Note the wing coverts that are showing through from beneath the side pocket and the scapulars. Note the dots of color that appear in the scapulars, which can be applied with the tip of a #1 sable brush. Note the variety of color in these dots.

(160) It is helpful to have a top view, showing the layout of the major feather groupings of the back. The illustration here is very detailed in the rendition of the area from the nape of the neck through the cape, showing the interplay of colors between the side pocket and the lesser and greater wing coverts; but as you approach the primaries and the tertials, the detail is not quite so distinct. Note the irregularity in the muscular interplay beneath the side pocket and in the back. These irregularities in the carving create a dynamic rather than a static pose.

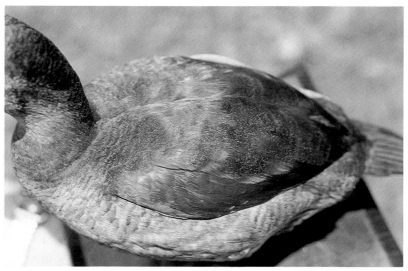

160

# 13
## Lesser Scaup

(161) Since our area sees very few greater scaup, we will concentrate on the lesser scaup with his purple iridescence, quite apparent in the head area. Note the skeletal configuration of the head, which creates the crest-like appearance discussed previously in the ring-necked duck.

161

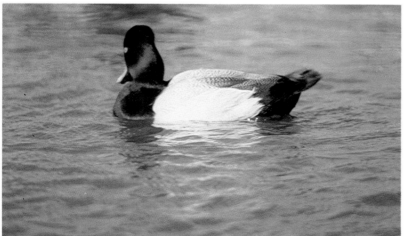

162

(162) The shape of the head is noticeably different from that of most other diving ducks. The side pocket extends much further back and its splayed edges must be very carefully contoured and textured to reproduce this effect.

(163) The pallet required to effect the speculum and vermiculation of the secondaries and the greater coverts calls for a combination of black, white, burnt umber, and yellow ochre. The feet of this bird are a blue gray—Payne's gray and white with a touch of black here and there would be perfect. The base undercoat directly on the wood would be burnt umber, black, and white, with the greatest percentage being white. After this has dried, you should come back and detail the vermiculation with black and burnt umber interspersed with lightly applied strokes of zinc white. The white in the vermiculation is in a considerably broader band than appears in the pintail. The effects on the greater coverts (on the leading edge of the speculum) are actually more stippled than vermiculated. These dots of white can be created by using a stiff bristle brush and stippling in the white. If the undercoat is tacky, you are merely going to get a brownish smear of muddy colors rather than the snowlike effect you are trying to create.

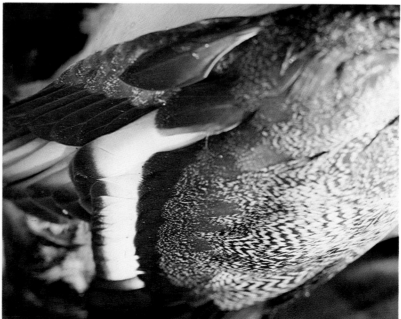

163

(164) It is apparent why the French referred to this little bird as the *dos gris* (gray back). From a distance, that is just what he looks like. In doing your first washes on this bird, I would suggest that you paint the entire bird with burnt umber and black, lightening the back area with an adequate amount of white to create the ground for the detailing to occur later. Be careful not to leave any distinct lines, blending the burnt umber and black gradually into the gray of the back and pulling the burnt umber and black from the tail area into the gray area of the scapulars.

165

164

(165) You could hardly find a better illustration of the scaup's vermiculation. The left edge of the photograph demonstrates the interspersal of the cape into the back. The irregularity of the vermiculation and the broad bands of white are extremely apparent. The mottling of the back and the V-like groove that divides the cape from the terminating scapulars are all

clearly illustrated. The upper right-hand edge of the photograph illustrates the change in pattern of the lesser coverts to a finer vermiculation and a much more irregular application of white bands. Most of the lesser coverts should be stippled in rather than stroked. The pattern of this vermiculation is so bold that it is almost impossible to find an individual feather in the maze. It is almost as though we have created a single feathered cape from the nape of the neck to the end of the cape and the final blending of the scapulars into the upper tail coverts.

(166) The belly of the lesser scaup is as close to a pure white as is found on any species. The line of the breast that pulls into the belly area has the purplish cast of black that is created by the use of burnt umber and black with just a touch of white. As you approach the area of the abdomen, a fan blender is used with pure white to blend the junction of these feathers into pure white. Look at the bolder vermiculation of the back as contrasted to the more muted and stippled effect created in the wing coverts. To create the extreme white of the abdominal area, the first wash should be white with a slight touch of raw umber. When this is dried, you then come over it with pure white, using the drybrush method so that the shadow effect of the undercoat will appear through the burn lines and create an even whiter white by contrasting the shadows from the first wash. As you approach the area where the thigh comes out of the abdominal area, there are some lightly stippled raw umber vermiculations that must be carefully applied as a final touch.

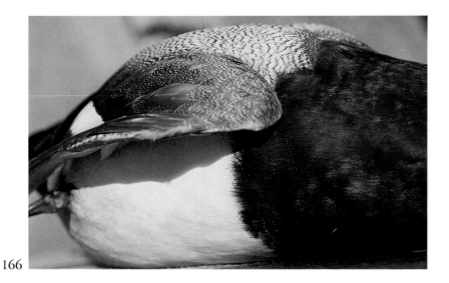

166

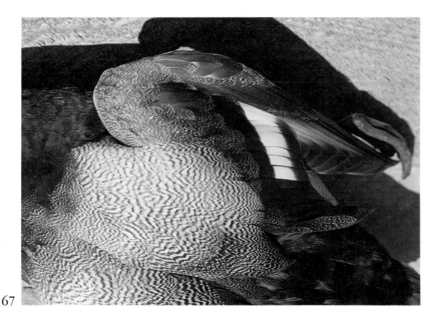

167

(167) One final look at the vermiculation of the back and the warm browns of the primaries is worth an additional comment. It should be mentioned that different manufacturers of umbers and siennas frequently use different tonal values. If you find you are getting a little too warm a color from one manufacturer, it may be possible that another one will give you exactly the value you are looking for. This is why anyone who continues to paint ends up with a host of colors and is always looking for different shades and different manufacturers' groupings. I have been using Windsor Newton and Grumbacher. The Windsor Newton is a much warmer burnt umber than the Grumbacher, but both offer excellent shades.

## SCAUP HEN

(168) The hen scaup has a strong white patch immediately behind the bill. This is very apparent in flight. The bill itself is a gray blue created from black, white, and a touch of Payne's gray. There is a slight purplish iridescence to the cheek in the lesser scaup, but this detail is much more pronounced in the drake. The greater scaup has a greenish iridescence, also more noticeable in the drake. Both the cape and the side pocket have a stippled, white detail that must be applied by drybrush rather than stroked in. The saucy, upturned bill of the lesser scaup gives it a Donald Duck look. Note how far the side pocket extends upward on the hen scaup and how the flow of the feathers sweeps to the rear and upward. The warm color of the breast can only be achieved if the undercoat is carefully applied—burnt umber, black, and white, with touches of burnt sienna create the polychromatic effect required. The head is a considerably darker brown, and the cheeks are touched with the purplish iridescence typical of the species.

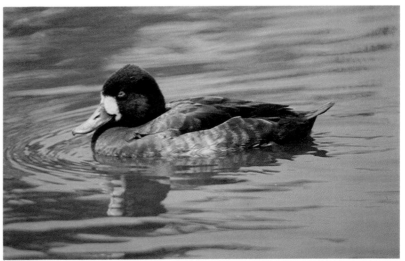

168

(169) Another angle to illustrate the sweeping curves of the side pocket and the crownlike aspect of the head. All in all, a beautiful little specimen, but seldom carved and painted.

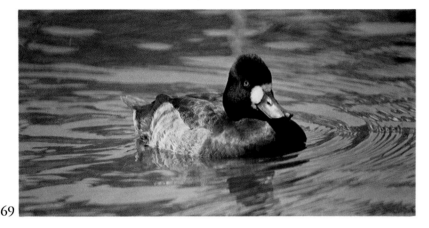

169

(170) The breast of the hen scaup, like the breast of the hen ringneck, requires at least three colors with a touch of a fourth. The first wash should be a burnt umber and black with a touch of white, increasing the percentage of white as you proceed to the rear of the bird. Permit this to dry thoroughly, then come back and create the dark swatches of burnt umber and black; highlight with raw umber and yellow ochre. Allow this to dry thoroughly, then pull in the streaks of pure white by drybrush from the back of the bird to the front.

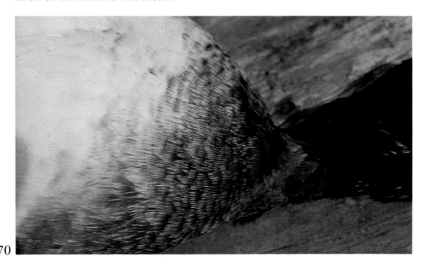

170

(171) The back of the hen scaup is more stippled than vermiculated. The undercoat is burnt umber, black, and white. This gives you a rather purplish brown that must be allowed to dry thoroughly before coming back with a stiff bristle brush to effect that white, snowlike appearance on the back. As you approach the front of the bird, you should get a slightly warmer effect, more brown than purple. The addition of a little yellow ochre while the paints are still wet will create the color you are seeking.

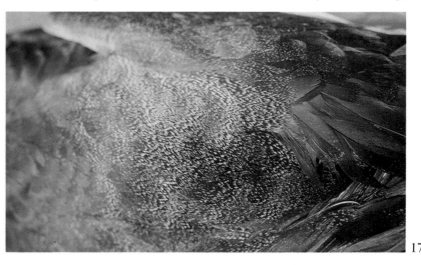

171

(172) The pallet required for the shoulder and lesser coverts is burnt umber, burnt sienna, black, and white. Touches of yellow ochre are applied while the undercoat is still wet. The white highlighting is pulled from the rear of the bird to the front after the undercoat is dry. The stip-

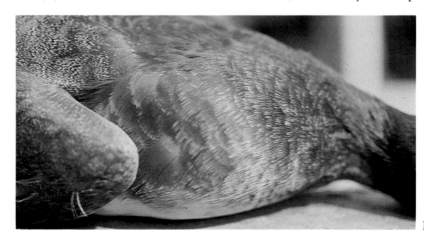

172

pling of the shoulder should also be completed after the undercoats have dried. The highlighting of this bird can make or break the carving.

(173) The side pocket, scapulars, and primaries of the lesser scaup hen show an entirely different vermiculation than that on the drake and are much more polychromatic than the colors on the hen ring-necked duck. The pallet required is black, white, burnt umber, and yellow ochre. The base wash of the scapular should be burnt umber and black, gradually washing in an increasing amount of white with a touch of yellow ochre as you approach the side pocket. After this blend of colors has been allowed to thoroughly dry, come back for the detailing of the vermiculation. Use

an interspersed pattern of black and burnt umber on the scapulars. The stippling is rather pronounced on this particular specimen, which appears to be in full nuptial plumage.

(174) It is interesting to note how dramatic the contrast is in a bird colored solely with earth browns and white. In this photograph one can see the softness of the vermiculation in the wing, the contrasted edging of the shoulder coverts, and the tonal variance of the cape.

(175) The wing of the hen scaup illustrates the direction of flow of the alula (bastard wing), the lesser coverts, the middle coverts, the greater coverts, the secondaries and the primaries. If you are carving a flying or a hanging bird with its wing extended, this photograph should be of invaluable help. If you create the right modeling of these feathers by burning techniques and texturing, your painting will be greatly simplified. The interfaces of the edge of the speculum are softly blended with a dry brush. Be sure to wipe the brush on a clean rag every few moments or you will destroy the effect you are striving to create. The leading edge, where the greater coverts overlay the secondaries, is a much sharper delineation of color. The lesser coverts and the middle coverts are both stippled with white, the underlying coat being burnt umber, black, and white. Note the delicacy with which the burnt umber is blended into the white of the primaries. This must be accomplished while the white is wet, using a dry stiff bristle brush and wiping clean every few moments.

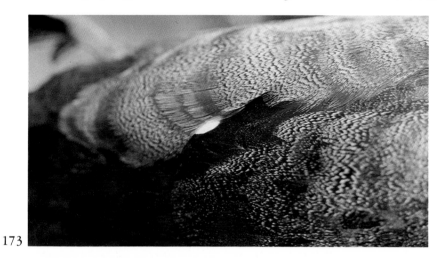

173

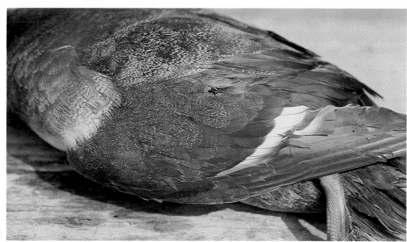

174

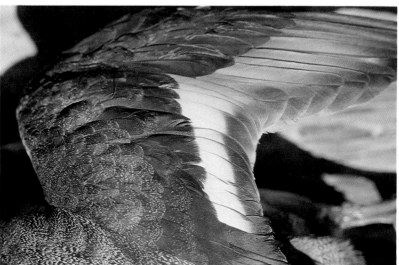

175

# 14

## Shoveler

### DRAKE

(176, 177) Probably no duck is more scorned by the hunter and more attractive to the artist than the shoveler drake. The initial coat on the bill would be lamp black with just a touch of raw umber added to give it a slight mottling of color. As on all waterfowl, on all parts of the anatomy, color is not monochromatic. Your pallet will have to be expanded considerably to paint this bird. Thalo blue and black with a touch of cadmium yellow (light) create the green shown in the throat area, and are also required for the head. The back is burnt umber and black with a little yellow ochre and white dragged through while still tacky to create the variegated color. The side pocket requires burnt umber, burnt sienna, yellow ochre, and white. The little blue patch is actually a portion of the wing coverts. It is not the speculum. The speculum is a dark green mixed from prussian blue and cadmium yellow (light). The primaries, the up-

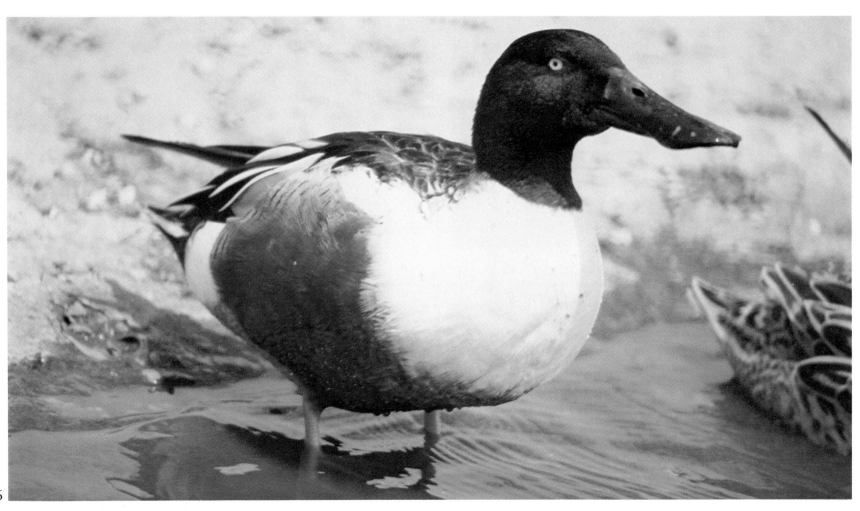

176

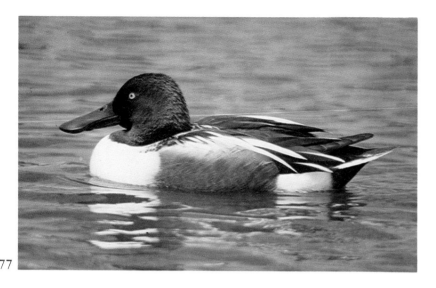

177

tertials and the scapulars coming out from the cape should all be very carefully noted. On the edges of the spikelike scapulars and tertials there is a thin border of dark green which should be created with thalo blue and just a touch of cadmium yellow (light). This is the same color that those upper tail coverts have. Like the drake mallard, the reflective aspect of the head and the upper and under tail coverts can cause the color to change from a deep green to a deep blue as the angle at which the light strikes the feathers varies. You can create this effect with a little practice. Mix the green and blue cast of these areas with black and burnt umber.

(179) Photograph 179 gives a good "at rest" pose for this specimen. We have already described the color in intimate enough detail; anything further would be superfluous. But it is fascinating to see the variety of positions a waterfowl can achieve by moving the groupings of feathers in each posture. The area between the side pocket and the breast shows very softly here. You can see how the white should be pulled over the side pocket with a fan blender after the side pocket is dry. It is a very good idea to be working on more than one bird at a time, as frequently you are inclined to rush into a color that has to be pulled over another color before the area has been allowed to dry. Pulling colors prematurely can frequently create a very muddy ground.

per tail coverts, and the under tail coverts would be created with black, burnt umber, and a touch of white to highlight. The tail coverts themselves are not a pure black, but should be highlighted with thalo blue. This is very similar in color to the upper tail coverts of the drake mallard.

(178) Notice how warm the color is in the primaries. The delicate vermiculation required on the edges of the side pocket, the junction of the under tail coverts and the rump, as well as the scattered pattern of the

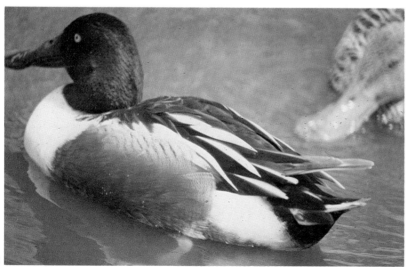

178

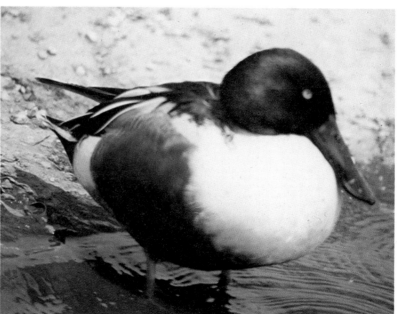

179

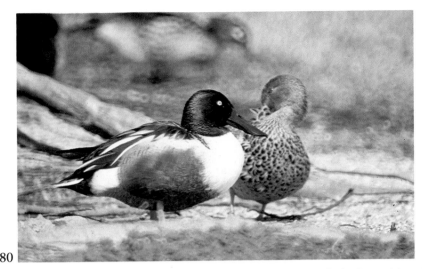

180

(180) Note the change in posture and profile that the drake has achieved —the full rounded curve of the back, the breast, and the belly, and the secondary curve of the under tail coverts. Also observe the richness, variety, and shade of colors as well as the soft manner in which one color blends into another.

(181) Note the inner color of the bill and the whitish pink nail. This specimen is a juvenile, but the colors of the lesser coverts, the speculum, and the feet are so brilliant that I thought it well worthwhile to take a

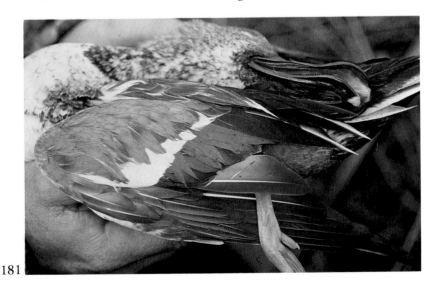

181

close look at them. The feet would require that you expand your pallet, adding cadmium yellow, cadmium orange, and burnt sienna to achieve this reddish orange that is so diagnostic of the species. The green of the speculum is created with thalo blue and cadmium yellow (light). The blue of the coverts, with Payne's gray and white.

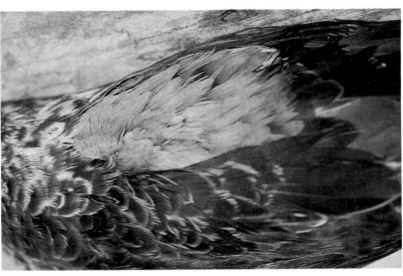

182

(182) Take a close look at the detailing you can achieve with your burning iron to create the cape and the curved flow of the feathers of the lesser wing coverts. Note how the feathers of the cape vary in form. Not only are the feathers irregular in shape, but note the difference in tonal values that must be created from one feather to the next. The color of the feathers varies from an almost pure black touched with burnt umber on the center of the feather, to yellow ochre and white on the edging, applied while the center of the feather is still wet. This allows you to pull the burnt umber into the yellow ochre and white and create this soft, highlighted edge.

(183) This is a macro detail of the speculum, the greater coverts, the middle coverts, and the lesser coverts. Note that the middle coverts are edged in white and the greater coverts are pure white. The speculum is a combination of very rich greens, half of the feather being burnt umber and black, the spline being a pure white, and the other half of the feather being created with thalo blue, cadmium yellow, and a touch of bronzing powder.

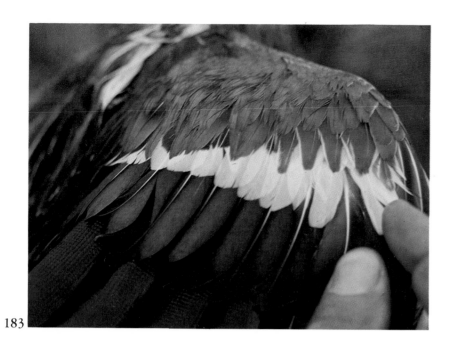

183

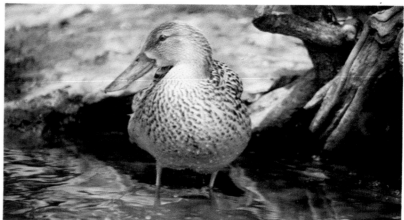

184

## SHOVELER HEN

(184) The hen shoveler brings us back to the muted earth colors again. Burnt umber, black, white, and yellow ochre predominate, with a touch of burnt sienna and a small dab of cadmium orange to color the legs and mottle the bill. Note the brushwork that is required on the crown. After the undercoat has been applied and allowed to dry thoroughly, you are going to use an awful lot of burnt umber and black to detail this bird. The undercoat should be washed in with an amount of Grumbacher I medium adequate to fill all of the fine burned lines, using white with a touch of burnt umber and black, and a highlight here and there of yellow ochre. All of these colors have to be irregularly applied so that the undercoat will appear to be swatches of various shades of earth tones with no sharply delineated lines separating them. Now come back and try to create the detail of the cape and the side pockets. If the bird has been properly carved and the feathers have been laid out correctly, painting will be a great deal simpler. If you have given these feathers a fish-scale effect and have failed to notice their irregularity in size, look out.

Notice how brilliant the lower mandible appears. Cadmium orange is the base color—cadmium yellow (light), burnt sienna, and white are pulled in while the cadmium orange is still wet. Notice how buffy white

the throat is and how it lacks the finely marked lines and dots of raw umber that the individual feathers of the rest of the head require. Note at the throat that the little dark centers of the fine feathers of this area gradually expand and become much more broken in pattern as they approach the breast. The breast itself requires burnt umber, burnt sienna, yellow ochre, and white. The darker areas require small amounts of black to achieve a greater degree of contrast.

(185) The same colors are apparent as this little shoveler hen quenches her thirst in a shaded pond. Note the full curves and almost perfect cylinder that her body obtains. When afloat the belly flattens out, but the portion of her body that remains above the surface of the water forms an almost perfect half circle.

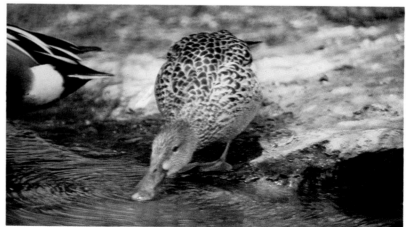

185

(186) An excellent rendition, always useful, is a shot showing the throat and lower mandible. Note the spatulate effect of the shoveler bill and the bright cadmium orange that is the basic color of this bird's legs and bill. Note the soft raw umber and white of the throat blending into the breast. Note the irregular pattern of the breast feathers, highlighted with burnt umber, black, and yellow ochre. The buffy undercoat should be allowed to dry before attempting to highlight either the throat or the breast.

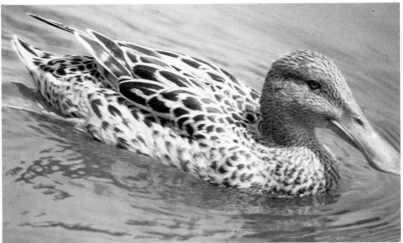

187

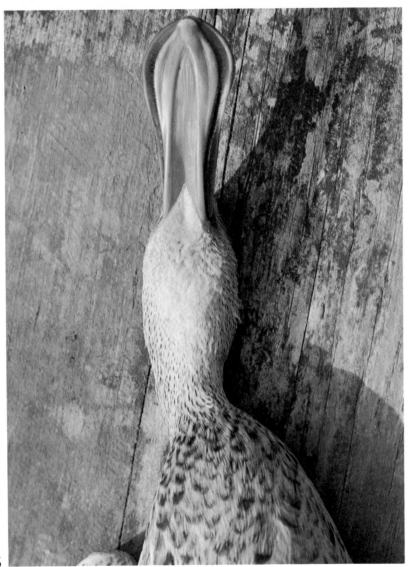

186

(187) Note how much lighter this specimen appears than the preceding bird. This is due to two things: the normal variance from one specimen to another, and the effect of direct light on reflective color. The feet and bill do not reflect the bright cadmium orange that is typical of this bird. There is a dark burnt umber and black ring around the eye, and the detailing of the head requires a very fine use of a #1 sable brush with paints that have been thinned to a degree of consistency such as will prevent them from building up on the carving. The side pocket detailing can best be affected by drybrush with burnt umber and black. The cape, the scapulars, and the tertials require a much sharper line between the darker sections and the light, but must still be blended at the interface of the contrasting colors. To soften this line between the interface of colors, a dry brush can be lightly pulled across the two colors, while still tacky, in the direction of the burns, that is, from the front of the bird to the rear.

(188) Although this photograph was primarily meant to demonstrate the way the feather groupings on the hen must be effected, it would be worthwhile to examine the difference in the color of the heads of the two drakes in the background, as this is an example of the effect that reflective light creates on color. One section of the head appears to be green, another section blue. As the bird quietly turns from one angle to another, these blues and greens can very quickly flash from one shade to the next. The spatulate shape of the bill from above, the delicacy with which the nape of the neck works its way into the cape, and the irregular shape and size of the feathers of the nape and cape are clearly illustrated here.

188

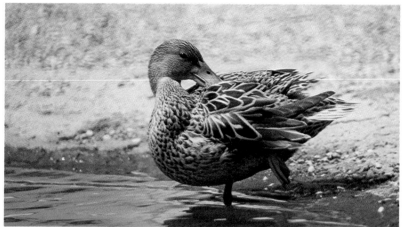

190

(189) The hen shoveler requires more attention to the detail of the bill than probably any other specimen. Use burnt umber pulled into cadmium orange. This is the underlying base color and illustrates one of the details most necessary to develop. The crown of the head also should be carefully observed. Note the use of burnt umber and black, interspersed in fine streaks, working its way into the nape of the neck and the cape. A limited pallet on a buffy undercoat, which should be allowed to dry thoroughly before attempting to detail.

out, the perfect balance achieved over the single leg, the bulge in the area where the neck is twisted to get the bill into the back area—all of these details serve to create a magnificent model for the ambitious waterfowl carver.

(191) Looking closely, you'll see that here the same bird has not completely hidden its foot in the side pocket. This photograph illustrates a variety of features—the richness of color, the sharp angles created by the spatulate shape of the bill, the colors of the edges of the scapulars and the tertials in contrast to the burnt umber and black of their centers, and the magnificent pattern of the breast feathers as they work their way into the side pocket.

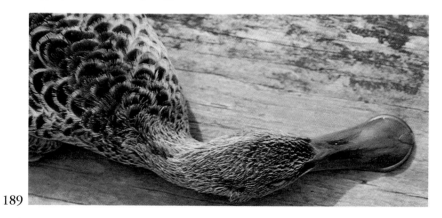

189

(190) I am particularly fond of this photograph, because just when we think we have seen every possible pose a bird can assume, a new one appears in the view finder. The foot raised under the outstretched wing as the bird preens, the bill buried under the scapular, the tail feathers fanned

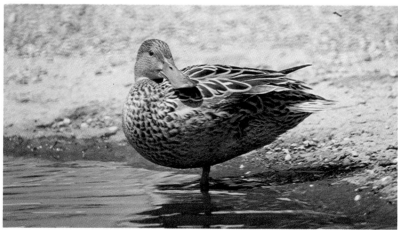

191

# 15

## Blue-Winged Teal

### DRAKE

(192) The blue-winged teal drake is one of the favorite birds of the Louisiana hunter and the Louisiana gourmet. The *praetonier* (or *printanier*, archaic French for "early" or "springtime") of the Cajun hunter, the springtime blue-winged teal is one of our most colorful marsh dwellers. Again we must have a rather ambitious pallet to copy the colors this bird displays. Let's start off with the undercoat, liberally applied with Grumbacher I medium. The bulk of the undercoat would be white with touches of burnt umber and yellow ochre, increasing the amount of burnt umber and black as you approach the back of the bird. There are irregular swatches of burnt sienna worked into the belly and the side pockets and the breast; care should be taken, as always, to eliminate any interfaces that might be created by layering your paint. This should be allowed to dry thoroughly before commencing the detailing. The bill itself is almost a pure black, with just a touch of raw umber added. The darker portion of the head should be pulled into the titanium white of the crescent-shaped

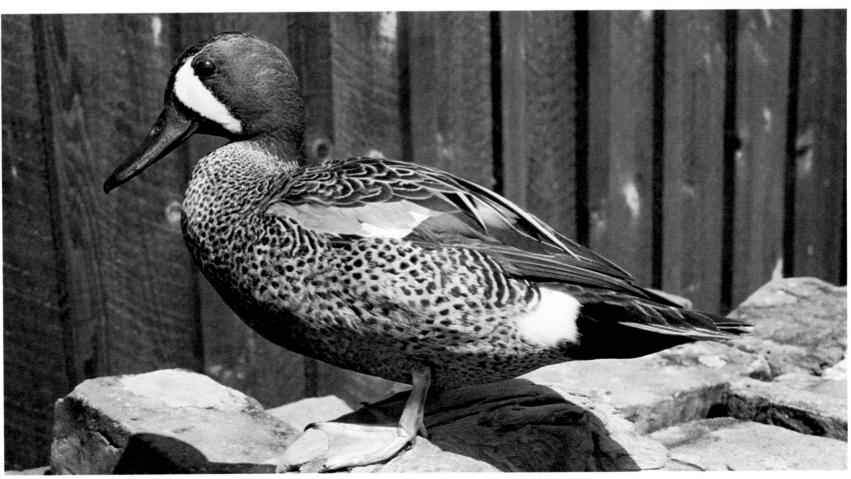

192

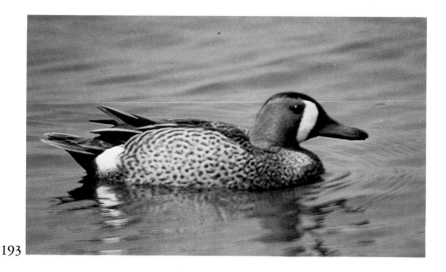

193

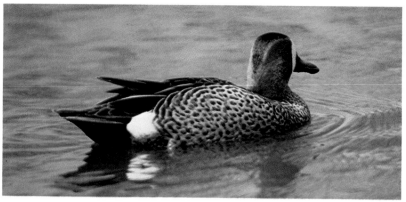

194

patch in front of the eye. The head itself is mostly burnt umber with a touch of Payne's gray and black. If you highlight with a touch of ultramarine red, you will create that rich purple shade that makes this bird so distinctive in the marsh. Having created the colors of the head, I would now proceed to the darker portions of the back, working toward the tail.

(193) The purple blue on the head that you tried to create is very apparent in this photograph. The light is striking the side pocket directly, and rather than burning or carving individual feathers in this area, I would suggest texturing with a fine Carborundum-type grinding wheel, turned to as high a speed as possible. If you prefer, a burning tool can be used, but rather than burning individual feathers, create a hairlike flow of feathers, almost as though you were creating one large feather for the side pocket. The detailing of the pocket should be applied by drybrush with a stiff bristle brush, using burnt umber and black. These dark spots can also be applied with a sable brush. Then, using a dry bristle brush, wipe clean with great regularity to soften the interface of the colors.

(194) Before you begin detailing, notice how warm the undercoat of the side pocket is and the variety of tones that are created there. The back of the head is excellently illustrated, showing how dark the crown is in contrast to the jowl and the mane. The burnt sienna and yellow ochre give you that warm golden brown that can be lightened, where required, with white. Note the almost pure white of the flank patch. The side pocket overlays this.

(195) The side pocket of the blue-winged teal is frequently raised to almost cover a large portion of the scapulars and the tertials, which is very apparent in both this and the preceding photograph. Note in the "at rest" position how deep-seated the head becomes, the tip of the bill barely extending past the curvature of the breast. Again, we would apply each of those dots on the breast using burnt umber and black with a sable brush and then softening the interfaces with a clean, dry bristle brush. The bright yellow of the feet and legs would be created with cadmium yellow (medium) and a touch of burnt sienna. The breast of this bird is extremely difficult to paint, mainly because the patterns are so irregular. Dick LeMaster told me that with a bird of this type you are again in the situation where you almost have to decide whether you are painting for competition or for realism, as the irregularity of the real bird will generally not win competitions. Some of the dark dots on the breast should be lightly washed with a buff-colored pass from a fan blender.

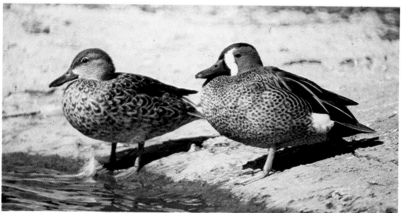

195

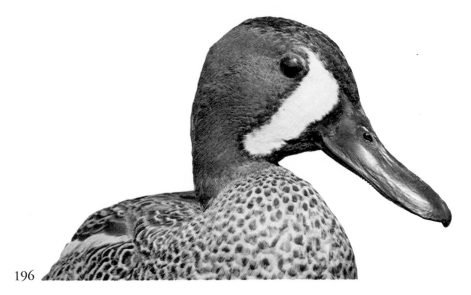

196

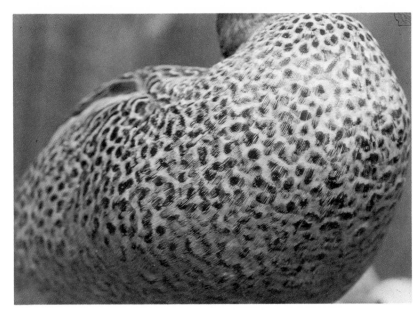

197

(196) The head and breast of the blue-winged teal drake require a pallet that is rather extensive—black, white, burnt umber, Payne's gray, yellow ochre, burnt sienna, and ultramarine red to create that purplish cast on the cheeks. Once again, the establishment of a satisfactory ground by burning or texturing can make your painting a great deal simpler to accomplish. I would lean to texturing with a high-speed abrasive wheel in the area being studied in this particular specimen. Note that the bill itself has a leathery texture rather than a smooth one. The white cheek patch is not a half-moon as it appears in flight when viewed in rapid-fire motion, but an irregular swatch darkly bordered with black, which pulls into the purplish black iridescence of the cheek and neck. The topknot itself is a mottled mixture of black and burnt umber, highlighted with white. The base coat of the breast and the side pocket is burnt sienna, yellow ochre, and white. The spots are applied with pure black and permitted to dry thoroughly. Then the base colors are reapplied and pulled with a fan blender over portions of the black spots.

(197) Note how warm the undercoat can be, particularly on the belly of this bird. Burnt sienna is pulled into the white, with a great deal of patch variance between the throat and the belly. The black dots in this area are touched with burnt umber and then dragged through with a fan blender, by drybrush effecting a buff-white. This is the correct method for the upper breast area, but this technique can also be exceedingly frustrating. The smallest excess of white can cause a muddy base, in which case you would have to start off again at square one.

(198) The variety of shades required of the few simple earth colors could nowhere be better illustrated than in this photograph. The combinations, burnt umber with black and raw umber with white, are mixed in a never-ending variety of percentiles to create the basic colors required for these feathers. The manner in which the mane works its way into the scapulars and the scapulars into the tertials, the manner in which the primaries cross, the high angle of the side pocket, the blue of the wing coverts, and the green of the speculum all offer a real challenge to the painter and to the carver.

(199) This photograph is illustrative of the wide variety of patterns that one specimen can reflect in comparison with another. I will always remember the remarks of judges who saw their first springtime teal in its nuptial plumage (down here in Louisiana) and would not believe that any bird of that species could have the colors it displayed. The layout of the back area of this particular specimen is soft and muted with a great deal of half tones of earth green, burnt umber, raw umber, and yellow ochre. Touches of burnt sienna appear here and there. Frequently the darker umber pattern of these birds creates greater contrast than in this particular specimen.

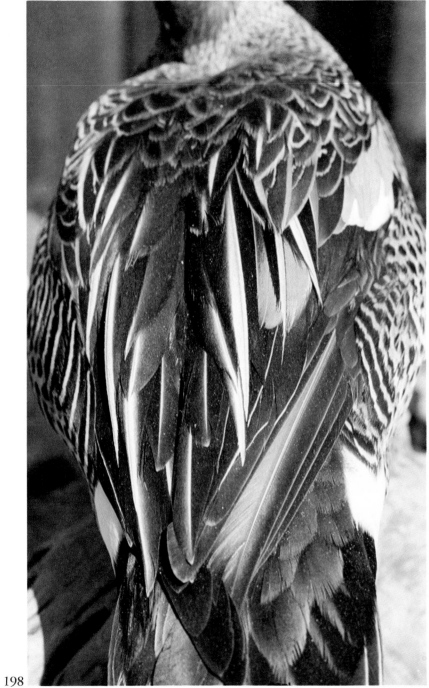

198

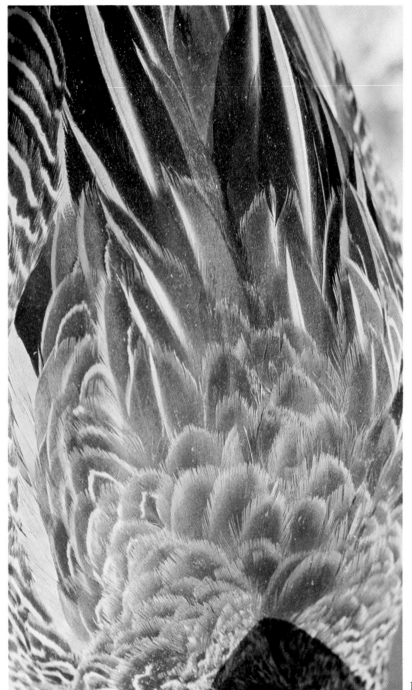

199

89

## BLUE-WINGED TEAL HEN

(200) A profile of the blue-winged teal hen shows, again, the muted earth colors common to the pintail hen, the mallard hen, and others of the puddle ducks. Your pallet consists of burnt umber, raw umber, burnt sienna, yellow ochre, black, and white. The leathery texture of the bill, not nearly as black as the bill of the drake—I describe it as more of a waxy brown—is created with black and burnt umber, the lower mandible being highlighted with yellow ochre to the rear. Although the pallet required is very limited in variety of color, a number of brushes would be helpful in creating the effects these colors produce. A #1 sable, a #3 or #4 sable, a stiff bristle brush, and a fan blender would all be used, each according to the type of application required in a particular area.

201

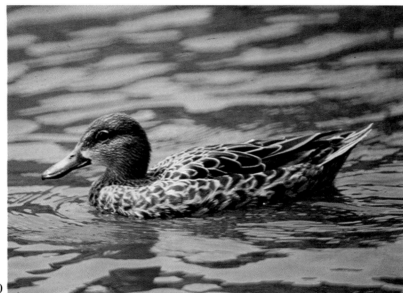

200

(201) The bill of the blue-winged teal hen has a much lighter color than the drake. Where the drake's bill is a blue black, the color of the hen's bill is created with burnt umber lightened with white, and a touch of yellow ochre pulled from the lamellae into the edge of the upper mandible. While still tacky, small black dots should then be applied to the side of the upper lamellae, working almost to the nail. The base color for the head itself is a buff created with white touched with yellow ochre and burnt umber. Very lightly colored, it is more a fawn or off-white than anything else. Now, note the manner in which the spots or streaks must be added. There is no regularity to the pattern. Spots appear to go helter-skelter in all directions and should be applied almost as dots to the front of the head, getting longer and longer as you approach the neck and the cape. Also, it is well to note that the undercoating itself should be given some color variance, yellow ochre or burnt umber predominating in various areas and, while still tacky, the spots being applied with black and burnt umber. Note that the lore (the streak that goes from the base of the bill through the eye) is more fawn-colored and less streaked than other areas of the cheek. Note that the topknot is much more densely streaked, almost appearing to be a blue or purplish black, but when observed closely, found to be a multitude of tiny streaks and dots. If done carefully, wet on wet, the effect will be much softer, but one must be careful not to establish a muddy ground by a superfluous use of medium. Another technique for softening this effect would involve the use of a clean bristle brush to stipple the wet markings, but wiping clean every few moments to prevent muddying the field.

(202) A view of a larger area, showing the deep bronze green of the speculum edged with white and touched with burnt sienna. Note how the edges of the greater coverts are pure white, but each individual feather of this grouping is a different shade of blue.

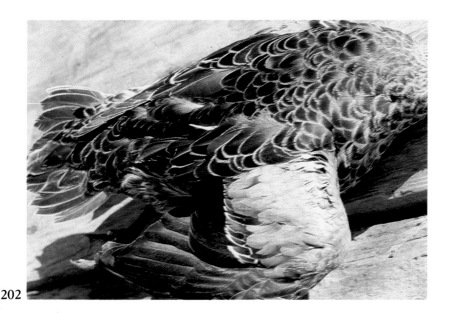

202

(203) This photograph should be very useful to the carver who is trying to figure out how to fair in the wing of this bird, using the scapulars as a fairing agent and showing how the lesser coverts, the middle coverts, and the greater coverts finally overlay the speculum.

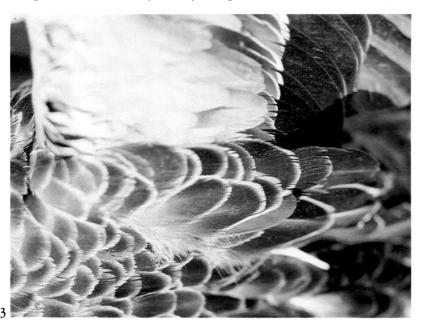

203

(204) The mane works its way here into the regular feathers of the cape. The burnt umber, burnt sienna, and yellow ochre are used in varying quantities to give the diverse shades that separate one feather from the next. The feathers gradually increase in size as they leave the mane and approach the scapulars.

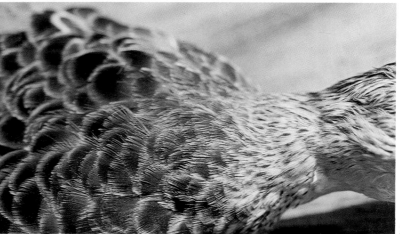

204

(205) The under tail coverts shown here are burnt umber and black. The underside of the tail feathers are raw umber touched with white. Note, as usual, the multiplicity of tonal values that these three simple earth colors can create. A touch of yellow ochre here and there highlights the edges of the tail feathers. This is blended, while the undercoat is wet, with the umber.

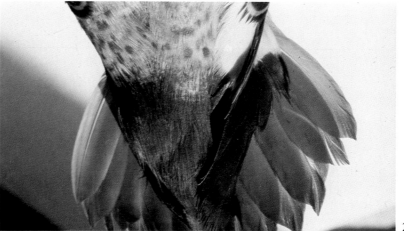

205

(206) In this photograph we see the use of burnt umber and black, applied with a sable brush, and the interfaces softened with a clean bristle brush. The pattern is much more distinct where the breast works its way into the belly.

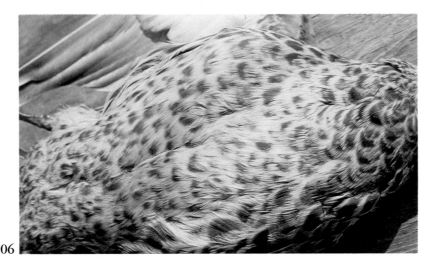

206

(207) The shoulder coverts are created with Payne's gray and white. Note the touches of white and burnt umber on parts of the greater and lesser coverts.

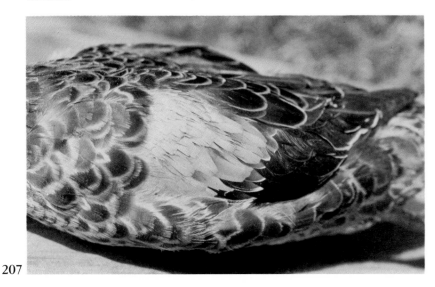

207

# 16
## Green-Winged Teal

### DRAKE

(208) A fine overall view of the green-winged teal drake. An excellent example of the crest, showing the richness of the eye patch and its surrounding area. Your pallet includes burnt sienna, thalo blue, cadmium yellow (light), black, white, yellow ochre, burnt umber, and raw umber. The vermiculation irregularly works its way into the breast. The dark spots on the breast are burnt umber and black with white, applied with a

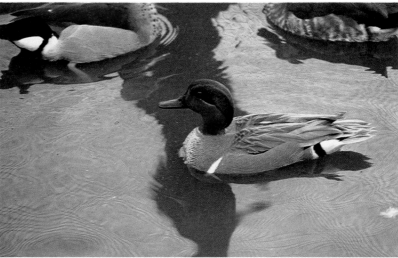

208

fan blender over portions of this area. The creation of the ground for the vermiculation would best be done by washing in your undercoat with raw umber, black, and white. Allow it to dry thoroughly before commencing the detailing—then apply the vermiculation with raw umber and black, then with white. Just the barest amount of yellow ochre should be added to the white. On the breast itself, the undercoat is a richer color than the vermiculated area. Here you would use burnt sienna, irregularly applied in the initial wash of white. Some sections should also be washed with a little burnt umber. Some of the black spots are much more apparent than

others. Some of the spots appear obscure because they have a layer of feathers on top of them. The use of the fan blender, allowing sufficient drying time between applications, is critical in creating this area.

(209) The breast of the green-winged teal drake should be very carefully observed. The hairlike overlay of the feathers must be copied in stages if the rendering is to be realistic. We have described in sufficient detail in other photographs the creation of the basic vermiculation. Let us concentrate in this photograph on the creation of the interfaces, by a succession of washes applied as layers of color. The base coat of the breast is burnt sienna, yellow ochre, and a small amount of burnt umber and white, applied with a large amount of Grumbacher I medium to create soft, but very tonal values—no sharp edges, no feather patterns, just blotches of blended colors in the area to be detailed. Now you are ready to apply the vermiculation and the black and burnt umber spots on the breast. The vermiculation works in an irregular pattern around the area of the neck and into the shoulder and part of the breast. Next apply the black spots and permit them to dry so they won't smear in the following stages. Come back, preferably the following day, with your same base coat colors on one or more fan blenders. I prefer to use two, as it is a little more rapid. Lighten with white and pull over parts of the breast area, including the vermiculation and the dark spots. Note that many of the dark spots are completely overlaid with the hairlike edges of the feather on the step shingled above. If you took a fine knife and lifted these white feathers, you would find that the spots below were an almost pure black or pure burnt umber.

(210) The photograph here illustrates a frightened bird. The colors are good and the pattern of the feathers of the head can be clearly seen. The eye patch is seen to be a blending of burnt umber and black, and thalo blue and cadmium yellow (light). A little raw sienna touches the white to produce the edging that separates the interface of the green eye patch from the rusty sienna of the rest of the head.

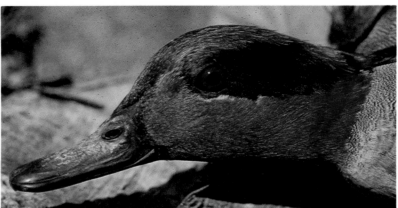

210

(211) The white band on the side of the green-winged teal is actually the culmination of the side of the breast and the beginning of the side pocket. The vermiculations of the leading edge of this white patch gradually cease, and then resume on the far side of the white in a similarly delicate fashion. The base of the white streak fades into the belly with additional burnt umber and black vermiculations applied.

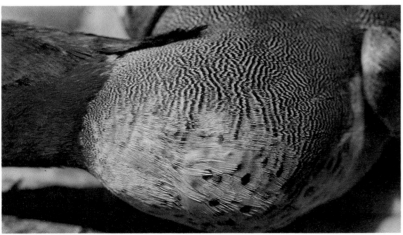

209

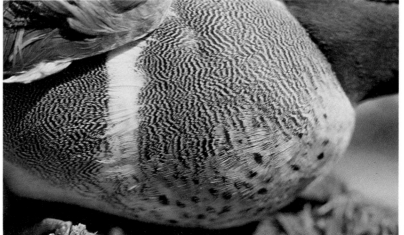

211

(212) This specimen is an immature bird. Usually the black spots proceed much further back into the abdomen, but I think you can see very clearly that the light overlay of white feathers causes the burnt umber and black spots to virtually disappear in certain areas. If you lifted up this overlayer of white edging, you would find a quite distinct burnt umber and black spot underneath. The use of burnt sienna, yellow ochre, and raw umber in occasional patches of this area is apparent.

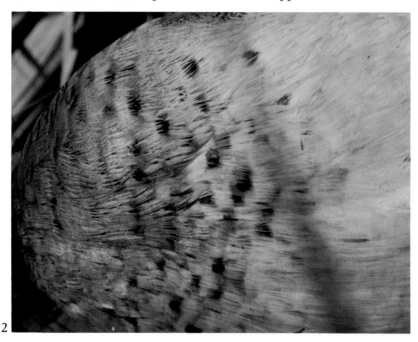

212

(213) There is no way to avoid spending a tremendous amount of time if you are to accurately reproduce the vermiculation that appears in the cape and in the side pockets of the green-winged teal drake. The base color should be the one that prevails if you look at this photograph with your eyes squinted, almost shut. While squinting, you will see one color rather than the detail apparent with both eyes open. I think you will agree that in this case burnt umber, yellow ochre, and white, toned down in certain areas with a touch of black, will create your ground. Now, while still tacky, using a Grumbacher III medium, which is slow drying, begin to apply the white with a #1 sable brush, varying the density and breaking the pattern of the vermiculation as you approach the central portion of the back. As the vermiculation works its way into the central back

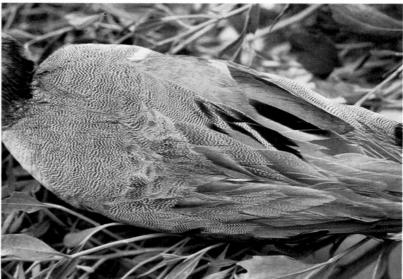

213

area, a great deal more stippling and blending than positive strokes are required for the cape. The vermiculation itself proceeds on the outer edge of the back as the wings work their way into the side pocket and into the speculum itself; but note how the edges of the greater coverts create an interesting pattern of black. In contrast, as you proceed into the primaries and secondaries, mostly white, burnt umber, and touches of black and yellow ochre give you the variance of tonal values that must be created. While all of this is still tacky, come back with the light stippling that is apparent on the rear edge of the greater wing coverts.

(214) The establishment of the ground for the vermiculation of the side pocket shows more yellow ochre in this specimen than I have generally seen, but it is there nonetheless. Note the little touch of burnt sienna and white that precedes the leading edge of the speculum. Note the break in the pattern of the vermiculation on the shoulder. This can be created by using a stiff bristle brush, after you have applied the vermiculating pattern, to pull the colors into a rather muddy ground. This has to be done quite gently in order to achieve the effect, but it is a detail that will be most rewarding in the finished bird. The delicacy with which the spots of the breast are applied and the broken pattern which they create are established in nature by the hairlike pattern of these breast feathers overlaying the spots themselves. If you took a knife edge and lifted these overlaying feathers, you would find that the spots were quite dark—burnt umber

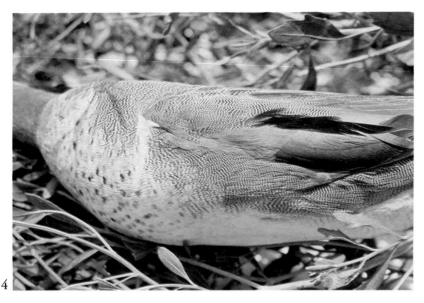

214

and black. The lightness is created by the overlaying feathers, causing some of the spots to appear almost fugitive. Skipping to the area where the belly approaches the rump, note the broken pattern created by stippling in black and burnt umber while the white base coat is still wet. A very challenging bird, but a magnificent example of nature at its best.

**GREEN-WINGED TEAL HEN**

(215) This little green-winged teal hen is frightened! Notice the erect positioning of the head, the wide open stare of the eye, the raised angle of the primaries, and the flattening of the tail feathers. The color of the bill is black, softened with a touch of white and just a dab of raw umber and cadmium yellow (light). Pull your secondary colors through while the undercoat is still wet. Mark the lower mandible, and place little black dots in the lighter portions of the upper mandible while the bill is still wet.

(216) The crease that marks the lower jawline is very apparent in this photograph and is a detail frequently overlooked. The buffy off-white color of the throat, the black, irregular splotches on the throat, the blending of the mane and throat into the breast—all are well illustrated with this photograph. Note the burnt sienna that must be pulled into the

215

216

breast feathers on an irregular basis. After these black streaks on the cheeks have dried, raw umber mixed with white can be used to apply the third color and to soften the effect of these dark markings.

(217) The extent of the pallet can be noted in this photograph. The mane and back area are burnt umber, black, and white, with occasional touches of raw sienna and burnt sienna. The greater coverts are a combination of burnt sienna, white, and yellow ochre. The speculum, black and thalo blue, highlighting the green area with a small amount of cadmium yellow (light) to achieve that iridescent green, which might be further highlighted with a touch of bronzing powder. The primaries are burnt umber and black on the dark side, raw umber and white on the light side. They are highlighted with white with just a touch of raw umber, graduating as you proceed to the outer primaries to black with a touch of burnt umber.

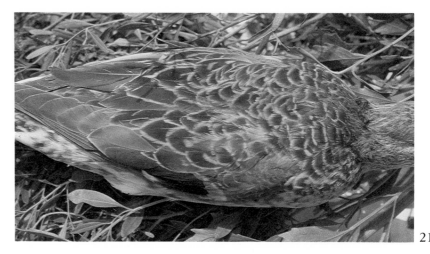

218

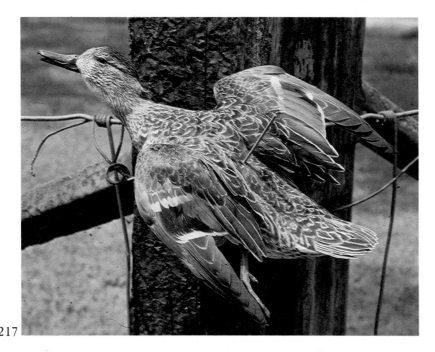

217

(218) This photograph is used to show the warm colors some specimens achieve. The cape colors can be obtained by the application of burnt umber, black, and white, pulled with a fan blender through the white of the edging. Note that some of the larger feathers of the cape contain an inner pattern of white touched with raw umber. Also, some of these feathers have a touch of burnt sienna highlighting the interface between the darker central portion of the feather and the tip. This bird has a little more burnt sienna in its color than the preceding specimen.

(219) An example with fine color balance of the numerous details we have discussed in the preceding slides. The full range of your pallet will be exercised in completing this area.

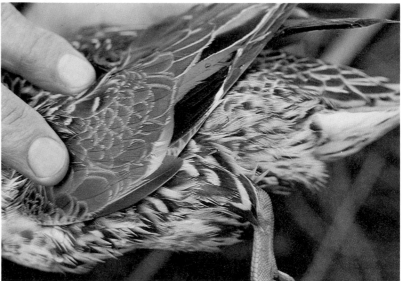

219

(220) The pearlescent quality of the bulk of the under wing coverts is accentuated by the ivory white of the greater underlying coverts and the soft blending of raw umber and black into the leading edge of the wing (lesser underlying coverts).

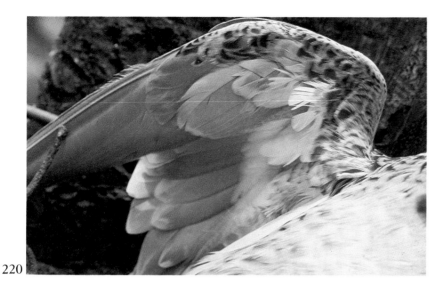

220

(221) This photograph illustrates the lesser wing coverts and the cape blending into the tertials. Note the secondary patterns that frequently seem to form an additional feather on some of the larger tertials. Note that these inner patterns seem to have a more vibrant hue, created with burnt sienna and yellow ochre.

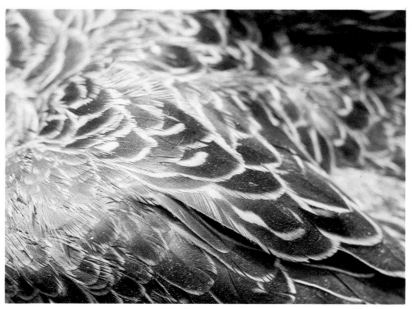

221

(222) There is always an argument with judges as to how many tail feathers should be shown and as to how the upper tail coverts and the oil gland coverts interact with one another. The photograph illustrating this example is atypical in that there is no regularity to the number or display of these feathers. Like the mantle, these feather groupings can be moved at will—in one specimen being spread, in another closed (almost coming to a point) and in a third, somewhere betwixt and between. The one thing that can be depended upon is that there will not be regularity to these feather overlays—the size, the shape, the color, and the texture will vary, not only from bird to bird, but from feather to feather. The center feathers, however, are two in number, not one. And the average bird will have an equal number of feathers on each side of these two. Sometimes the center feathers are so nearly overlying that they will appear as one. And, sometimes the taxidermist will arrange one central feather with an extra feather on one side or the other.

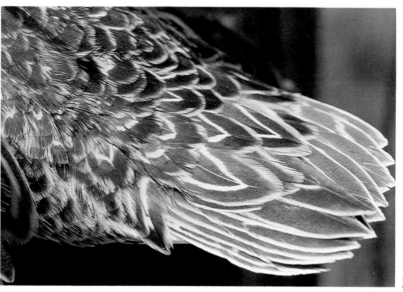

222

# 17

## Cinnamon Teal

**DRAKE**

(223) One of the most dramatic differences between the members of the teal family is the exaggerated length of the bill on the cinnamon teal. Although the hen could be mistaken for a green-winged or a blue-winged teal hen, the color of the drake in full nuptial plumage leaves no question as to its identity. The red eye is the other distinguishing characteristic. Most of these birds, photographed in Louisiana, have not reached full maturity and are mistaken for blue-winged teal in the immature phase. Get ready to use a lot of burnt sienna, burnt umber, and yellow ochre for this one.

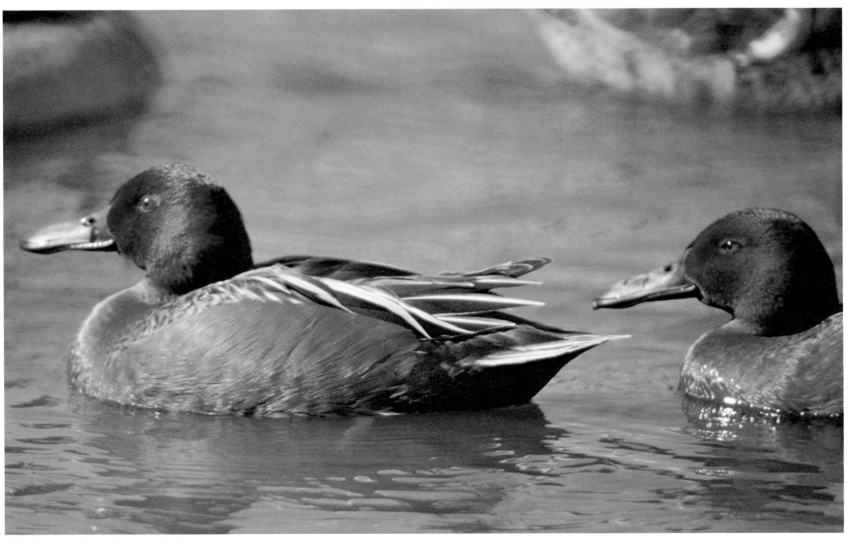

223

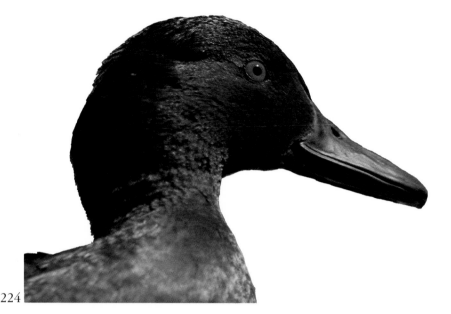

224

(225) An excellent example of the reason this bird can be mistaken in certain molts for the blue-winged teal. The lesser coverts and the middle coverts are Payne's gray with a touch of white and burnt umber. The splines of the feather can be put in with a very fine liner brush in pure burnt umber. The greater coverts are an ivory white.

(226) The foot of the cinnamon teal is cadmium yellow (light) with just a touch of yellow ochre and the barest touch of burnt sienna, lightened with white. The underpart of the foot is burnt umber and black; the web and the nail are a similar color. Note the edging on the scapular. This is burnt sienna, yellow ochre, and white thoroughly mixed on your pallet, carefully applied with a #1 sable brush, and the interface barely brushed with a clean dry sable brush.

(224) This photograph illustrates a number of salient features that should be observed. Note how the ear cover is accentuated. Note also the black of the eyelid and the gun-metal color of the bill. This can be obtained with thalo blue, black, and just a touch of white. The basic color of the head is practically pure burnt sienna. Add a touch here and there of black, and darken the crown by using more black and burnt umber than on the rest of the head.

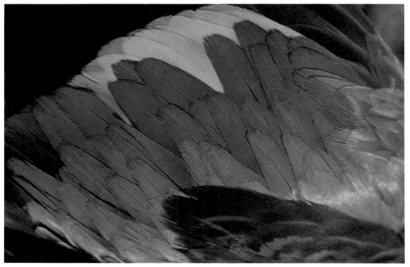

225

226

(227) One could hardly improve on the warmth and richness of the colors of the drake cinnamon teal in nuptial plumage. Payne's gray and white create the base color of the lesser wing coverts and the middle coverts. While still tacky, a touch of burnt umber pulled through in spots will give you a lovely effect. Note the richness of the burnt sienna, highlighted with yellow ochre and white, that is created in the side pocket. The flecks of black and burnt umber only tend to accentuate the rich tones required. The speculum requires a fair amount of bronzing powder, but the base coat for the speculum should be burnt umber and thalo blue. Then pull in a small amount of cadmium yellow (light) to create the green, highlighting with a touch of bronzing powder if you so desire. The white on the trailing edge of the speculum must be very gently blended with a sable brush to prevent the creation of sharp interfaces of color. Since the area is so minute, it is frequently necessary, after the bird has dried, to come back with a liner brush and rehighlight the extreme edge with pure white. The broken pattern of the greater coverts, as they work their way into the shoulder and into the cape, should be very closely studied. Notice how variegated the shading is—burnt umber and black, touches of yellow ochre and white, with detail in burnt sienna and yellow ochre. The real artistry is in learning to pull these feathers together and to create the softness that the actual specimen has. It isn't just a matter of getting the right colors. It is a matter of blending the interfaces and getting the tremendous diversity of tonal values rather than getting the paint-by-number effect that is created without pulling one interface into another. This is an area where burning can create a ground for the artist that is most helpful. If the feathers are burned in loosely and the edges are overlaid, creating the color is a great deal simpler.

227

228

(228) The breast is an almost pure burnt sienna, highlighted with yellow ochre. If you would like to give the breast that sheen you see here, a delicate use of white applied by drybrush followed with a bisque spray, will achieve it. The burnt umber and black begins to work its way into the area that connects the breast with the cape. The cape itself is a combination of a variety of all of the earth colors—raw umber, burnt umber, burnt sienna and black, highlighted here and there with a touch of yellow ochre.

(229) An excellent rendition of the color of the speculum. I would put in your first wash with black and a touch of burnt umber. Then towards the upper part of the speculum, add thalo blue and the merest smidgen of cadmium yellow (light) to achieve the green iridescence. A dab of bronzing powder would complete the effect. After this has dried thoroughly, I would edge the majority of the feathers of the speculum with white, blending the interface with a #1 sable brush wiped clean between each small segment of feather. The outlining of the feathers comprising the tertials is burnt sienna with a touch of yellow ochre. The interfaces are blended as in the preceding illustration. Note that the spline of the feathers is a white, fawn color. The spline would be a white line drawn in with a fine liner brush with just a trace of raw sienna added.

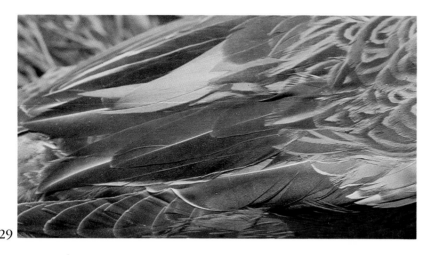

229

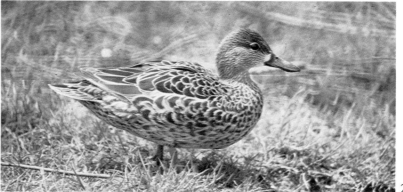

231

(230) We have described the method of obtaining the colors in all aspects of this photograph already, but the combination and interplay of the feathers and the contrasting of the interfaces is well worth another look. The detailing of the speculum, the detailing of the tertials, and of the scapular and the wing coverts are always due a few moments of additional contemplation.

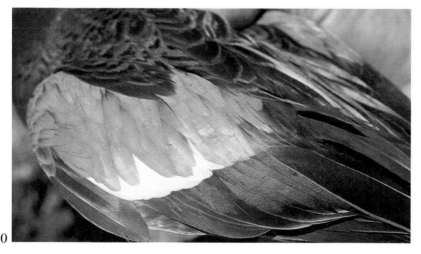

230

## CINNAMON TEAL HEN

(231) If it were not for the length of the bill, one would feel sure that this graceful little hen was a blue-winged teal. The exaggerated spatulate shape of the bill lets you know you are looking at a hen cinnamon teal.

(232) The size and spatulate shape of this bill almost make you think you are looking at a spoony. What an interesting little devil we have here. He looks like a bluewing in one shot and a spoonbill in another. The color of the bill is burnt umber and black lightened with white, with raw sienna and white used to lighten the edge of the mandible. The posture and shape of the head in this photograph show the bird in a state more frightened than relaxed. The streaks of burnt umber and black can be applied over the off-white undercoat. Allow this to thoroughly dry and then apply by drybrush the white around the bill and the throat area. The upper mandible is burnt umber and black. The white around the eye should be touched with yellow ochre. There is a dark streak in back of the eye, which blends into the darker crown and mane.

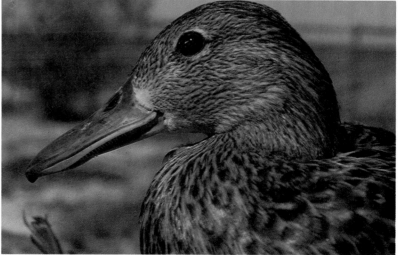

232

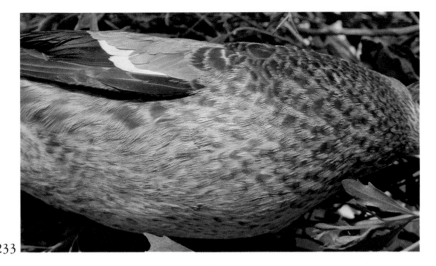

233

(233) The breast uses a similar pallet, but with the addition of burnt sienna and yellow ochre. Don't forget—wherever you have used burnt umber, a little yellow ochre will prevent you from getting that purplish cast that obtains when you merely lighten burnt umber with white. Note the lack of any pattern as the breast moves into the belly. The base coat is white darkened with burnt umber. Then, while still wet, use burnt umber and black to create centers of dark color in each individual feather. This should be applied by drybrush, using a stiff bristle brush.

(234) The cinnamon teal hen looks so much like a blue-winged teal that if it were not for the difference in the shape of the bill and head, one could frequently be confused. The primaries, the secondaries, and the cape are a muted combination of burnt umber, black, white, and a touch of yellow ochre. While still tacky, the addition of such details as a touch of sienna here and there, a fawn-colored feather spline, or a trace of an earth green would increase the value and perfection of the finished painting. The lesser coverts, as previously explained, are Payne's gray and white with touches of burnt umber pulled in while still tacky. Traces of pure white will give you the broken pattern you desire.

(235) The comingling of the feathers of the breast, the shoulder, and the cape can be observed in this example. Use burnt umber and black for the centers of the feathers, highlighted with burnt sienna lightened with white and edged with white touched with burnt sienna and yellow ochre. Note that a number of the larger feathers have a central pattern of burnt sienna, burnt umber, and black. Remember that where I have used colors such as burnt sienna, burnt umber, and black, they should be blended on the pallet and then applied with a sable brush. The interfaces are softened while still wet. In the event the colors are to be pulled or stippled, I have been quite specific about it.

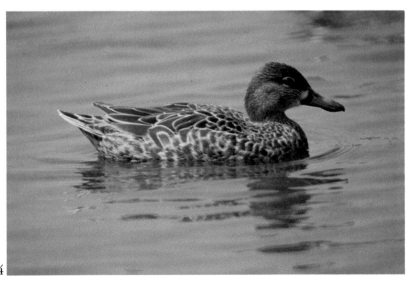

234

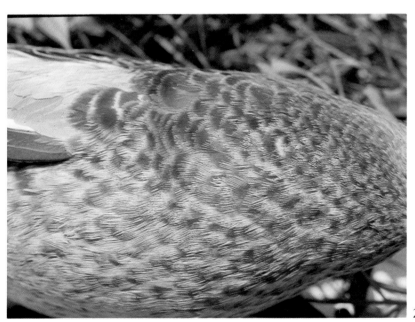

235

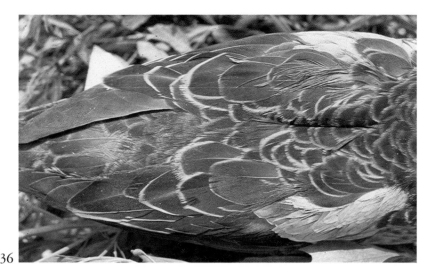

236

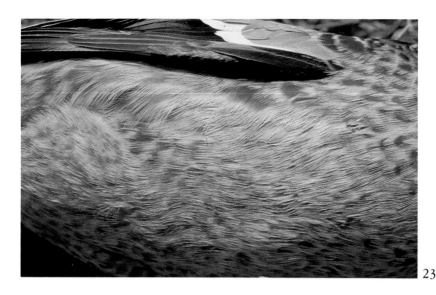

237

(236) We have described the color in sufficient detail, but take a closer look at the irregular shape of the feathers on the mantle, the back, the scapulars, and the primaries. Watch how the blue shoulder coverts are broken in spots by feathers from the mantle. Also note the broken pattern of the highlighting. The pallet here would be basically raw umber, a touch of white, and a touch of black. The edges of the feathers are highlighted with white barely touched with yellow ochre and raw umber, pulled in while still wet.

(237) Zooming in on the breast with a macro lense, you will notice the hairlike looseness and the broken colors on the edge of each individual feather in this cinnamon teal hen. This area can be better burned than textured to establish the pattern of the breast feathers and the broken hairlike effect that the ends of these birds project. Establish this carefully by outlining these features with a pencil. Then burn them in lightly, putting the greatest weight on the burning iron at the base of the feather and lessening the weight as you draw the burning iron to the edge of the feather. Your painting will be greatly simplified by this technique. The muted softness of the colors of the cinnamon teal hen are a counterpoint to her more lusty mate. The center of the feathers are black and burnt umber; the edges are burnt sienna and yellow ochre, lightened with white and pulled into the darker center.

# 18

## American Widgeon

**DRAKE**

(238) The American widgeon is not only a dramatically plumed bird, but one which is quite plentiful in the Louisiana marshes. The breast and side pocket of this bird defy more painters than any other color phase I have had to cope with. The shades you are trying to create should be mixed on the pallet from Payne's gray, alizarin crimson, a touch of burnt sienna, and white. The Payne's gray and alizarin crimson give you a pure purple; the addition of the other colors gives you a blend that is precisely the

color of the breast. When you are putting this onto the carving, it would be a good idea to pull, while wet, varying quantities of white, alizarin crimson, and burnt umber. This will prevent you from getting a monochromatic background. If you look closely at this area, you will see that it is in swatches rather than being a uniform color. The vermiculation of the side pockets will have to be applied over this effect, after it is dry. This photograph also gives you an excellent example of how to lay out the primaries, secondaries, tertials, scapulars, and wing coverts if you are doing a flying bird. An excellent positioning of the feet, head and tail feathers.

(239) The side pocket and thighs should be very closely observed in this photograph. The pocket base color is burnt sienna lightened with white and yellow ochre. Some burnt umber is added to the darker areas to produce the patchlike effects of color; in other areas the predominant additive is white. Then burnt umber and black are blended on your pallet and you are ready to draw in the lines of the vermiculation as finely and as delicately as you can. While still tacky, take a perfectly clean fan blender and pull from the front to the rear to create the hairlike interspersal of black splines into the burnt sienna and white. You will note that these vermiculations are a great deal straighter and more regular than on most birds.

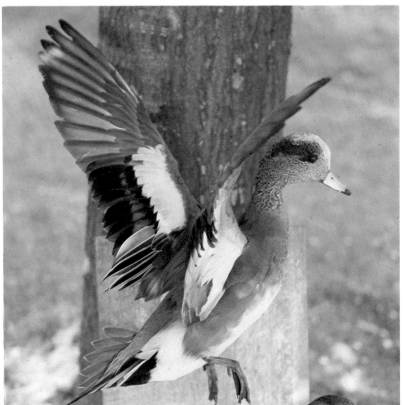

238

239

On the thighs the vermiculations are heavier, with an overwash. I would use a transparent overwash of raw umber after the vermiculation is thoroughly dry.

(240) Notice the interplay of the purple color of the breast feathers as they join the shoulder and the extreme white of the wing coverts. This is a very distinctive flight-pattern marker that sets the widgeon apart at great distances. The irregularity of the vermiculation in the back in contrast to the regularity of the side pocket is quite apparent here. Note the difference of pattern. Almost every conceivable combination of raw umber, burnt umber, burnt sienna, white, and black are included in this small area.

241

240

(241) The American widgeon is frequently called the baldpate. The reason for the name is obvious. The off-white of the crown is a soft blend of raw umber and white. The feathered base of the bill is a mottled black, burnt umber, and raw sienna with yellow ochre pulled in. The eye patch is a magnificent bronze green that pulls into the mane.

(242) Another specimen and another degree of variance in the colors visible as the oil gland coverts and the upper tail coverts blend into the tail feathers, including that spiked middle feather. Note how beautifully the raw sienna and white of some of the upper tail coverts contrast with the burnt umber and black half of these feathers.

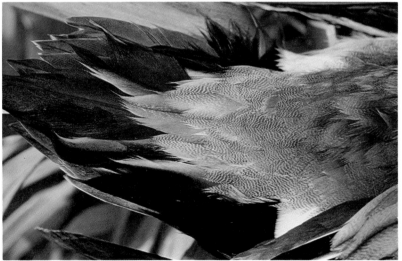
242

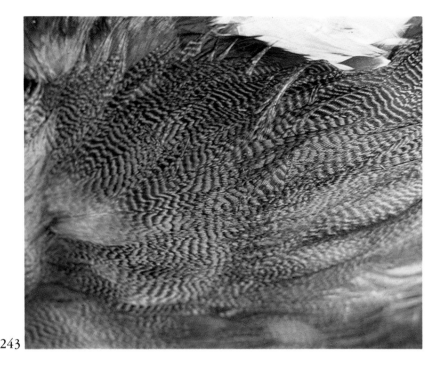

243

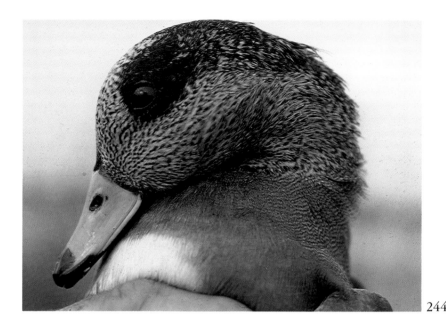

244

**WIDGEON HEN**

(243) The vermiculation of the cape shows the necessity for carefully applying a variegated undercoat before beginning the detailing. It is always necessary to look at these areas from a distance to determine what color will best suit your needs in washing the undercoat in. Liberally apply your medium (Grumbacher I), blending all interfaces so that when you have finished the bird creates the effect you are looking for when viewed from a distance. Now, come back in close to detail.

(244) A frightened drake widgeon, but one which provides an excellent opportunity to view at close range the detailing of the nail of the bill, the nostril, and the Payne's gray and white with a touch of raw umber that creates the color of this bill. We have already described the purple of the breast, but it is well to note the interplay of burnt umber and black in the cheeks and the bronze green worked into the mottled eye patch. Although the colors are not quite as vibrant in this eye patch, a little green bronzing powder would be in order if you are going to catch full nuptial glamour in your plumage pattern. Had this bird been turned a few degrees, a bright metallic green would have appeared. Structural color!

(245) Like the cinnamon teal hen, the widgeon hen is more colorful than the norm for female of the species. This photograph gives an outline of the body and head shape of the widgeon, which is quite definitive. You will notice the thickness of the neck and the posture of the head, which, in silhouette, even in black and white, would be easily identified as a widgeon.

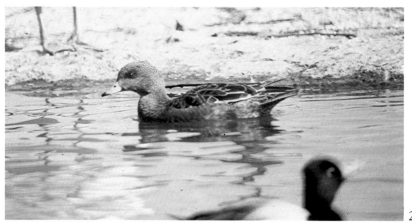

245

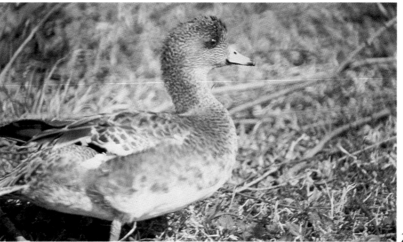

247

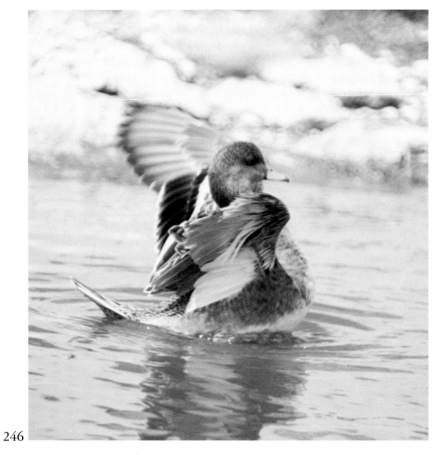

246

(246) Rather than concentrating on color for this particular bird, I would like you to look at its position as it fluffs its feathers. This is a typical display of the bird at play. The flight pinions of the right wing have been clipped, but the breast position and the uplifted tail are quite representative of the preening release position most waterfowl assume in rearranging their plumage.

(247) The mottled pattern of the widgeon hen and the combination of earth colors in the side pocket, the cape, and the shoulder are well worth noting. The head is a cool brown combination of colors, while the side pocket and the flank, as well as various parts of the back and the shoulder, are warm brown. Once again I call your attention to the fact that, for a competition painting, these feathers would be more clearly delineated and much more contrasted than they are on an actual bird.

(248) The cape and the scapulars have a central portion that is colored with a mixture of burnt umber and black, with a secondary pattern in the center of the feather of raw sienna, white, and a touch of yellow ochre. These central patterns should be applied by drybrush (almost as a very light vermiculation) and then stippled with a stiff bristle brush to soften the interface. The edges of the feather are an off-white, made by blending just the faintest amount of raw umber with the white. Moving over to the coverts, you will use a combination of raw umber and white, highlighted in spots with a little raw sienna. The side pocket is burnt sienna, yellow ochre, burnt umber, and white, interspersed irregularly. The primaries are raw umber and burnt umber, lightened with white.

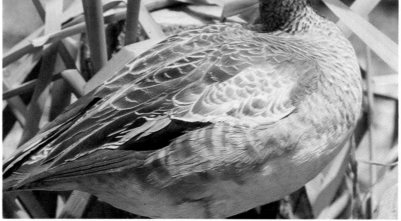

248

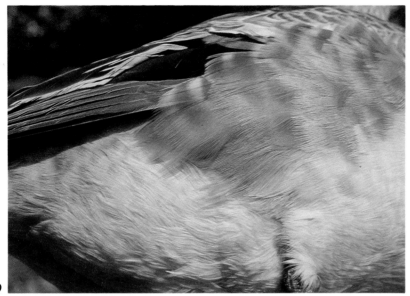

249

(249) Note the bronze green of part of the speculum, showing through above the side pocket. Note the softness with which the interfaces of the side pocket blend in from feather to feather. To achieve this effect, the colors in your pallet would be burnt umber, burnt sienna, yellow ochre, and black, in varying quantities, over an almost pure white undercoat. One of the most striking features about the widgeon, both hen and drake, is the amount of white that shows when the bird is in flight. This white is accented by applying, by drybrush, the slightest amount of raw umber.

(250) It is always nice to have a good layout, showing the interplay of the cape, the shoulder coverts, the scapulars, the tertials, and the primaries. This is well illustrated in this specimen. Note the varying degrees of tone, from warm to cool, that are achieved with the barest minimum of colors in your pallet. The percentile of white is the determining factor in creating this effect.

(251) I believe that the color in this photograph reflects a warmer, truer color for the cape and would be more indicative of an average specimen. Again, a great deal of the color variance in photographs occurs because of the angle at which the light strikes the feathers. This is the miracle of mechanical color reproduction. Note the magnificent interplay of siennas,

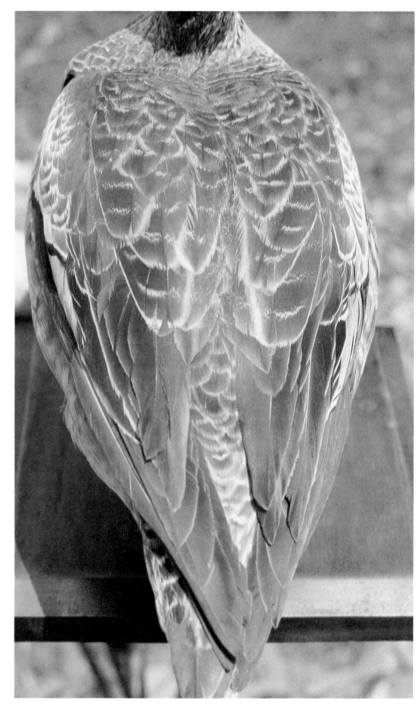

250

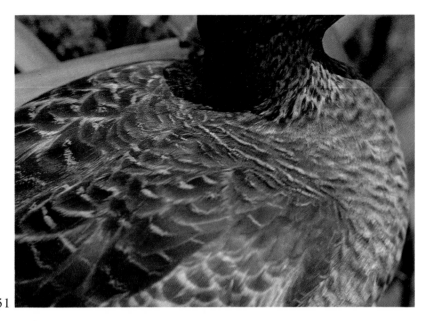

251

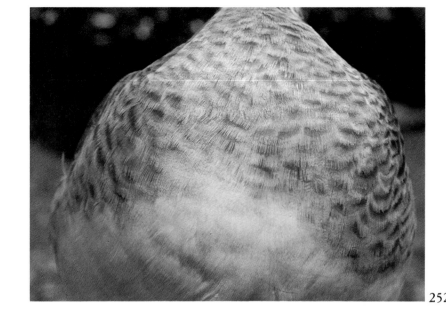

252

umbers, and ochres and the individual tonal variation from feather to feather. The softness of the wing coverts and the irregular size of these little feathers should be carefully noted. The raw umbers of the leading part of the coverts gradually become warmer as the siennas are added.

(252) Irregular lines should be as a sign, a constant motif before your eyes. The interspersal of the breast feathers with the abdominal area does not form a regular, straight interface. If you are trying to paint a bird for competition, you might end up with a graceful curve here, but if you are painting for realism, both the irregularity of color and the irregularity of pattern should be painted in. Again we are using the raw umbers, burnt umbers, blacks, burnt siennas, ochres, and whites. Bring the determining color in with the white, which will give you the multiplicity of tonal effects that must be created.

# 19

## Wood Duck

### DRAKE

(253) Probably no avian specimen has frustrated carvers more than the drake wood duck. It furnishes the first model for more carvers and painters than any other species of bird in existence. Looking at the magnificent plethora of color and the softness with which this little bird rides the waters, it is not difficult to see why it is a specimen both arduous and exciting to render. We will use this photograph to suggest blocking in the base color, using Grumbacher I medium liberally, with a small amount of lacquer thinner added to penetrate into the wood and establish the general areas to be detailed. Your pallet will expand to a greater degree with this specimen than with any other bird. The cadmium orange of the bill, the siennas, the umbers, the ochres, the black, the white—all such various colors appear in the drake wood duck.

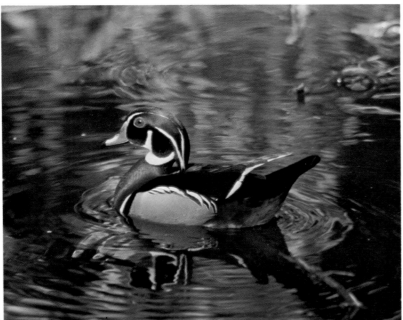

253

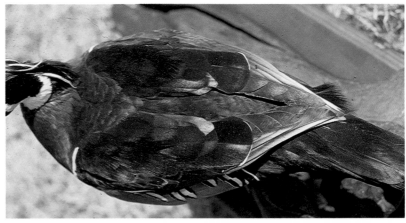

254

(254) This photograph should be used more for the layout of the feather pattern than for the colors involved. The amount of iridescence will vary tremendously with the angle of the light. You will notice purples, greens, blues, and various combinations of iridescent colors from one end of the cape to the extreme tip of the tail feathers. Note the squared appearance of the secondaries, the contrasting halves of the primaries, and the layout of the cape and the mane. All of these features should be established with a burning tool and the texturing stone before beginning the coloring. After texturing and burning, I would strongly recommend that you stroke the bird from the breast to the rear with a bronze wire brush to remove the fine particles created by the abrasives in the grinding wheel and by the carbonization of the wood from the burning iron. It is extremely important that the surface be adequately prepared before you attempt to apply your colors.

(255) If you are going to do a bird in flight, you have an excellent illustration here. It shows the raw umber, black, and white required to tint the underlying coverts of the wing. Note that the speculum, which is bright iridescent blue green on the top of the secondaries, is comprised of raw umber, black, and white from the bottom edge of the wing. The ground established on the breast is alizarin crimson, burnt sienna, and burnt umber. The ground established on the side pocket is white and yellow ochre, with touches of burnt umber. The ground established on the mane and cape blends into the breast area while still wet and is comprised of black, burnt umber, and a touch of yellow ochre to prevent the purpling effect.

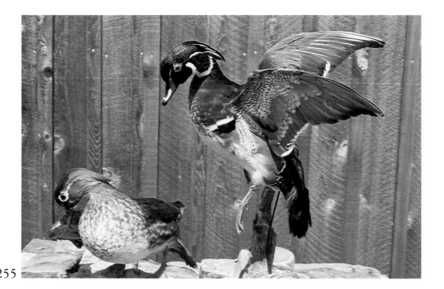

255

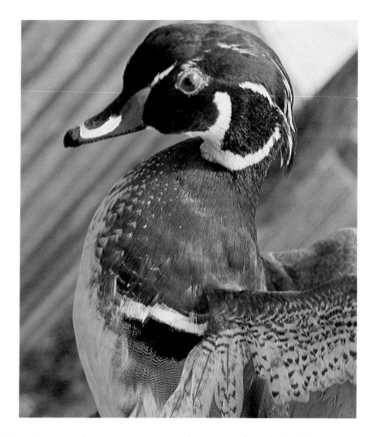

257

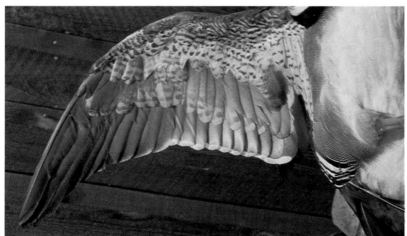

256

(256) Raw umber, black, and white for the under wing coverts. Note that the interfaces of the colors must all be delicately blended by stippling, with the exception of the trailing edge of the speculum, where there is, relatively speaking, a sharp line of demarcation between the colors. Note the irregularity with which the vermiculation of the side pocket works its way into the belly area. The purplish cast of the under tail coverts is obtained by the use of alizarin crimson, burnt umber, and a little ultramarine red. Not only the under tail coverts but the flank as well are a gradient of this combination of colors.

(257) Note the bright crimson and yellow of the bill. The crimson area is a pure harrison red (Grumbacher). The yellow is cadmium yellow (light) with the interface blended into the crimson. Note the multiple colors in the cheek and the crown, your pallet requiring black and thalo blue, with a streak of cadmium yellow (light) to bring out the grain. The purple is mixed from harrison red and black and a touch of white. The back of the neck blends into the breast area, with no sharp line of demarcation between the hairlike feathers that comprise the breast and the cape itself. The overlay of hairlike colors on the strip that separates the breast from the side pocket once again can obtain by dragging a fan blender over the interfaces of color that have been established in the preceding section. Note the interface of the black trailing edge of this area as it is pulled into the vermiculation. The vermiculation itself has a base color of yellow ochre with a touch of burnt umber added, and white to give it some tonal variance. Then it is layered with a very fine mixture of pure black thinned with Grumbacher III medium.

(258) The detailing on the breast of the wood duck drake is probably the most difficult thing to render so as to look natural. I have seen these feathers painted in as "v's" with harsh lines of delineation between them and the rest of the breast. Observe very closely that it is a hairlike effect, that can best be obtained in the following manner. First put the dark underlying color in and permit it to dry thoroughly. Then establish the white areas with a #1 sable brush in an extremely irregular pattern. Start off with tiny "v's" up toward the throat, interspersed with dots. Work into larger and larger v-shaped swatches, with white becoming increasingly predominant as you approach the belly area. Note the "v's" becoming broader based and narrower as they approach the side pocket.

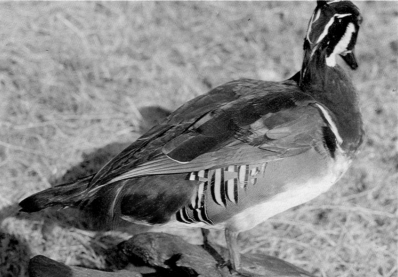

259

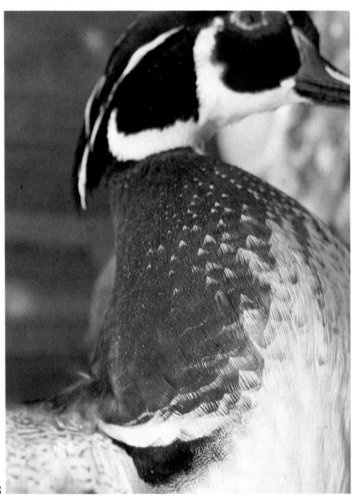

258

(259) We have pretty well covered the wood duck drake, but there are some details that still require a little more attention. These should be obvious from this photograph. Note the flank and under tail covert areas and the plumage that hangs loosely from beneath the primary. The plumage has an almost horsehair effect, with a streak of yellow ochre touched with a little burnt sienna. Note the flank area itself and the beauty which obtains from the use of Grumbacher red, burnt sienna, and burnt umber. While still tacky, a small amount of white should be pulled into the color to give you the varying tonal values required. Notice the side pocket and the contrasting black and white plumage that intersperses with the vermiculation. Again, this effect will establish itself in color if you have been careful in developing it first with a texturing tool or a burning iron. Note the contrast between the outer edges of the primaries and the inner half. The fine white line and the square ends of the secondary and the scapular overlay the primary. I don't think this is a bird that should be started as your first project. It requires a degree of sophistication that most beginners lack, and they will find this bird most frustrating to paint.

(260) We have discussed every possible posture for the wood duck, those in which the speculum shows and in which it is hidden. This last photograph gives you a wonderful broad brush treatment and shows why your pallet had to be expanded to include both the warmest and the coolest of colors.

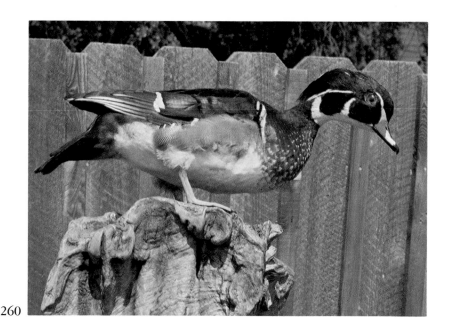

260

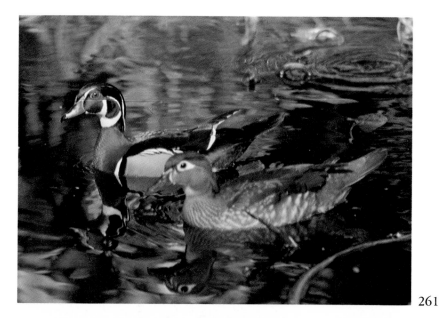

261

## WOOD DUCK HEN

(261, 262) As vividly as the wood duck drake stands out against this pin oak pond, I think the muted beauty of the hen creates an equal magic in the eye of the beholder. In blocking in the undercoat to establish the ground, use Grumbacher II medium, which dries quickly and will penetrate the wood almost as effectively as lacquer thinner. The pigment is raw umber and white with a touch of black for the head. Burnt umber, yellow ochre, and a touch of black and white establish the breast, the side pocket, the cape, and the back. While still wet, try to establish the pattern of off-white feathers that comprises the side pocket and the breast. Note that the smaller white areas on the breast gradually enlarge and expand in all directions as they approach the tail. Note the speculum, the forward portion of which is thalo blue and white with touches of black; the rear area is prussian blue touched with white. Use black on the trailing edge, pulled into the white. Note the eye streak stretching into a half-concealed subliminal color that works its way into the crest. Note the cadmium yellow (light) that marks the top edge of the upper mandible and the white that marks the rear edge of the upper mandible. The purple seen in parts of the photograph is created with Grumbacher red with a dab of white and black.

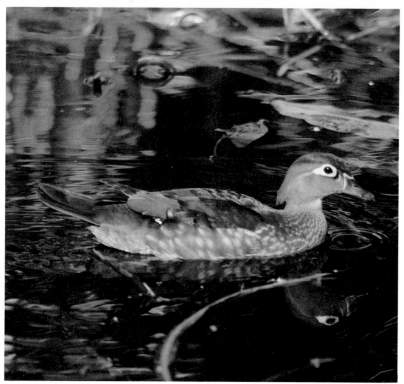

262

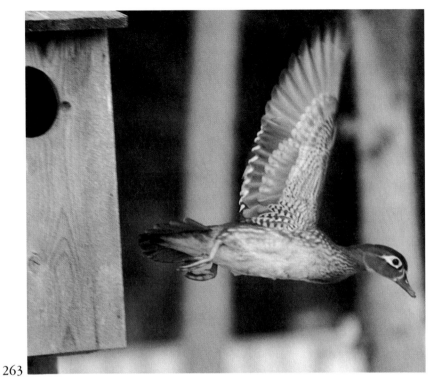

263

(263) If a bird in flight is required, it would be difficult to find a better example of the irregularity of pattern that the underside of the wing presents. Notice the flight feathers in expanded position, the primaries dark-tipped, the secondaries white-tipped, the greater underlining coverts and the middle underlining coverts a combination of white, raw umber, and black. Note the warmer color of the breast in contrast to the coolness of the tonal values of the cheeks and the mane.

(264) Here you would apply a mixed ground using Grumbacher III medium, which is slow-drying. Start off at the top of the breast with burnt umber and white with a touch of yellow ochre, increasing the percentage of white as you approach the middle of the breast, increasing the amount of burnt umber as you approach the lower part of the breast. All of this would be floated with an adequate amount of medium. Allow this to tack up. When it is almost dry, come back and detail with a #1 sable brush. Use white to overlay the darker portions of burnt umber. Use a slight amount of burnt umber and yellow ochre to overlay the upper portions of the breast and to create the hairlike, shingled effect this breast requires.

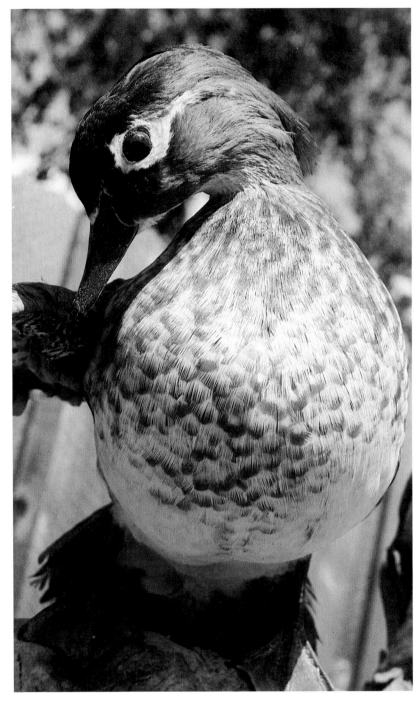

264

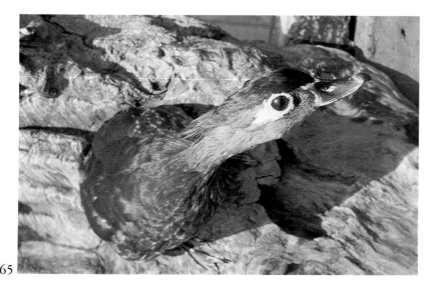

265

(265) We have described every aspect of this little bird except the erectile crest. It is created with yellow ochre, burnt umber, and black, with a touch of white, gradually lightening into an iridescence with an increased percentage of black. The highlighting is done with the cadmium yellow and white. Then, as we reach the rear end of the crest, the green iridescence would be obtained by adding small amounts of thalo blue with just a streak of cadmium yellow (light) to create the green. It might be desirable at this point to add a tiny amount of a deep green bronzing powder to complete the effect. Note the broken pattern of white stippling required in front of the eye patch and the contrasting dark edge that precedes this patch.

(266) A layout of the lesser coverts, the middle coverts, the greater coverts, the scapular, and the tertials is well worth studying in this photograph. On the hen the primaries have an outer edge or outer half that is a gray white, while the pigmentation and iridescence color the inner half of these feathers. Note in the secondaries and in the scapular the wide variety of colors that iridescence creates—purples, golds, light greens, and dark greens—but much more muted than those that appear in the drake. The tail feathers themselves are dark on top, burnt umber and black predominating, and raw umber and white on the underside. I think the effect of the hen is dramatically improved by the use of a fan blender when your final detailing has been completed, but with the bird still tacky enough to pull the interfaces together. This can be effected by

pulling from the back of the bird to the front. The burnt umber and black on the tail should be highlighted with white and yellow ochre to prevent a purplish cast from obtaining.

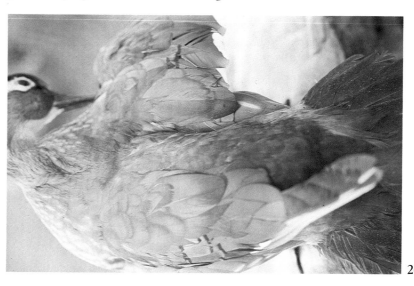

266

(267) Another shot of the breast, showing the effect on mechanical colors caused by turning the head.

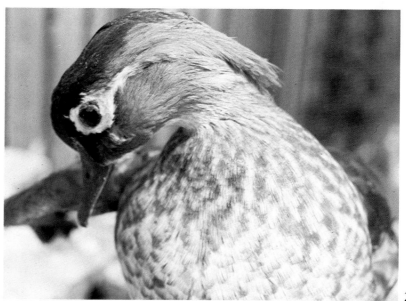

267

(268) As we have already described the colors of these areas, I merely present this photograph to give a possible pose in which the layout of the primaries and the speculum can be copied. Note the effect of the light at right angles to the interfaces of color. A shift of only a few degrees would cause this brilliance to dissipate dramatically.

# 20
# Canada Goose

(269) One of the most majestic birds in North America is undoubtedly the greater Canadian goose. The black head and neck, the white cheek patch, the soft burnt umber, burnt sienna, black, and white of the back create a pattern which is visible for miles. The large size of these birds does not prevent them from being graceful subjects, as their proportions are classic. We will require a very limited pallet, but an awful lot of pigment to cover the area, as again, this is probably the largest specimen amongst the waterfowl. Since the areas are so large, I would suggest that the painting be scheduled in three or four sessions. Work forward from the tail, from the black edging of the tail feathers themselves, to the white of the flank and the upper tail coverts. Continue with the burnt umber, black, and white with a touch of burnt sienna that create the ground of the back and the cape. Finally you reach the black of the neck and head and the white of the throat patch. When working from the breast through the side pocket, start with the white on the forward part of the breast and work in a gradually increasing amount of burnt umber, black, and yellow ochre, interspersed with the white, as you proceed to the end of the side pocket.

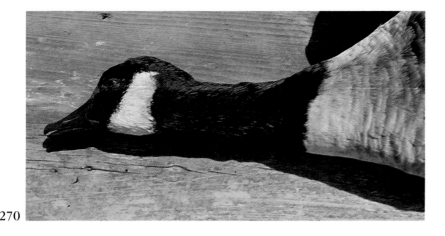

270

(270) The bill itself is a blue black. The head and neck show touches of burnt umber and white which highlight the black and will create that little purplish reflective color, preventing a solid black effect. The throat patch itself appears snow white at a distance, but when observed at close range has many darker areas. The darker areas are created by the shadows of the feathers overlaying one another and by the raw umber and white base coat of the throat patch having a pure white overlayer on the texturing. Note the stippling required at the interface and the irregularity of this throat patch when observed at close range compared to the sharp delineation of colors that appears at a distance.

(271) This is an excellent layout of feathers if you are going to attempt a trompe l'oeil position. The light has caught the edges of each individual feather and established the highlights in an unmistakable fashion. Note how much squarer the trailing edge of the scapulars and the wing coverts themselves appear in contrast to the rounded edges of the cape and mane. Note how delicately the burnt umber, black, and yellow ochre must be shaded and varied from the trailing edge of the black of the throat to the almost jet black of the rump. Note the delicate use required of burnt sienna to enrich and warm the tones of the back feathers. The stippling on the interfaces of the trailing edges of the feathers blends the highlighting into the darker central portions.

(272) Viewed in detail, the lesser coverts have a broken highlight pattern that can be quite effectively obtained by establishing the texture with burning iron and layout prior to the painting. The scapulars should be undercut to establish a depth to your feather pattern. Don't make the mistake of carving each individual feather, but undercut feather groupings at random in the scapulars, the secondaries, and the primaries as they approach the wing tip. An occasional lifting of a lesser covert or a cape or mane feather also has the effect of softening the final result and creating the random shadows that make the final work appear much more lifelike.

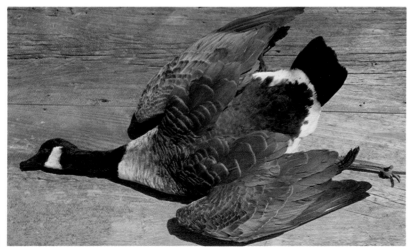

271

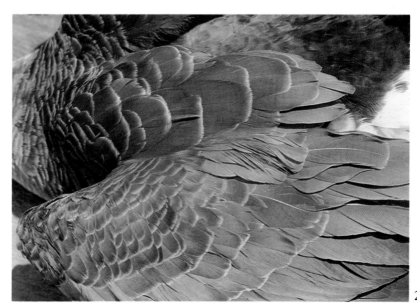

272

(273) The legs themselves are mostly black with the purple created by highlighting with burnt umber and white. There is a softness of texturing required on the rump and the under tail coverts as they approach the tail feathers. Unless this is established in the texturing of the bird before you begin to paint, you will never conceal it or hide it with pigment. At each step of the way, the more you have perfected your technique in the preceding steps, the easier it will be for you to establish the colors as you progress.

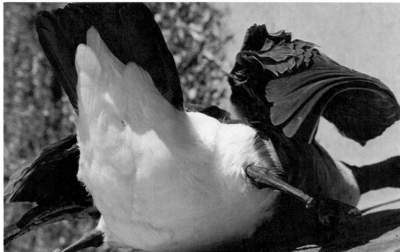

273

274

(274) Again, texturing and a broken pattern of the secondaries and the primaries are required. The effect of undercutting these feathers creates shadows as you apply pigments. The highlighting of the upper tail coverts and the back feathers follows a random design in which the purple cast is obtained from burnt umber, black, and white without the addition of yellow ochre. The warmer tones at the top of the upper tail coverts are obtained from burnt umber, yellow ochre, and white. A touch of burnt sienna would be helpful in enriching this color, giving you a warmer tone. The ends of the scapular and the secondary are also a very warm color, which will obtain from the judicious use of burnt umber, burnt sienna, black, and white. While this is still wet, I would pull a little yellow ochre and white to highlight the trailing edge of these feathers.

(275) We have already described the color of the cape and the mane in preceding photographs, but a close-up of the area should help to establish in your mind the random pattern and hairlike end effects of the almost squared and layered feathers of a Canada goose. The tonal values are more readily accentuated if you have established the texture through the judicious use of burning iron and texturing abrasive wheel.

275

118

(276) This photograph shows warm to cool tonal values, stretching from the shoulder of the bird to the tips of the primaries. The spline of the feathers in the primaries should be accented with white and a touch of burnt umber and black, using a #1 sable brush and an adequate amount of medium to thin the paint into a consistency that works well with a liner brush. Note the highlights on the edges of the secondaries and the tertials. Observe how carefully the interfaces are blended without having any sharp lines of demarcation between the tonal layers of off white, a fawn color on the trailing edge, a dark band accentuating burnt umber in the middle, and an increased amount of white as one approaches the trailing edge of the next feathers. This will have to be done in a series of steps, blending the interfaces while still wet and applying the final highlighting of white and yellow ochre on the extreme trailing edge of each row of feathers to establish a brighter contrast. Note the effect that can be achieved by pulling the colors while still wet, using white to create the tonal values in the secondaries, and lightening the effect of the burnt umber and black with a slight amount of white and yellow ochre, in the darker areas.

276

# 21
## Snow Goose, White Phase

(277-81) I think that in discussing photographs 277 through 281, the most effective method would be to describe the technique and the texturing en masse. Obviously, the pallet is very limited—the color of the legs, the bill, and the primaries being the only divergence from the shadowed white that the rest of the bird evidences. The bill and legs are white toned with alizarin crimson and a touch of cadmium red (light). The lamellae are burnt umber and black. The primaries are burnt umber and black, highlighted with white and yellow ochre. When observed at close range, the remainder of the bird is a snow white, but the shadows of the textured layers of feathers must establish a ground. The undercoat is a very, very light gray with a touch of silver. Permit this to tack and then come over the whole bird with titanium white. If you have textured the bird properly and established the right ground, the effect will be dramatic. If you fail to take into consideration the shape of the bird and the texture of the various areas of the throat, the side pocket, and the back, you will be extremely disappointed at the loss of drama when compared with the living creature. Why is it so difficult to reproduce the simplest of nature's color patterns? Subtleties are always more difficult to create than sharp contrasts.

277

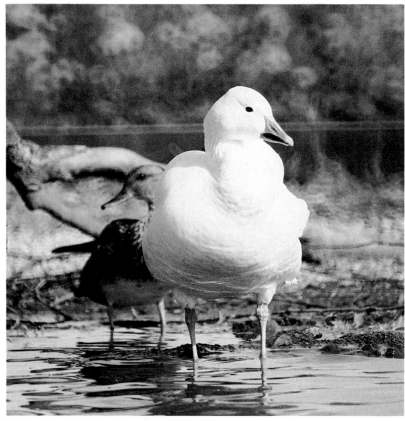

278

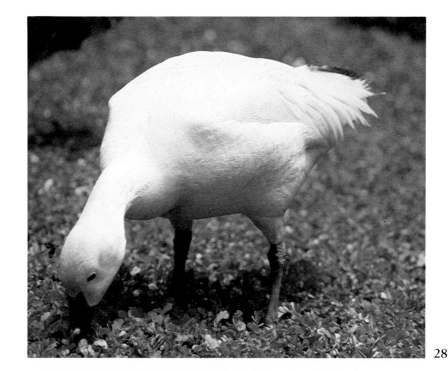

280

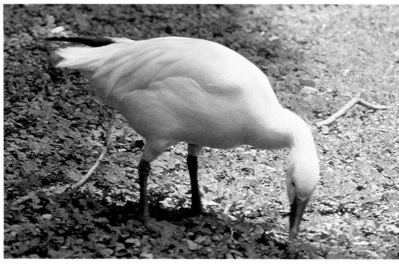

279

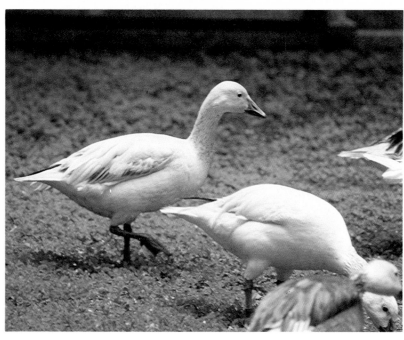

281

# 22

## Snow Goose, Blue Phase

(282) For many years the blue phase of the snow goose was considered a separate species, but today we know that it is merely a color variation of the same species. The pallet is slightly expanded, but the area to be covered with darker colors is, of course, much greater. Start off by washing the entire bird with Grumbacher III medium and titanium white. While still tacky, add small amounts of raw umber, burnt umber, black, yellow ochre, and white to block in the pattern of the back, primaries, secondaries, and greater coverts. Since the bird is so large, use an area technique, as it will be virtually impossible to do the entire bird in one sitting. Allowing these base colors to establish themselves and set up thoroughly, we could then proceed with the detailing.

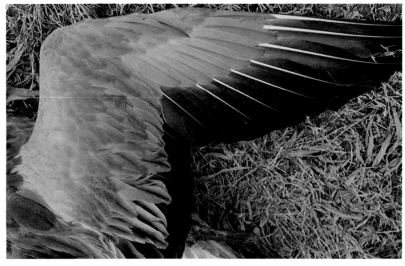

283

(284) A detail of the cape shows you the significance of texturing carefully before you begin to apply pigment. The area of the lesser coverts can be textured best with a burning iron. The area of the cape is best textured by the use of an abrasive grinding wheel. The higher the speed of the grinding wheel, the more effective and lifelike the texturing seems to become. I like a minimum of 15,000 rpm, but prefer 30,000 to 50,000 rpm.

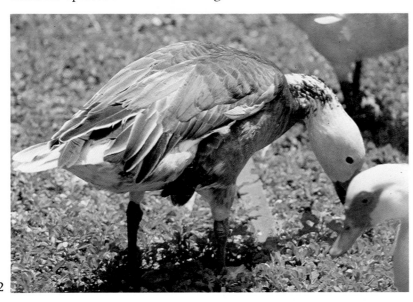

282

(283) With the wing expanded, a great deal more silver gray is apparent in the lesser coverts, the middle coverts, and the greater coverts. Note the white silver appearance of the splines of the primaries and the dark central portions of the greater coverts. The interfaces are blended by stippling. The secondaries are burnt umber and black, highlighting edges with yellow ochre and white.

284

285

(285) The random feather pattern of the chest is raw sienna and white, the trailing edges of the feathers being highlighted with burnt sienna, white, and yellow ochre. The lesser coverts, undercoated with white, are now highlighted with a wash of silver and gray. The splines of the feathers are done with a liner brush, with raw umber pulled through while still wet. Note carefully the broken, random pattern of color that appears in

this area. Pull these colors into one another. Don't be afraid to reapply wash after wash, learning to thin your pigments with medium to achieve the right degree of opacity without allowing the pigments to build up and form ridges that will plague you when the bird's colors begin to set up and dry.

(286) At a distance, much of the detail disappears. The sole purpose of a photograph of this kind is to show you the subliminal recognition that is possible at a distance and the loss of color detail that obtains as distance increases. The closer one gets, the more beautiful the detailing appears.

(287) The pinion of the right wing having been removed, we are looking at the secondaries, the middle coverts, and a portion of the lesser coverts. In the rear of the photograph, the primaries of the left wing appear. I believe this photograph is worth including because the tonal values of the tips of the lesser and middle coverts show the hint of the burnt sienna, raw umber, burnt umber, and yellow ochre that must be used to give the correct tonal value. The texturing and the undercutting of the secondaries is well illustrated in this example. Note the broken edges of the feathers. You very seldom find them perfectly arranged—flight tends to separate and destroy their symmetry.

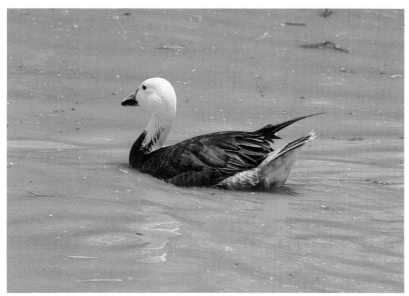

286

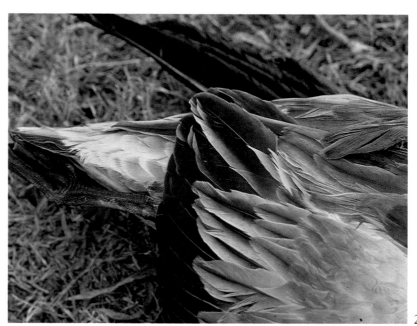

287

288

and primaries with respect to one another. Unless these details are attended to carefully before you begin the painting and detailing, there is no way to conceal your errors. Note the rounded appearance of the rump as it blends into the tail. Note the highlighting of the primaries and tertials and the broken pattern established as the side pocket works its way into the lesser coverts. The irregular pattern that is created as the breast works its way into the white of the throat and the neck should pose no problem if laid out in advance.

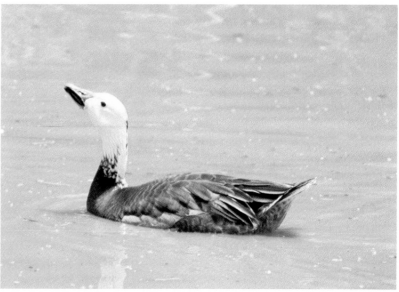

289

(288) The texturing of the neck can best be obtained by the use of a coarse abrasive wheel, but the pattern should be laid out with a pencil before one attempts to grind in this detail. Note the effect that turning the head has on this pattern. If you are doing a bird with the head in the erect position, the pattern sweeps from the front of the neck downward towards the nape. If the bird is feeding and the head and neck are bent, a double convolution obtains in which the pattern sweeps up and bends and twists in a helical fashion down into the nape and cape. The effect of the refractive index on feathers is apparent on both of these birds, where a slight bluish iridescence appears on the tertials. Note the variance in marking on the head as it joins the darker portion of the lower neck and throat. It always amuses me to hear the judges criticize birds on the basis of color patterns in areas they delineate. The more birds you observe, the more temperate your judgment becomes as to just what the precise pattern should be, and just how far it should extend.

(289) I think we have described the color of this bird in sufficient detail, but once again I would like to stress the importance of undercutting the tertials and the secondaries, as well as the positioning of the tail feathers

# 23

# White-Fronted Goose (Speckled Belly)

(290) The speckled belly goose is an epicurean delight to South Louisianians and a magnificent bird to paint. The pallet required is a limited one—raw umber, black, white, burnt umber, yellow ochre, and cadmium yellow (light), with cadmium red (light) for the bill and feet. The significance of texturing should be extremely apparent in the neck area, and can best be done with a high-speed abrasive wheel. Note the rounded shape of the body and the bowed stance of the legs.

(291) Like all species of geese, the areas involved are so large that it is virtually impossible to paint the bird in one sitting. I would suggest blocking in the head, neck, back, and side pocket with raw umber, black, and white. Block in the belly and the rump exclusively with white. In order to achieve symmetry, it is important that you mix an adequate amount of color and block in your color areas working from the front of the bird to the rear. Go from side to side to maintain a level tonal value. If you complete one side and get halfway through the other, it can create quite a problem. It would be extremely difficult for the neophyte to precisely match the tonal values established on the side pocket on the opposing side. Be sure the undercoat has no sharp edges where the side pocket joins the back or where the rump blends into the side pocket. These interfaces will be established as you detail the bird in later steps. Note the highlighting of the trailing edge of each row of feathers; unlike many waterfowl species, a pattern is established here. All of the goose family tend to have irregular rows of feathers from the breast through the side pocket, from the nape of the neck through the cape into the tertials and secondaries.

(292) If the bird has been properly textured, this throat effect can be achieved by a dark undercoat of black and burnt umber painted over with raw umber and white. In the breast area, the black and burnt umber of the irregular pattern that gives the speckled belly its name should be allowed to almost dry before pulling into the raw umber and white of the rest of the bird. Be careful not to allow the layers of pigment to build up

into ridges, as there is very little texturing in this area, the feather pattern being very minute and almost hairlike in appearance. The area directly in back of the upper mandible is titanium white with burnt umber blended at the interface into the white on the leading edge and pulled into the raw umber to the rear. The light outline of the eye and the eye shadow is created by a slight indentation to the rear of the eye itself.

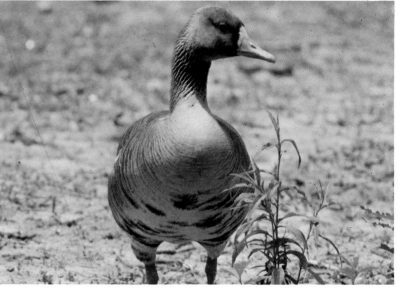

290

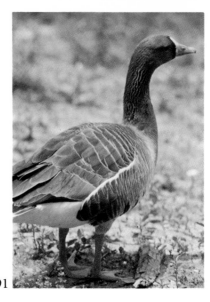

291

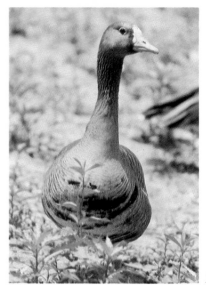

292

(293) The highlighting of the interface of the side pocket and the middle coverts should have been established in the carving before the pigments were applied. The correct procedure is to create a soft, irregular interface by pulling titanium white into raw umber.

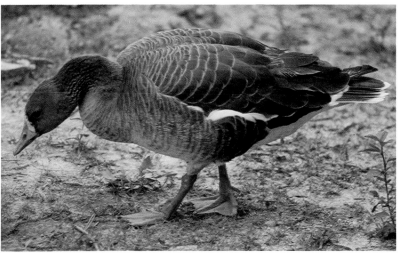

294

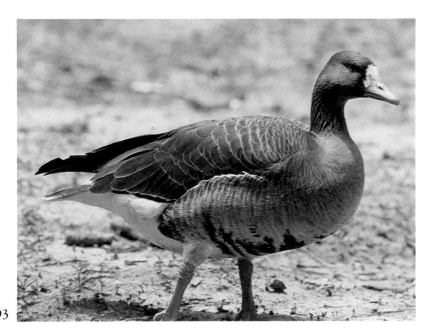

293

(294) This bird offers an interesting study in position. The neck is in the feeding position and the bend is almost swanlike in appearance. The effect that positioning of the head and neck has on the side pocket and the positioning of the cape, the tertials, and the lesser coverts are all apparent here. Note the white of the upper tail coverts and the white tips of the tail feathers themselves. As the side pocket proceeds from the breast area, an increased amount of burnt umber and black are required. A second and third highlighting step are required to permit the blending of the interface at the trailing edge with white and yellow ochre. This is overlaid with white, and then overlaid and touched here and there with a trace of raw umber. This blending of colors on the interfaces creates a softness only if the colors are separate and distinct. The area should be almost dry before attempting to apply the next color or you will end up with a muddy, washed appearance rather than the sharpening of the interface that you are attempting to create. Note the change in the pattern of the breast feathers as the neck is pressed into the back.

(295) Another interesting position for those who are seeking an unusual pose to create a competition-grade bird. The darkness of some of the spots on this specimen, in the abdomen and on the bristles of the thigh, are black, burnt umber, and yellow ochre. Note the warmth of the raw umber, tinged with burnt umber, on the top of the head and the side of the chest.

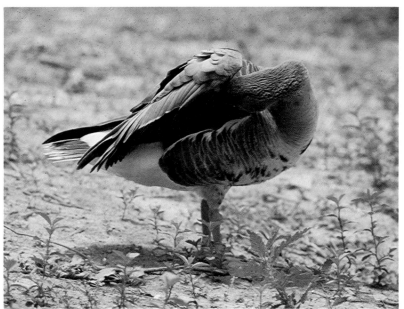

295

(296) The regal appearance of this drake and hen could hardly be more impressive had it been copied from the tomb of some Egyptian pharaoh. The grace, the strength, the kinetic positioning of the head and neck, and the thrust of the legs make this one of my favorite illustrations. The color of the speculum requires wet-on-wet application, pulling black and then white into the raw umber of the undercoat. The upper portion of the speculum is highlighted and blended with burnt umber with a little yellow ochre. This will create more of a golden cast than a purple cast. Again, note the highlighting of the eye streak.

(297) Figure number 297 is another example of the texturing required on the neck of the speckled belly goose. I would paint the undercoat with black and burnt umber. Permit this to almost dry and then pull raw umber, white, and a little burnt umber to highlight the top edges of the texturing.

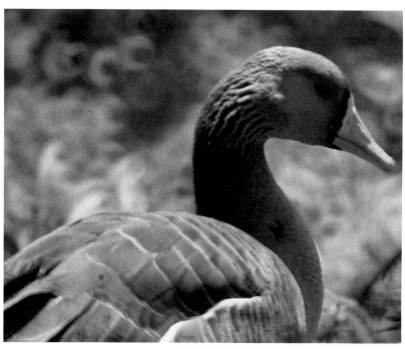

297

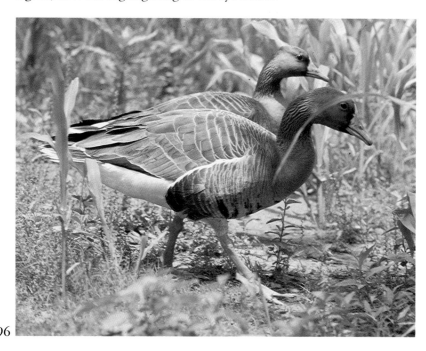

296

There you have it—color details of the anatomy of a waterfowl. I hope you will derive nearly as much pleasure from using these photographs as I have derived from presenting them to you.

# A Glossary of Frequently Used Art Terms

**Bronzing powder**—Powder made from bronze or brass alloys and various pigments, used with a varnish or oil-base medium to simulate iridescence. The powder comes in almost any color. It is usually used to give a mechanical color to the speculum or cheek in birds where iridescence is common. Bronzing powder is not long-lasting, and not presently recommended by fine art experts.

**Burning**—The technique of impressing, with a hot iron, the quills and details of a feather pattern in a wood carving. This technique is a necessity for the decorative carver.

**Chemical color**—Color produced by the use of pigments suspended in a medium.

**Cool colors**—Those colors in which blue is dominant, i.e., greens, violets, bluish grays. The term also can be used in a relative sense—raw umber is cooler than burnt umber.

**Drybrush painting**—This technique is used in creating a broken or mottled effect and is done by holding a brush at an angle, so that its side lies almost flat against the carving, and drawing it rapidly across the surface. It is sometimes referred to as a dragging stroke or scruffing. After the pigment and medium are applied to the brush, it is usually wiped on a soft cloth to remove any surplus liquid. The strokes are rapid and light. It calls for a free hand and will result in muddying the color if second or third strokes over the surface are used—a very useful technique, but one that must be applied very carefully.

**Ground**—A surface to which paint is applied. Also, a coating material used to prepare a surface for painting. Remember that acrylics may be used as a ground for oil-base paints. In order to seal a surface on a working decoy, acrylics are often used. Oil paints can then be applied and will adhere. If the base is an oil-base paint, acrylics will layer and peel.

**Half tones**—Color value, intermediate between a darker and a lighter tone of that color.

**Highlight**—Used in the text to denote the high point of color value in a particular area. For example, the iridescence in the cheek of a mallard drake or the trailing edge of a feather. Most feathers have a lightening of the tonal value towards the edge of the feather. This is most effectively created without an interface and requires a little practice to perfect.

**Interface**—I have used this term to describe the line of demarcation between two contrasting colors. In usage, it also refers to the edge buildup of pigment too liberally applied, which creates, from the outset, a faint ridge that detracts considerably from the artistry of the work. Interfaces may be sharply delineated, as on the eye patch of a bufflehead, or they may be blended, as in the edge of the color patches in a mallard hen's back. In any case, the gentle application of a sable brush to the line of the interface is usually a prerequisite to a lifelike effect.

**Iridescence**—A color effect caused by defraction of light rather than by pigmentation. A play of the spectrum of colors occurs when light is defracted from a thin layer that lies between two mediums of different refractive index. This can be created as an illusion with pigments, as well as by the use of bronzing powder.

**Liner brush**—Originally designed for coach painters and decorators, now used by sign painters for fine straight lines and sharp edges. Most are made with long camel hair with wide, straight ends. Others, called angular liners, have the hair set so that the end is diagonal. Dagger stripers look like miniature knives with a sharp point and short handles. One side of the brush is straight and the other is curved. The sword liner has both curves inward towards the point, and is the one that I prefer to use on waterfowl.

**Mechanical color (structural color)**—The iridescence in birds is caused by the refraction and interplay of light on the tiny reflective and transparent surfaces that create that magnificent natural phenomenon, the feather. In effect, layers of translucent, refractive surfaces cause the spectrum of light to be displayed from the brightest to the darkest of hues or from the coolest to the warmest. This phenomenon is brightest when the angle of light strikes the object perpendicularly to the surface. As the eye moves, it alters the angle from which the light emanates, and the color hue consequently can change from bright green to almost black. This is the wonder of mechanical color.

**Posterized**—A technique used by commercial illustrators in which there is a sharp interface between colors. When viewed from a distance, the eye blends the interface. This technique is generally used in working decoys to make it easier for the average individual to repaint the working bird.

**Stippling**—The application of small dots of color with the point of the brush. Stippling can also be done by tapping or pouncing a vertically held brush on the surface, using repeated staccato touches.

**Texturing tools**—In recent years, decorative birds have been enhanced by the use of numerous devices to create the texture of certain parts of a waterfowl carving. Most common are the high-speed dental stones, in various shapes, which can be applied in many patterns. Texturing tools are particularly effective on the under tail coverts, the belly, and the breast.

**Trompe l'oeil**—A French term meaning "deception of the eye." It is applied to paintings so photographic and realistic that they may fool the viewer into thinking the objects represented are real rather than painted. It usually designates a style of painting also called "Cabin Door Art," one of the earliest proponents of which was an American painter named William Michael Harnett (1848-1892). This cabin door art usually depicted a waterfowl or game bird hung from a nail on an old barn door.

**Vermiculation**—Twisted markings, usually of darker colors on light, seen in many waterfowl. The markings are wormlike in shape of movement—the irregularly twisting lines or ridges suggest worm track. The twisting lines can either be a half tone different in color value from the background or sharply accented against the background by a contrast of extreme color value, i.e., from black to white.

**Warm colors**—Those colors in which red and yellow are dominant, including yellowish or brownish grays.

**Wash**—An application of an extremely dilute mixture of pigment and medium. A transparent touch of thinned color, as distinguished from full strength or concentrated color.

**Wet on wet (alla prima)**—The technique of applying a second color over a base coat that is not completely dry.

# Bibliography

Barber, Joel. *Wildfowl Decoys.* Miami: Windward House, Inc., 1934.

Forest Service, U.S. Department of Agriculture. *Important Trees of Eastern Forests.* Published by U.S. Department of Agriculture, 1968.

Gibbia, S. W. *Wood Finishing and Refinishing.* rev. ed. New York: Van Nostrand Reinhold Co., n.d.

Gould, Mary Earle. *Early American Wooden Ware.* Rutland, Vt.: Charles E. Tuttle Co., Inc., 1962.

Louisiana Geological Series of 1938. *Geology of Grant and LaSalle Parishes.* Bulletin No. 10.

Louisiana State Museum, Biennial Report of Curators. *Contemporary Art and Artists in New Orleans-Isaac Monroe Cline.* New Orleans: Louisiana State Museum, 1924.

Lynch, John P. *On Louisiana's Bayou Language.* Published by Louisiana Wildlife and Fisheries Commission, 1942.

Matthiessen, Peter. *The Snow Leopard.* New York: Viking Press, 1978.

Mayer, Ralph. *A Dictionary of Art Terms and Techniques.* New York: Thomas Y. Crowell Co., 1969.

McCurdy, Raymond R. *Los Islenos de la Luisiana, Supervicenia de la Lengua y Folklore Canarios.* Baton Rouge: LSU Press, 1958.

Morris, Rev. F. O. *A History of British Birds.* London: Ballantyne Press, 1897.

————. *A Natural History of the Nests and Eggs of British Birds.* London: Ballantyne Press, 1896.

Murphy, Stanley. *Martha's Vineyard Decoys.* Boston: David R. Godine, 1978.

Nolan, Bruce. "Marshland Dying, Slowly but Surely." *Times Picayune.* 15 April 1979.

*North American Decoys.* A quarterly magazine.

Queeny, Mosanto. *Prairie Wings.* Exton, Pa: Schiffer Publishing Co., 1979.

Richardson, R. H. *Chesapeake Bay Decoys.* Cambridge, Mass.: Crow Haven Publishers and Tidewater Publishers, 1973.

Simon, Hilda. *The Splendour of Iridescence.* New York: Dodd, Mead & Co., 1971.

Starr, George Ross. *Decoys of the Atlantic Flyway.* New York: Winchester Press, 1974.

Wiesendanger, Martin and Margaret. *Louisiana Painters and Paintings from the collection of W. E. Groves.* Gretna, La.: Pelican Publishing Co., 1971.

Wills, Dewey W. "This is Catahoula Lake." Master's thesis, Louisiana State University, 1963. Published by Louisiana Wildlife and Fisheries Commission.